O!
SAY
CAN
YOU
SEE

The story of America

Color
Reproductions
by Edward Wilson

Jacket
and
Design
by
Earl R. Blust

O! SAY CAN YOU SEE

through great paintings

Compiled and Narrated by Frederic Ray

Introduction by Robert H. Fowler

Epilogue by Dr. Charles C. Sellers

STACKPOLE BOOKS

a National Historical Society book

O!
SAY
CAN
YOU
SEE

ND
205
.R37

Standard Book Number: 8117-1185-4
Library of Congress Catalog Card Number: 70-100349

Printed in U.S.A.

Contents

Paintings and Narration

Contents continued

An Introduction to the Paintings

"I have lived so long in our American past that it is like a certain part of my life," Howard Pyle once wrote. "My imagination dwells in it and at times when I sit in my studio at work I forget the present and see the characters and things in those old days moving about me. . . ."

This master illustrator of America not only had an almost palpable feeling for the past, he was also a student of history with a passion for getting details just right. And he had a marvelous ability to transmit both his knowledge and feeling through his paintings. Several generations of Americans have visualized pirates or Revolutionary War soldiers as Pyle saw them in his own rich, well-informed imagination.

What's more, Pyle inspired students of his "Brandywine Tradition" to develop their own imagination in painting scenes from American history, and they—men such as Stanley M. Arthurs, N. C. Wyeth, Clyde O. DeLand, Harvey Dunn, and W. H. D. Koerner—in turn depicted scenes and characters from the national past in bold, colorful, accurate fashion.

But Pyle and his artistic progeny are only one link in a chain of talent that stretches back to colonial days, back to Benjamin West, the Peales, and others. Without the work of these and other painters of different schools and techniques, our understanding of American history would be drab indeed; it would lack the vivid appreciation that can be conveyed only by inspired paintings.

History influences art; of that there can be no doubt. Consider how many artists have concerned themselves with historic events. Has their art in turn influenced history?

Probably not *history* itself. Rather, art influences strongly a people's view of history, their image of how they came to their place in time and even their view of themselves. It may be even that, except for a tiny minority of history scholars, Americans have been more influenced by the paintings of the Peales, Trumbull, Remington, Pyle, Wyeth, and Ferris than by the writings of academic historians. The painting conveys its message in a swift glance; the book takes hours.

The debt of history to art goes far back, long before the American experience began. This tremendous debt ranges from some prehistoric Michelangelo for the drawings of a bison hunt he left on the wall of a French cave, to the artwork found on the walls of Egyptian tombs. Trajan's column is a great historical record, but

even where the ancient artists had no thought of history, as in the wall decorations of the excavated cities, they contributed to it, and have left a far more direct and emphatic record of the cultures of the past than the writers.

Crude and biased as it is, the famous Bayeux tapestry records much about the Norman conquest of England that is unobtainable through manuscripts. This and earlier examples of art that serves as history are remarkable because they are so rare. American art, as a vehicle of history, is remarkable because there is so much of it and so much of it is good.

Europeans sometimes scoff at Americans who are proud of their history. America is a "new country," a stripling among nations such as France or Italy, they say. They overlook, for one thing, that the United States government is second only to that of Great Britain in age. It predates that of France, Spain, or Greece. And America was a country with a national consciousness, not to mention government, while Italy and Germany were groupings of separate little states. But there is more to it than that.

No single historical event can match in importance the discovery of America. Suddenly, the teeming populations of the Old World, fettered by age-old customs, by rigorous boundaries of class and status, were confronted by a new and overwhelming force. Status stemmed from the ownership of land. But here was half a world, a whole hemisphere of wild, rich land, open to adventurers, to settlers of every sort.

The changes came gradually, but with increasing speed and ever greater impact on the old cultures. The first Americans brought with them the European sense of status, but class distinctions crumbled rapidly where every man of spirit could acquire a domain as great as any British lord's. Englishmen came to America with their cherished concept of British liberty, but in America it took on a larger meaning. By the close of the American Revolution, every citizen *was* a lord—an equality alarming even to some of the English liberals who came over to taste the free air of this new nation.

The American Revolution had an echo—its sequel, really—in the French Revolution. By then almost two centuries had passed since Americans had first begun scratching out a foothold in the wilderness, setting up governments of their own, building cities, highways, founding universities, moving westward in the great march of progress which dominates our history. In Europe in the years that followed the Bourbon overthrow, waves of reaction and revolution surged and ebbed, and between wars there were the tides of emigration. Slowly, class distinctions everywhere were crumbling and the new democratic ideals gaining ground. Feared on one side, emulated on the other, American history had become a quickening and liberating influence felt throughout the whole world.

At the heart of American liberty is full freedom of expression for all. The ordinary citizen has been free to speak, the editor to print, the author to write, the historian to record and interpret . . . and the artist to paint. Add to this their sense of participation; rather, the *fact* of participation that most Americans have possessed over the centuries as they have elected representatives and served on village councils, gone first to colonial and later state legislatures, sat on juries, voted in free elections. This sense of participation is shared by the American artist. He is both spectator and participant.

It would be marvelous if the work of all these great American historical artists could be gathered in one vast hall . . . marvelous and impossible. If someone were determined to see each one of the hundreds of their paintings qualifying as "great," he would have to spend months crisscrossing the country (and even going to

Europe) to see them all. He would have to visit public museums such as the Metropolitan Museum of Art in New York on the Corcoran Art Gallery in Washington, privately owned galleries such as the Wilmington Society of Fine Arts in Wilmington, Delaware or the E. B. Crocker Art Gallery in Sacramento, California, plus scores of small collections owned by individuals.

To our knowledge there is not even a collection of selected paintings which concentrates on telling the story of America, from prehistoric days to the dawning of the Space Age, in chronological order, with guides who are knowledgeable both in history and art.

Again, this would be marvelous but hardly possible unless an organization had millions of dollars to hire a staff, construct a building, and purchase the masterpieces. *O! Say Can You See* is an attempt by The National Historical Society to create such a gallery within the covers of a handsome book. Many months have gone into this creation. As indicated in the section on credits, the pictures have come from many sources: museums, government agencies, and private collections. With a vast reservoir of historical paintings and illustrations from which to select, those have been chosen that best pictorialize the highpoints of the nation's history—from the visit of Leif Ericson in 1001 to the landing on the moon in 1969, sprinkled with occasional genre studies of everyday life. Excluded are some of the long-popular scenes, but at the same time some not-so-familiar pictures are introduced.

It is academic whether one classes the pictures as "fine-art" or as "illustrations"—they all tell a story, reflect an event, set a mood. The "illustrator" only restricts himself more realistically to facts than does the "painter". The point of view may vary, but both were equally draughtsmen and colorists; both alike engaged in pictorial communication. Artists like Winslow Homer began their careers as illustrators, and later luxuriated in the independence of the more imaginative "easel painting."

The purpose of *O! Say Can You See* is to present the works of a variety of artists of diverse tastes whose pictures give continuity to the theme. Some depicted their own times; others recreated the past. Columbus carried no artist among his crew; N. C. Wyeth's gifted brush and fertile imagination has re-created for us that moment of the admiral's landing. But James Walker *was* an eyewitness to the Battle of Chapultepec in the Mexican War and he has impregnated his canvas with an authority that could hardly have been duplicated by the imagination. Howard Pyle's masterful re-creations of the Battles of Bunker Hill, Germantown, and Nashville bear witness to his immersion in the American historical scene. He did not live during the American Revolution; yet he could breathe life into his pictures of that era.

Some traditional paintings which might be expected here are, in some instances, missing; not because they are any less relative to our theme, but because they have been, perhaps, overexposed. John Trumbull's "Battle of Bunker's Hill" has been supplanted by a substitute in Pyle's interpretation of the same event from another viewpoint. And Trumbull's "Signing the Declaration of Independence," seen so often with its frozen gallery of portraits of those venerable signers, has given way for J. L. G. Ferris' painting depicting the drafting of that immortal document. Emanuel Leutze's heroic canvas "Washington Crossing the Delaware" is also missing here; again we felt that a lesser known and seldom seen painting like Pyle's "Battle of Germantown" could infuse a fresh image to the Revolutionary War scene. Nor will the reader find Gilbert Stuart's Athenaeum portrait of George Washington. How often, since childhood, have we seen that splendid, tight-lipped visage? Rather let us look upon Charles Willson Peale's portrait of Washington in

1772; here is the young and prospering Virginia planter, still unaware that he had been marked for greatness.

Portraits are limited to Washington and Jefferson. They portray two remarkable Americans, one who directed the nation's destiny on the battlefield, later in the Presidency; the other, brilliant, a visionary, who drafted the Declaration of Independence at thirty-three and served as third President of the United States. Both shared in laying the foundations of the great American experiment in freedom.

Conversely, O! Say Can You See includes many of the familiar pictures; Benjamin West's "Death of Wolfe" and Trumbull's "Surrender of Cornwallis" will be readily recognized. J. L. G. Ferris, a name familiar to those who remember his pictures in their history textbooks or on the covers of the old Literary Digest is an artist leaned upon heavily, for it is felt that his works deserve re-exposure after a long period of relative obscurity. His original paintings presently repose in the vaults of the Smithsonian Institution.

The name of W. H. D. Koerner will be remembered, no doubt, by those old enough to recall his Saturday Evening Post illustrations. He is represented here by his paintings "The Mountain Men" and "Wagon Train West." The West of this early period was painted by capable contemporaries, Charles Bodmer, Alfred Jacob Miller, George Catlin. All have been duly celebrated in a long procession of current books on Western art. Illustrator Koerner captured the spirit and look of the early West with equal veracity, and his work is included with a pang of nostalgia for those old Post days when Koerner's Indians and frontiersmen rode across the pages of Steward Edward White's serialized novels.

Again, while the artist's imagination plays an integral part in the following pages, there are also pictures in this selection which are the products of personal observation. Like James Walker at Chapultepec, C. C. Beall was an observer at the Japanese surrender aboard the USS Missouri. The same may be said for "The Charge Up San Juan Hill" by Frederic Remington, who was an artist-correspondent in Cuba during the Spanish-American War. Captain Harvey Dunn was a combat artist in the trenches of France in 1918, and his painting "The Prisoners" has that ring of truth to it, and Ogden Pleissner ("Tank Breakthrough at St. Lô") followed the footsteps of Harvey Dunn into another war in France a quarter of a century later.

There was no artist present at The Alamo; so the illustrator's skill must convince us that "this is the way it might have been." Grant's muddy boots at Appomattox are a matter of record, and Mr. Ferris' thorough research has noted that fact. The illustrator of history, like the professional reporter, searches the records, evaluates the facts, and reports the story to the best of his capacity and talent.

In exploring the lives of the artists contributing to this gallery of pictures, it is of interest to note a continuity of association which evolves. Peale, Trumbull, and later Samuel F. B. Morse all studied under Benjamin West, the American expatriate who was the idol of the London art world, and who rose to become president of the venerable Royal Academy. In the mid-1800s, the Düsseldorf art community was the magnet that drew so many American genre painters to Germany—among our contributors, George Caleb Bingham, Eastman Johnson, and Richard Caton Woodville. J. L. G. Ferris was the nephew of Edward Moran ("Landing of Leif Ericson"), and both are noted for their respective series of American historical paintings. Howard Pyle's early apprenticeship in New York brought him into close contact with the young prodigy, Edwin Austin Abbey ("Von Steuben at Valley Forge"), and the two men remained lifelong friends. And, of course, Pyle's overwhelming influence, which reached out to touch so many illustrators and teachers in the early 1900s, has already been commented upon.

O! Say Can You See was developed by The National Historical Society, whose founders sought to create an organization that would stimulate wide interest in American history in several ways. Not only would a magazine be published—*American History Illustrated*—but the Society would also offer activities such as historical trips in the United States and abroad, and seminars in places of historical interest. The Society soon realized that its purpose of "making history come to life" could be served well by telling the story of America through great paintings. We found ourselves in a unique position to create this book because of our acquaintance with sources and facilities for reproduction. It was decided to develop *O! Say Can You See* as the first major book project of The National Historical Society.

Frederic Ray, Art Director of the Society's magazine, *American History Illustrated,* surveyed the possible choices of paintings. Many consultants were involved then in choosing this final exhibit of paintings that tell the history of America. Mr. Ray wrote the narratives and descriptions accompanying the paintings. A longtime student of American history and art, Mr. Ray studied illustration at the Pennsylvania Academy of Fine Arts. A Fellow of the Company of Military Historians, he has prepared many cover paintings for both *American History Illustrated* and *Civil War Times Illustrated.* Mr. Ray was assisted greatly by Mr. Edward Wilson of Wrightsville, Pennsylvania, whose firm, Color Service Incorporated, is responsible for the color separations for this book.

Dr. Charles Coleman Sellers of Dickinson College, an outstanding expert on the history of art, relates the story of 200 years of pictorial history in America in the essay, "Two Hundred Years of Pictorial History," which follows the reproductions of the paintings.

The heart of *O! Say Can You See* consists of the gallery of fifty-four paintings reproduced in full color. The true creators of this volume, then, are the thirty-five American artists represented between these covers. Their pictures portray a panorama of America's history stretching from N. C. Wyeth's "The Indian in His Solitude" and Edward Moran's "Landing of Leif Ericson" to Cliff Young's specially commissioned "The Eagle Has Landed," depicting the first landing of man on the moon. A number of the paintings appear here for the first time in full color in any book.

To make each painting more effective in carrying forward the story of America, Mr. Ray provides a descriptive narrative highlighting the times and events represented in the paintings. He also offers a brief biography of each of the thirty-five artists.

Should this book stimulate interest in exploring further into the works of the artists represented, we shall feel rewarded, for this is not merely a collection of diverse pictures; each painting tells something about the man who created it, for he too, was a part of history.

Do historical painters tend to "romanticize" history? Perhaps. But the artist was necessarily a man influenced and molded in one direction or the other by the tastes of his own times. Those tastes may have been Georgian or Victorian. He was, like the playwright, a dramatist. His stage was the canvas upon which his creations took shape and form, and the success of their performance depended upon the artist's own direction. Like the stage, the artist's canvas was the vehicle employed to stimulate his audience, to please, to inspire, and to inform. And so The National Historical Society presents this selection of one-act historical plays in the hope that they will do the same. Here is something old, hopefully something new.

It is the earnest desire of the Society that *O! Say Can You See* finds favorable response and spurs an increased interest, not only in America's history, but also in those artists who have by their combined and varied performances spread this colorful panorama before us.

ROBERT H. FOWLER
President, The National Historical Society

Acknowledgments

The National Historical Society wishes to express thanks to the many persons and organizations who made publication of this book possible.

Special thanks to Mr. William E. Ryder for permission to reproduce seven paintings by J. L. G. Ferris, and for making available Mr. Ferris' own research notes on these paintings; and to Mrs. Ruth Koerner Oliver, who generously provided the paintings by her late father, famed western artist W. H. D. Koerner. Also Mr. C. R. Smith, Mr. Andrew Wyeth, Mr. Cliff Young, Mr. C. C. Beall, Mr. and Mrs. George A. Weymouth, Mr. Ogden Pleissner, and Mr. Jay Altmayer.

The following have been most cooperative and unstinting in their help: Mrs. Mildred B. Dillenbeck, Remington Art Memorial, Ogdensburg, N.Y.; Mr. Rowland Elzea, Curator of Collections, The Wilmington Society of Fine Arts, Delaware Art Center, Wilmington, Del.; Mrs. Carolyn R. Shine, Cincinnati Art Museum, Cincinnati, Ohio; Miss Charlotte La Rue, Museum of the City of New York; Captain Dale Mayberry, Director, U.S. Naval Academy Museum, Annapolis, Md.; Mr. Frank W. Kent, Director, E. B. Crocker Art Gallery, Sacramento, Calif.; Mrs. Susan C. Ruch, City Art Museum of St. Louis; Mr. Walter A. Newman, Newman Galleries, Philadelphia, Pa.; Miss Cynthia Carter, Metropolitan Museum of Art, New York City; Washington and Lee University, Lexington, Va.; The Wilmington Institute Free Library, Wilmington, Del.; The Continental Insurance Companies, New York City; The Maryland Historical Society, Baltimore, Md.; The Smithsonian Institution, Washington, D.C.; The Corcoran Gallery of Art, Washington, D.C.; M. Knoedler & Company, New York City; The National Academy of Design, New York City; The American Heritage Publishing Company, New York City; The Pennsylvania Historical and Museum Commission, Harrisburg, Pa.; The General Electric Company, Nela Park, Cleveland, Ohio; The Civic Center Commission, Detroit, Mich.; The Minnesota State Capitol, St. Paul, Minn.; The New York Historical Society, New York City; and The National Aeronautics and Space Administration Manned Space Center, Houston, Tex. The Ambrose Printing Company and The Methodist Printing House, both of Nashville, Tenn., provided the color separations for "The Battle of Nashville" and "Stampeded by Lightning," respectively.

For material contained in the narratives for "The Bay and Harbor of New York, 1847" and "Wagon Train West," the author wishes to acknowledge the articles "To America Via Hell" by Joseph P. Cullen and "The Oregon Trail—Then and Now" by John Clark Hunt, respectively. Both articles appeared in *American History Illustrated* magazine.

O!
SAY
CAN
YOU
SEE

12

Guide
to
the
Paintings

13

Guide to the Paintings continued

O! SAY CAN YOU SEE

Guide *to* *the* Painters

Guide to
the Painters
continued

O!
SAY
CAN
YOU
SEE

This early painting of the American Indian by a young N. C. Wyeth was a harbinger of the rich harvest of pictures to follow in that artist's productive years.

The red man who roamed the eastern forest still lived in the Stone Age when the first Europeans came. With flint-tipped arrow and spear, he hunted his abundant game, fished the lakes and rivers, planted maize, and waged war on neighboring tribes. The forest trails he followed across the eastern mountain ranges remain today, as do other relics of his past, but the red man himself now lives among the restrictions and humiliations of the reservation.

The Indian in his Solitude

by N. C. WYETH

Courtesy Andrew Wyeth

The lone Indian hunter stops beside a forest pool to meditate upon the solitude of his surroundings of which he is so much a part. For centuries this native American ruled his primitive domain without challenge, unaware that blond, white-skinned men had already briefly touched the northern shores of his continent, or that his world would soon be shattered, his lands wrested from him, his virgin forests felled by the ringing axes of Europeans. Longfellow's Hiawatha spoke the prophecy:

> I beheld our nation scattered
> All forgetful of my counsels,
> Weakened, warring with each other;
> Saw the remnants of our people
> Sweeping westward, wild and woeful,
> Like the cloud-rack of a tempest,
> Like the withered leaves of autumn!*

* *"The Song of Hiawatha," by Henry Wadsworth Longfellow.*

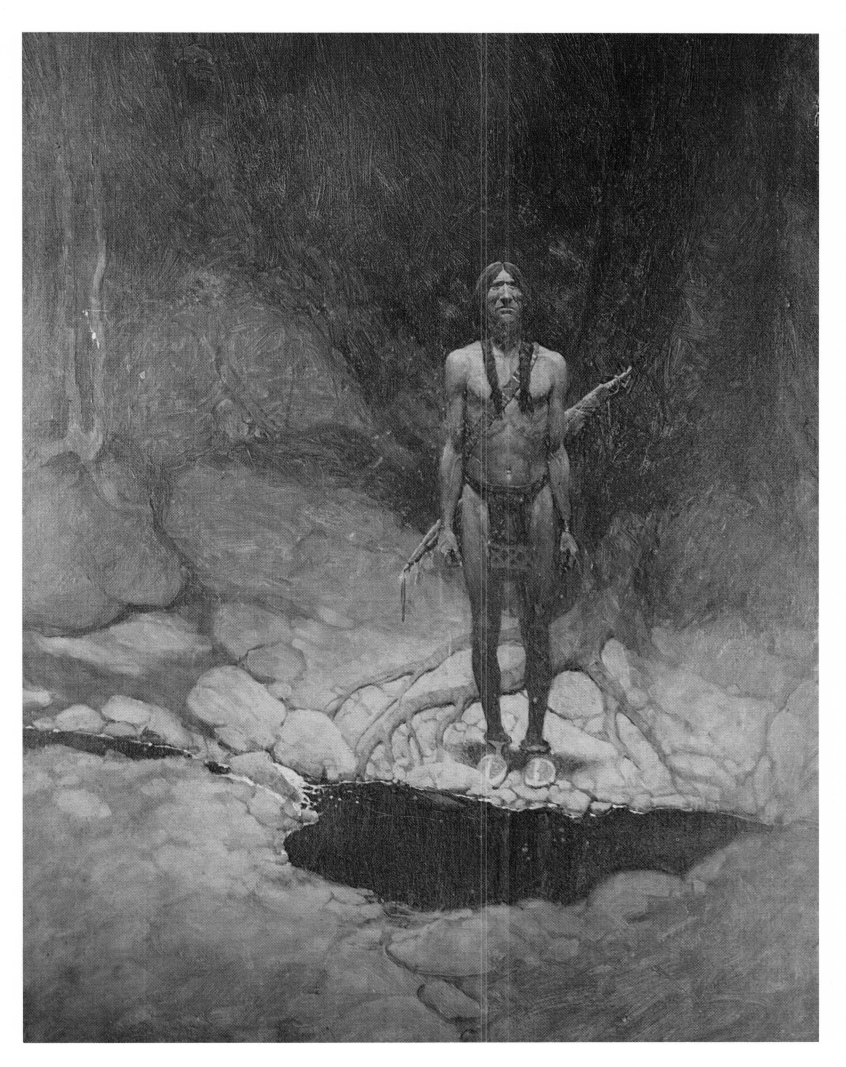

The Indian in his Solitude
by N. C. Wyeth

Landing of
Leif Ericson

in the New World in 1001

by EDWARD MORAN

Courtesy of the United States Naval Academy Museum, Annapolis, Maryland

In 1001 A.D., Leif Ericson, sailing west from Norse settlements in Greenland founded by his father, Eric the Red, landed on the coast of North America. He had followed a course taken by Bjarn Herjulfson who, some years before, sighted these new lands to the west but did not go ashore. Sailing southward from his first landfall, Ericson made two more, naming them Helluland and Markland, before he and his party of Norsemen landed on a shore rich in natural resources, established a small settlement, and called the new country Vinland for its abundant wild grapes. Leif left for Greenland the following year, and never returned to Vinland, but according to the Norse sagas other voyagers followed in his wake. One expedition was led by his brother Thorvald Ericson, whom the "Skraelings" (Indians) killed, and another about 1011–13 by Thorfin Karlsefni. Finally, efforts at colonization in North America by the Scandinavians of Greenland and Iceland were abandoned. Four centuries passed before another European, the Italian navigator Christobal Colon (Christopher Columbus), set foot in the New World.

O!
SAY
CAN
YOU
SEE

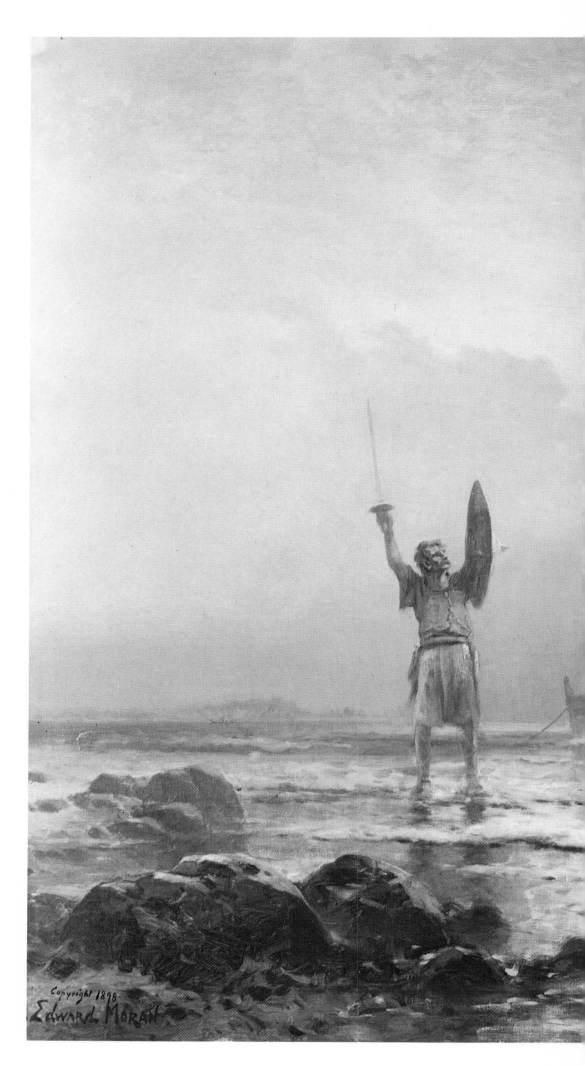

*Landing of Leif Ericson
in the New World
in 1001*
by Edward Moran

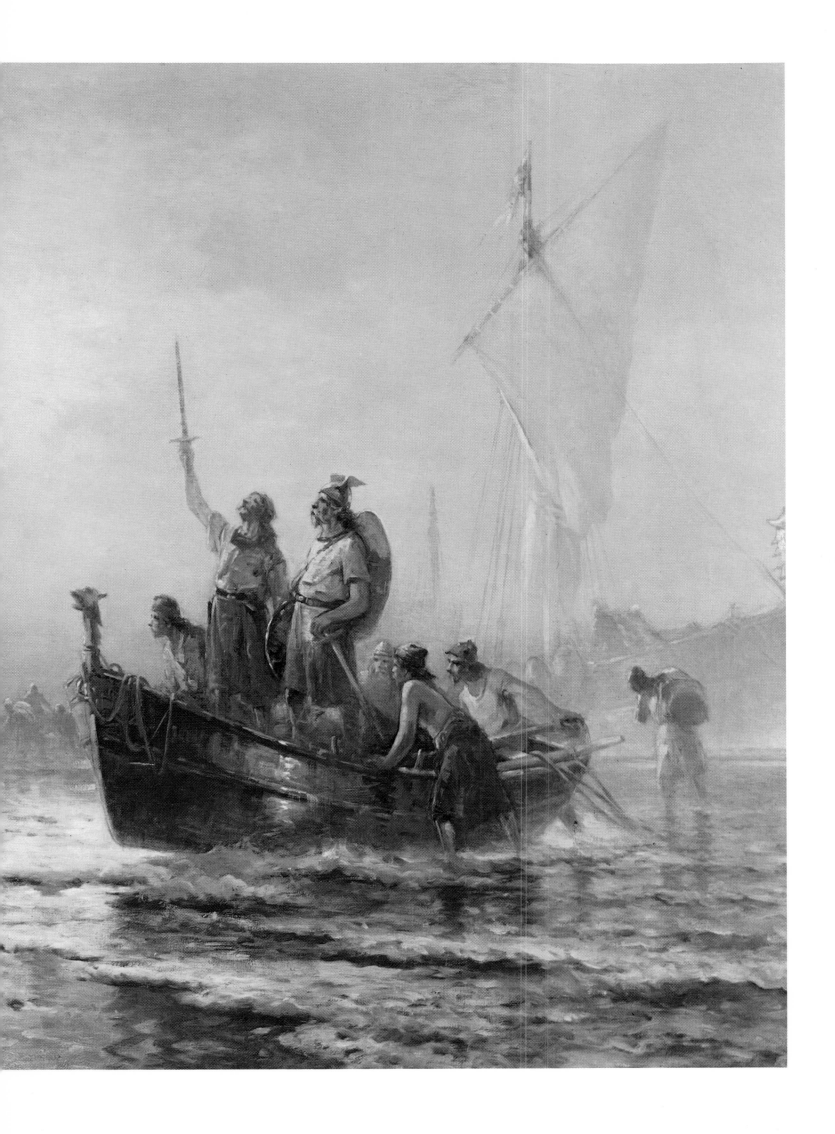

The Landing of Columbus

by N. C. WYETH

Courtesy of the United States Naval Academy Museum, Annapolis, Maryland

Two long months out of Palos, Spain the three tiny caravels of the Italian navigator Christopher Columbus dropped anchor on the twelfth of October, 1492, off the Caribbean island which Columbus called San Salvador (Watling Island). The admiral, confident that he had reached the East Indies by sailing west, landed and planted the flag of Ferdinand and Isabella of Spain on the shores of the New World. Then, sailing on to the south, Columbus touched the shores of Cuba and Haiti. Soon his flagship, the *Santa Maria*, foundered, and he returned to Spain with his two remaining ships, the *Niña* and the *Pinta*. He proceeded in triumph to Barcelona, where the Spanish court showered him with honors. Columbus later returned to the Caribbean on three more voyages, searching in vain for the fabled golden cities of the Indies. The North American continent always eluded him, but his voyage of discovery initiated a new era in world history as ships of the great powers of Europe, following in his wake, came to land on a coastline washed by the western reaches of the Atlantic. They would carry men motivated by diverse aspirations, bringing an era of exploration and colonization, opening new vistas, new conflicts, new dreams.

24

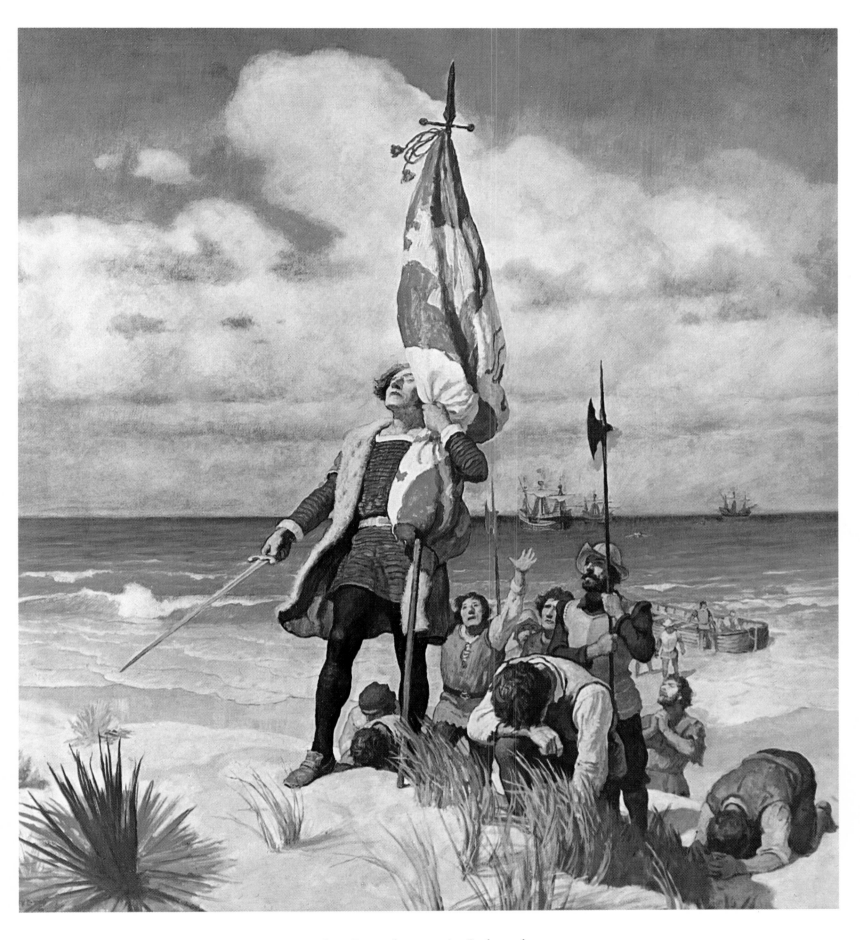

The Landing of Columbus
by N. C. Wyeth

The First Sermon Ashore

by J. L. G. FERRIS

Courtesy of William E. Ryder and the Smithsonian Institution

On a wintry day in December 1620, a small group of men and women, members of a separatist movement fleeing the autocratic England of Charles I, stepped ashore on the bleak coast of Massachusetts. They came aboard the little vessel *Mayflower* from Plymouth, England. Originally they intended to settle in Virginia, where the first permanent English colony had been established at Jamestown thirteen years before. The weariness of a sixty-five-day voyage, the lateness of the season, and the unknown influence of the Gulf Stream persuaded them, instead, to seek a landfall at Cape Cod.

On January 21, 1621, these "Pilgrims" held their first general meeting ashore, with a divine service led by Governor John Carver. Already they had begun erecting a few dwellings of their settlement, Plymouth Plantation. There followed a bitter winter in the wilderness. Many in the small colony, including Governor Carver and his wife, sickened and died, and in the spring the *Mayflower* returned to England, leaving behind the determined little group, the vanguard of the English migration which would follow in the coming years to carve out the Massachusetts Bay Colony.

Religious freedom was one of the principal motivations in the colonization of the Atlantic seaboard—the Separatists or Puritans in New England, the Catholics in Maryland, and the Quakers in Pennsylvania.

The painting shows the location of what later became Leyden Street, where the first houses of Plymouth stood. The finished Commons House is seen to the left. At the top of the street sits Burying Hill, where the following summer Captain Miles Standish built a combined fort and church. Governor Carver leads the assemblage in prayer. Standish, hand on sword, and Edward Winslow occupy the center of the picture; John Alden stands with arms folded on the right, and his future bride, Priscilla Mullins, wrapped in a furred hide, stands beyond the fire. A winter sun sets over the hills beyond which the friendly Indian, Squanto, later taught the Pilgrims to plant fish with their corn in the spring.

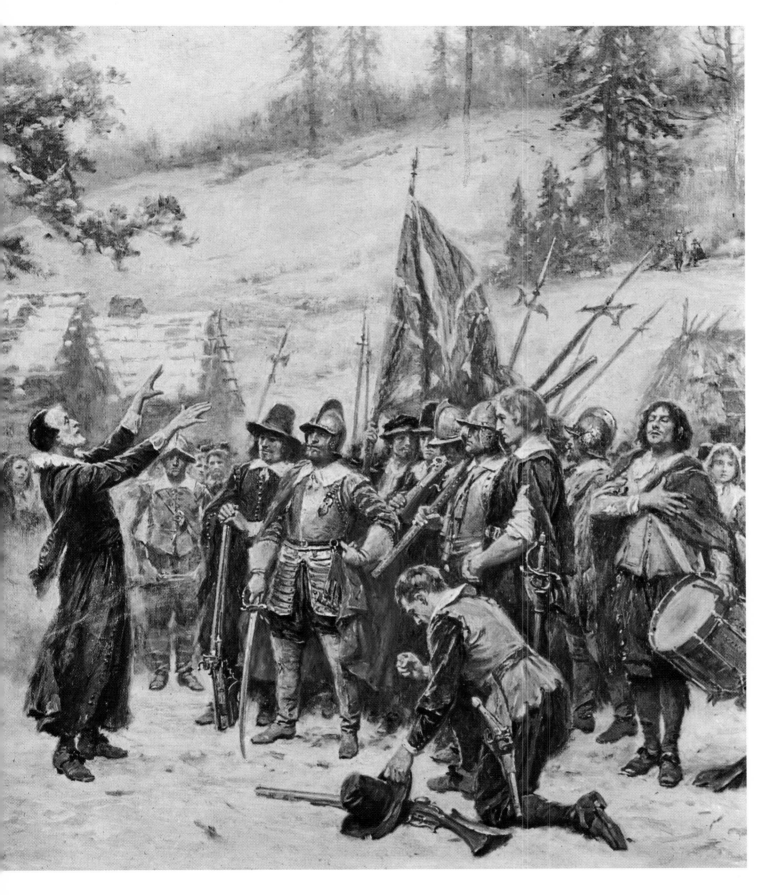

The First Sermon Ashore

by J. L. G. Ferris

The Fall of New Amsterdam

by J. L. G. FERRIS

Courtesy of William E. Ryder and the Smithsonian Institution

William Henry Hudson, sailing under the Dutch flag, explored the river which bears his name in 1609. Fifteen years later the Dutch purchased Manhattan Island from the Indians for a legendary $24 worth of trade goods, and established the prosperous trading village of New Amsterdam on the southern tip of the island, the first Dutch foothold in the New World. War between Holland and England later brought a British fleet of four ships under Colonel Richard Nicholls to the mouth of the Hudson in 1664. Nicholls' ultimatum to the doughty and defiant Director General of New Amsterdam, Peter Stuyvesant, demanded the surrender of the "towns situated on the island commonly known by the name of Manhattoes." Though short of powder and lacking the heavy arms to resist, Stuyvesant strove to arouse the Dutch of New Amsterdam to armed resistance. But he received a petition signed by ninety-three principal citizens urging that he surrender lest the town be reduced and innocent blood spilled. Stuyvesant yielded, saying, "I had rather be carried to my grave," and a white flag rose above the fort. The following day, September 6, all of New Amsterdam was given up to the English. The conquerors honored James, Duke of York, by giving his ducal name to the new possession, and New Amsterdam became thereby New York.

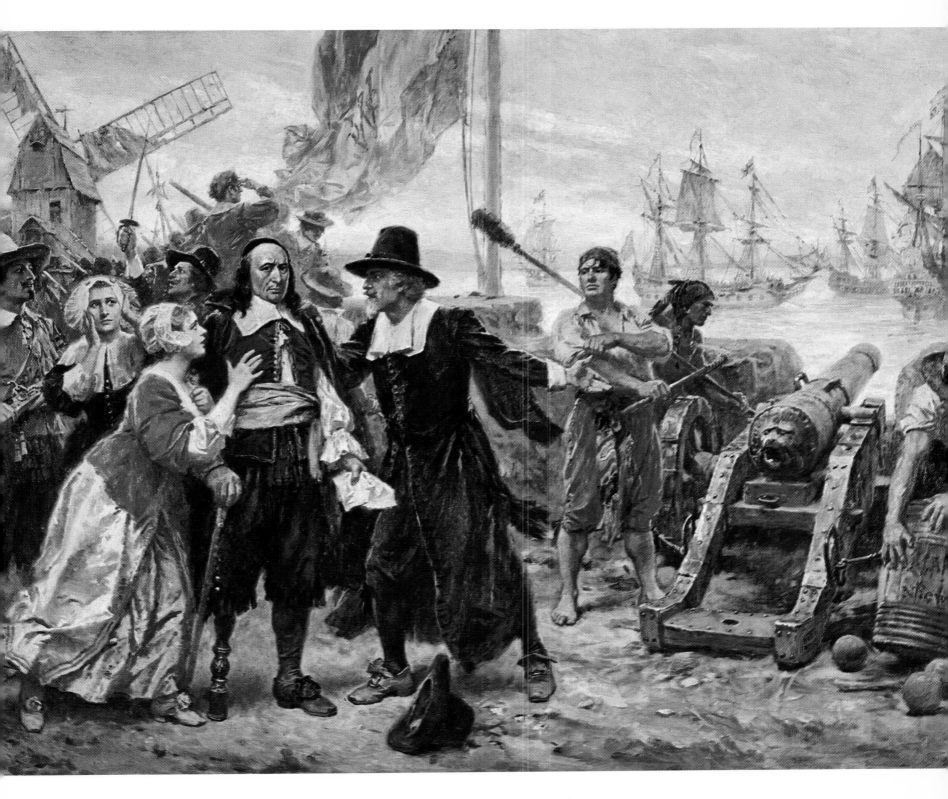

The Fall of New Amsterdam
by J. L. G. Ferris

William Penn in somber Quaker garb steps ashore and is welcomed to Pennsylvania by a few inhabitants who preceded him, and by neighboring Indians. To the left can be seen the Blue Anchor Tavern, then under construction. In the Delaware River, riding at anchor, is Penn's ship The Welcome.

Landing of William Penn

by J. L. G. FERRIS

Courtesy of William E. Ryder and the Smithsonian Institution

On August 30, 1682, William Penn, outspoken adherent of Quaker beliefs, sailed from his native England for America on *The Welcome* with a hundred colonists. When Penn's father, Admiral Sir William Penn, died, King Charles II owed him some 16,000 pounds. He paid off the debt to the admiral's son with a 500-square-mile tract of land in America to be called Penn's Woods, or Pennsylvania. Six weeks later, after an epidemic of smallpox aboard ship, *The Welcome* arrived off the Delaware River. Penn, with a company of friends, came up from Chester in an open boat and landed at the mouth of Dock Creek (Philadelphia). He was actually a latecomer to the shores of the Delaware, for the Swedes traveled the area forty-four years before his landing.

Thus began the experiment of the Quakers in Pennsylvania. Penn's subsequent relations with the Indians were eminently fair, and the colonization of Pennsylvania proceeded in peace. Within two years Philadelphia boasted 300 houses and 2,500 inhabitants.

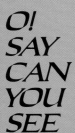

O!
SAY
CAN
YOU
SEE

Landing of William Penn

by J. L. G. Ferris

Benjamin West's painting portrays the mortally wounded General James Wolfe, supported by his aides and surgeon. In the background British warships dot the St. Lawrence River. To the right stands a bareheaded British grenadier, and to the left a ranger in green coat (purported to be the noted Robert Rogers, though he was not present at the battle of Quebec) conveys to the dying general the news that the French are in flight. "Now God be praised," whispered the 32-year-old Wolfe. "Since I have conquered, I will die in peace."

Death of Wolfe

by BENJAMIN WEST

Courtesy of the National Gallery of Canada, Ottawa

The date was September 13, 1759. The long struggle for domination of North America between England and France comes to a close on the Plains of Abraham within sight of the walls of Quebec as General James Wolfe's British army ends two centuries of French power in the New World. He thus secured Canada and North America for the British crown. In an audacious maneuver, Wolfe landed his troops during the night under the Heights of Abraham, and scaled the cliffs, presenting his "thin red line" before the citadel of Quebec in the morning light. Led by the brilliant Marquis de Montcalm, the French and Canadians sailed forth to meet Wolfe's Highlanders and grenadiers. In a fifteen-minute battle, disciplined British fire cut the French line to pieces. Wolfe, wounded three times, died on the field, while Montcalm, himself mortally wounded, expired within the city walls. Quebec, bastion of French power in North America, fell to the victorious English. The Treaty of Paris in 1763 finally ended forever the dream of French domination in the New World, with Canada passing to British control.

O! SAY CAN YOU SEE

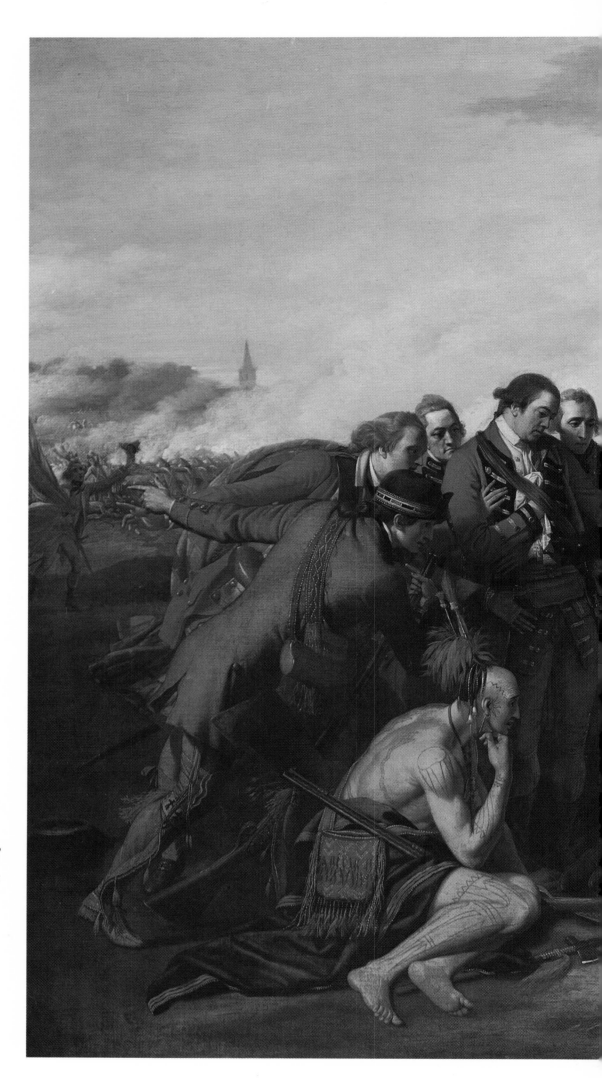

Death of Wolfe
by Benjamin West

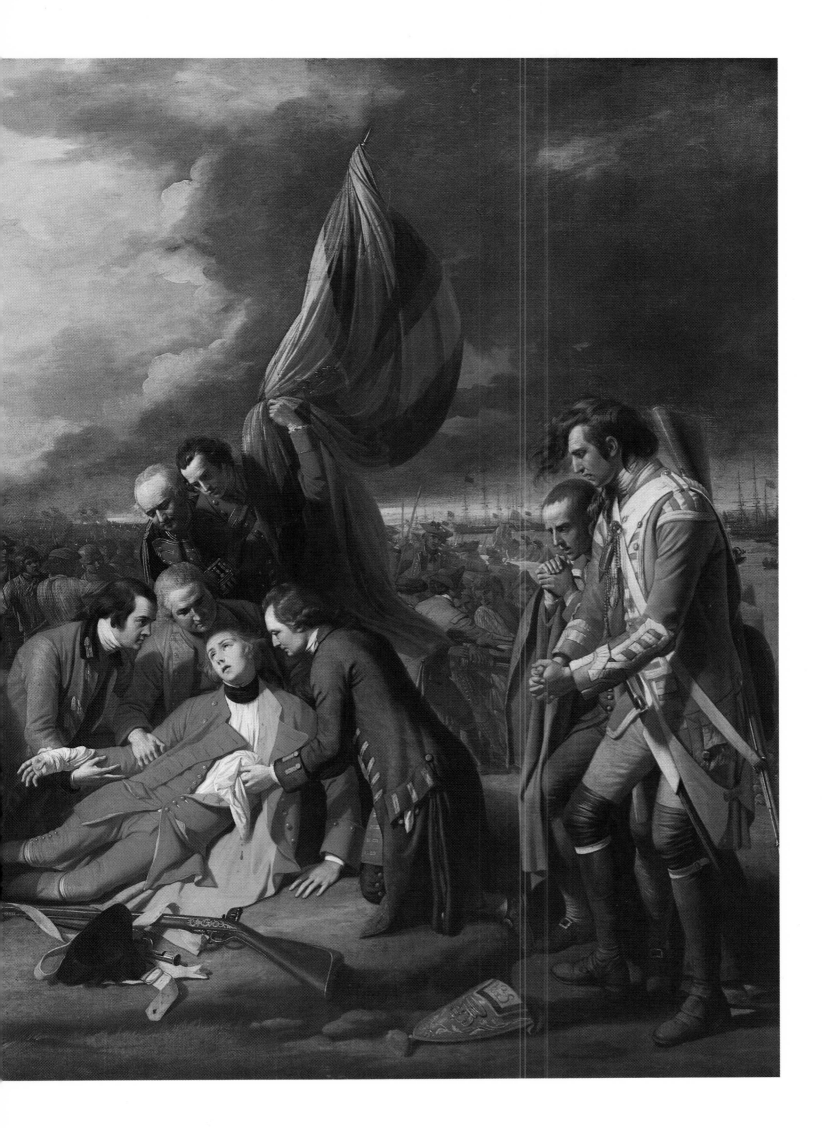

Old Bruton Church,
Virginia, in

the Time of Lord Dunmore

by ALFRED WORDSWORTH THOMPSON

Courtesy of the Metropolitan Museum of Art, New York, N.Y.;
Gift of Mrs. A. Wordsworth Thompson, 1899.

Williamsburg, the capital of colonial Virginia, was both the political and social center of the colony. In old Bruton Parish Church sat the elite of Virginia; its pews were occupied by such notables as George Washington, Thomas Jefferson, Patrick Henry and others, who worshipped here when stopping in Williamsburg during the rule of Lord Dunmore, the last Royal Governor of Virginia. One of the finest examples of colonial churches, Bruton Parish Church, completed in 1715, still stands, a mellow-red brick structure with white shuttered windows and an eight-sided steeple. Sunday gatherings such as that shown in Thompson's painting served as social as well as religious events. It was in Williamsburg that the House of Burgesses convened, and these sessions gave Tidewater planters an opportunity to mingle with their fellow Virginians and discuss the political gossip, news of the London tobacco market, births, deaths, and romantic entanglements. The landed gentry, cultivating their broad estates with the labor of indentured servants and slaves, assumed the status of English squires. They lived the "good life," proud of their reputation for hospitality to the traveler; and unlike their more sober New England brethren they enjoyed their fox hunting, cock fights, gambling, and dancing. Yet for all their lighter social diversions, they were men of culture and learning who contributed heavily to the struggle for independence and the shaping of the new nation.

Artist Thompson captured the colonial mode in costume and transportation in this painting of Old Bruton Church. The landed aristocracy arrive in their coaches, and on horseback. One lady appears riding on a pillion at the right.

37

O! SAY CAN YOU SEE

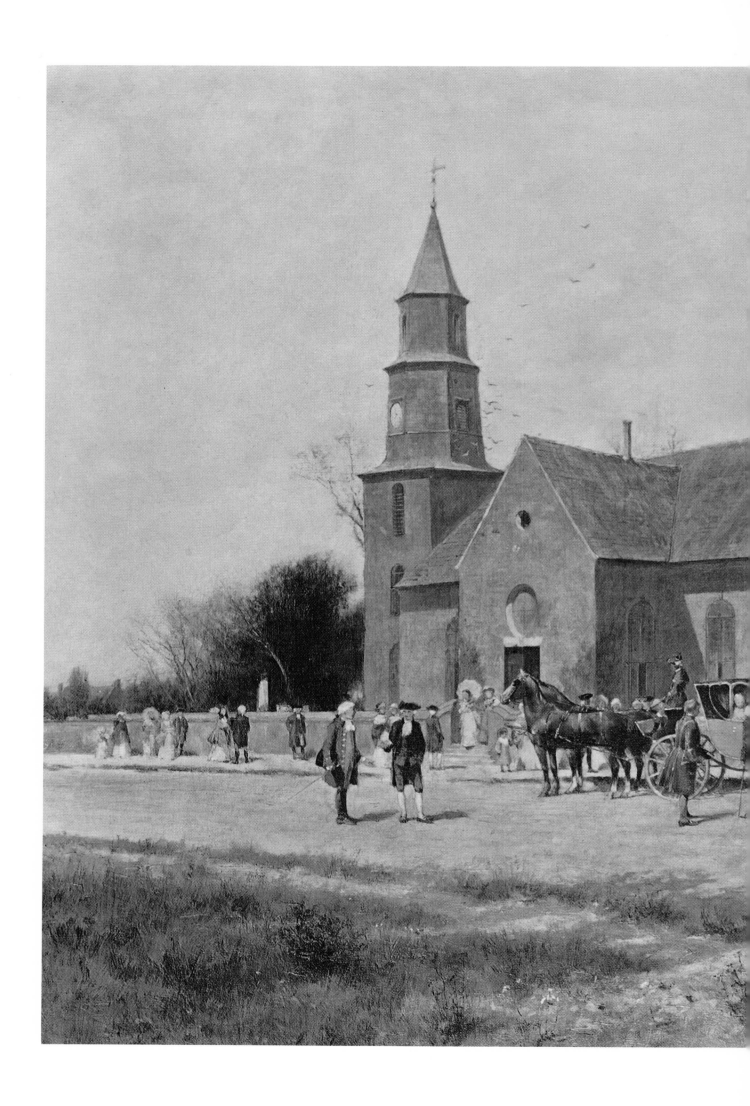

Old Bruton Church, Virginia, in the Time of Lord Dunmore
by Alfred Wordsworth Thompson

George Washington

by CHARLES WILLSON PEALE

Courtesy of Washington and Lee University, Lexington, Virginia

In 1772, 40-year-old George Washington—planter, soldier, and member of the Virginia House of Burgesses—posed for his portrait at Mount Vernon in the uniform of a lieutenant colonel of Virginia militia. Behind him lay his campaigns in the French and Indian War, his surrender to the French at Fort Necessity, and his role in Braddock's disastrous defeat in 1755, where enemy bullets felled three horses under the Virginian. After his first exposure to battle, young Washington wrote to his brother, John Augustine, "I have heard the bullets whistle; and, believe me there is something charming in the sound." Now the distant rumblings of rebellion sounded in New England, and just three years after sitting for this portrait, Washington, in May 1775, donned the blue and buff uniform of Commander in Chief of the Continental Army. Ahead lay eight long and often despairing years of rebellion against George III of England, final victory at Yorktown, and his installation as the first President of the United States.

It is doubtful that the Revolution could have succeeded without Washington's unwavering faith and courage in the face of initial defeats. Upon his death at Mount Vernon in 1799, Henry Lee, in an address before Congress eulogized Washington as "First in war, first in peace, and first in the hearts of his countrymen."

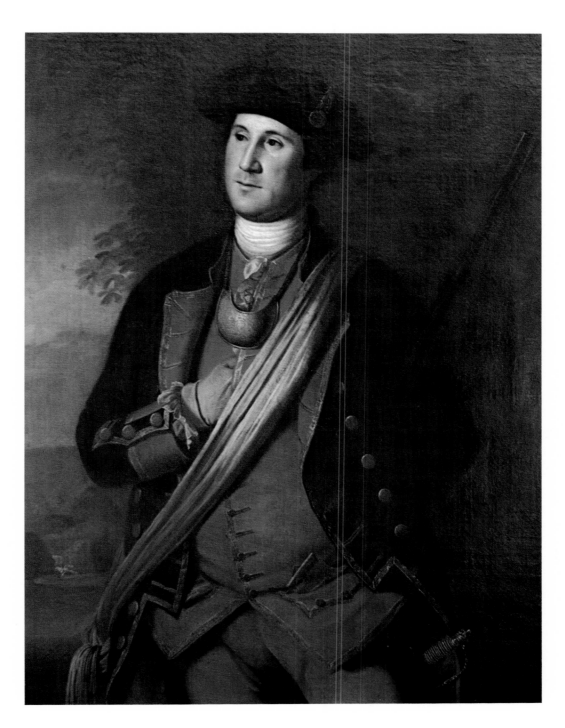

George Washington
by Charles Willson Peale

At Concord Bridge

by N. C. WYETH

Courtesy of M. Knoedler and Company,
Inc., New York City

The "embattled farmers" stand by Old North
Bridge spanning the Concord River, on the morning
of April 19, 1775. The "shot heard round the
world" is moments away. Paul Revere and William
Dawes aroused the inhabitants of Middlesex during
the night, warning them that the British were on
the march from Boston to destroy stores of arms
and ammunition at Concord, and to arrest the
firebrands John Hancock and Samuel Adams. At
dawn, American provincials confronted the
advancing British on Lexington Common, where
an English volley dispersed them. The redcoats
then continued their march to Concord, where they
set about destroying the stores secreted there. It was
here that the determined company of minutemen
opened fire on British troops across the Concord
Bridge. Meanwhile, angry swarms of local militia
gathered and harassed the British troops all along
the road back to Boston, inflicting heavy losses on
the foot-weary redcoats. The smoldering sparks of
revolution had at last flared into open flame. The
siege of Boston commenced, and the following
March, Howe's British army evacuated the city.

Wyeth's determined band of minutemen await
the approach of British troops at Concord across
the bridge. His figures represent the charac-
teristic rawboned farmers of New England.
A blacksmith in his leather apron stands
among them.

O!
SAY
CAN
YOU
SEE

At Concord Bridge
by N. C. Wyeth

The Battle

of Bunker Hill

by HOWARD PYLE

Courtesy of the Wilmington Society of the Fine Arts, Delaware Art Center, Wilmington, Delaware

On the morning of the seventeenth of June, 1775, the British occupying Boston awoke to find the American "rebels" dug in along Breed's Hill on the Charlestown peninsula, overlooking Boston. By midafternoon thousands of British troops under Sir William Howe had been ferried across the Charles River from Boston, and moved against the entrenched Americans.

"Don't fire until you see the whites of their eyes!" ordered Colonel William Prescott, commanding the provincials. As the scarlet ranks neared the breastworks a deadly fire decimated them and threw back the first frontal assault. The second assault fell like the first, but a third attack carried the hill, and the Americans, short of powder and ball, fell back fighting with clubbed muskets and stones, retreating across Charlestown Neck. For the British, this dearly bought victory cost two thousand men killed and wounded.

Curiously, history misnamed the battle. In the darkness on the night before the assaults, the Americans mistakenly fortified Breed's Hill instead of the higher promontory called Bunker Hill, and the ensuing conflict actually raged on Breed's Hill.

O! SAY CAN YOU SEE

The Battle of Bunker Hill
by Howard Pyle

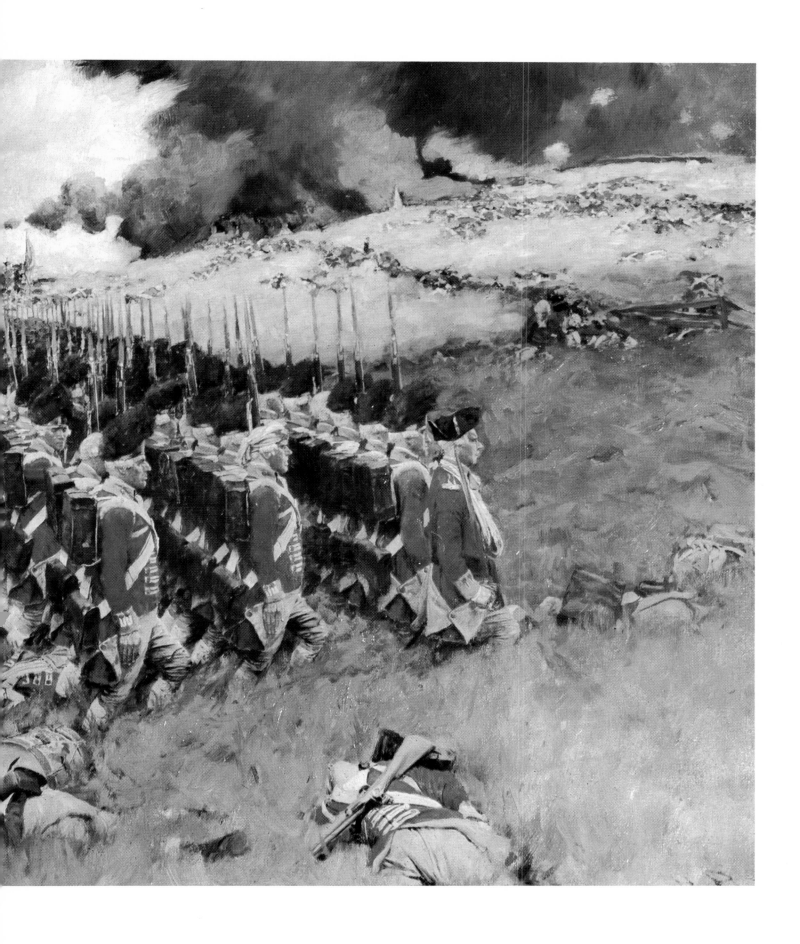

Drafting the Declaration of Independence

by J. L. G. FERRIS

Courtesy of William E. Ryder and the Smithsonian Institution

"We hold these truths to be self-evident, that all Men are created equal, that they are endowed by their Creator with certain unalienable Rights, that among these are Life, Liberty, and the Pursuit of Happiness." Benjamin Franklin, John Adams, and Thomas Jefferson work on the latter's draft of the Declaration of Independence at Jefferson's quarters in the second floor parlor of a house on the corner of Seventh and Market streets in Philadelphia. "I rented the second floor," wrote Jefferson, "a parlor and bedroom ready furnished. In that parlor I wrote habitually, and in it I wrote this paper [the Declaration] particularly."

On July 4, 1776, the delegates to the Second Continental Congress, meeting in the State House, later to be called Independence Hall, adopted the Declaration of Independence. Fifty-six delegates from the thirteen colonies, mutually pledging "to each other our Lives, our Fortunes, and our sacred Honor," affixed their signatures to the parchment. Four days later the Declaration was read to the populace, the Liberty Bell rang out the news, and everywhere the reading of the Declaration met with celebration and joy. This cast the die. The English colonies no longer fought in mere defense of their rights as Englishmen; their goal now became the sovereignty of a new nation.

Jefferson himself said of his handiwork: "Neither aiming at originality of principle or sentiment, nor yet copied from any particular of previous writings, it was intended to be an expression of the American mind, and to give to that expression the proper tone and spirit called for by the occasion."

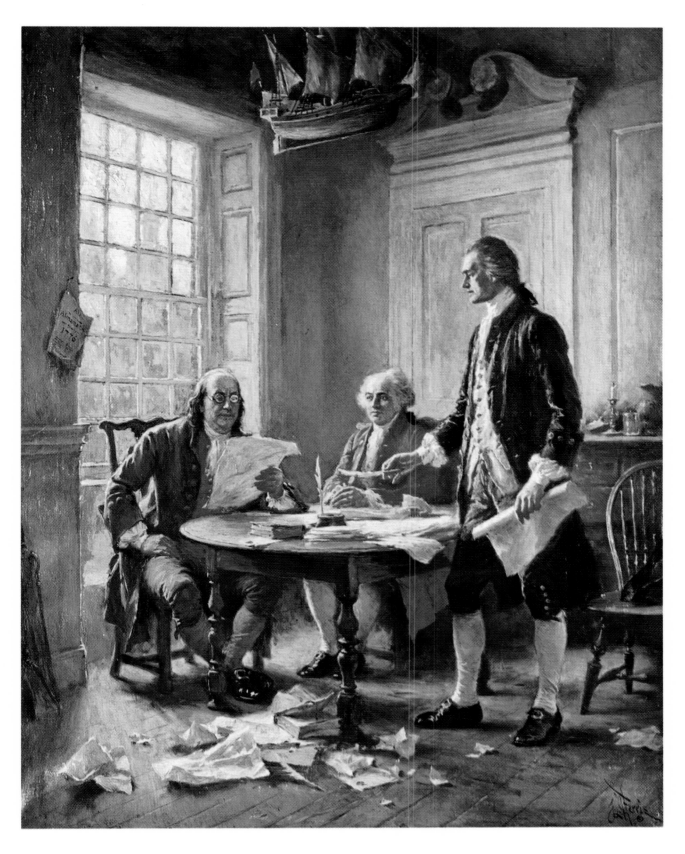

Drafting the Declaration of Independence
by J. L. G. Ferris

The Battle of Germantown

(detail) by HOWARD PYLE

Courtesy of the Wilmington Society of the Fine Arts, Delaware Art Center, Wilmington, Delaware

On September 26, 1777, after Congress fled to York, Pennsylvania, a British army commanded by Sir William Howe occupied the "rebel" capital at Philadelphia. Washington's army, still smarting from its defeat at Brandywine Creek, lay at Pennypacker's Mills. Then at dawn on October 4 Washington launched a surprise attack on Howe's forces at Germantown, north of Philadelphia. The American advance, hampered by thick fog, encountered unexpected resistance from British troops barricaded inside the Chew mansion. Firing into each other in the fog, the Americans fell into confusion and finally retired from the field. In December Washington moved his army out of Whitemarsh to take up winter quarters among the frozen hills of Valley Forge, while twenty miles away in Philadelphia, Howe settled down comfortably to await the spring campaign.

Pyle's painting shows an incident in the battle when the ragged Continentals tried in vain to batter down the door of the Chew mansion, held in place with a heavy iron bar. From the steps an officer of the Seventh Pennsylvania Infantry cheers them on.

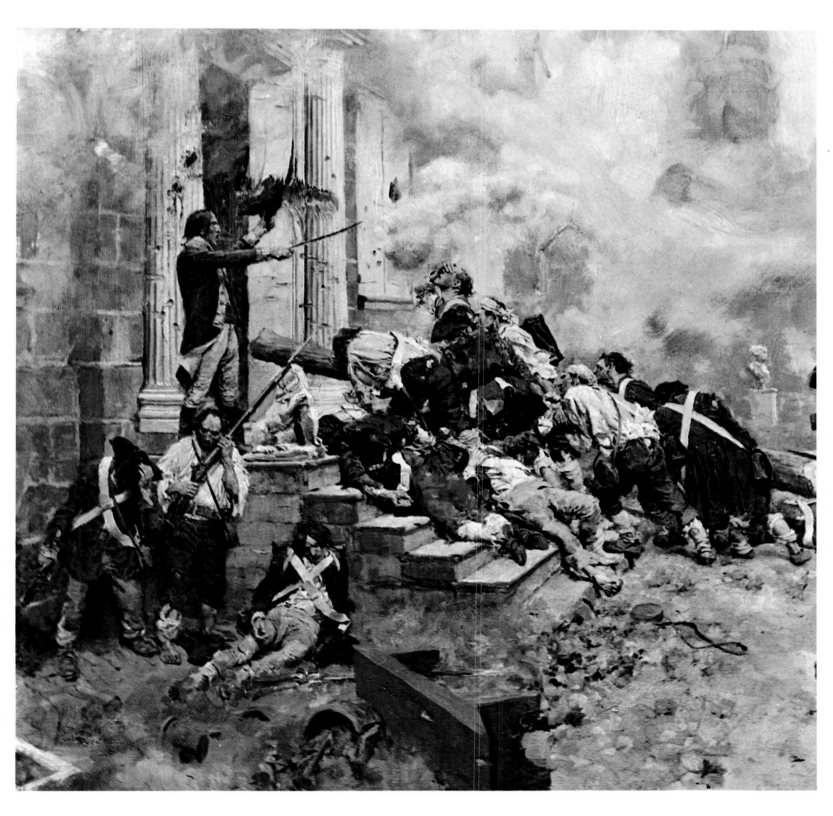

The Battle of Germantown (detail)
by Howard Pyle

Von Steuben at

Valley Forge

by EDWIN A. ABBEY

Courtesy of the Pennsylvania State Capitol, Harrisburg, Pennsylvania

"No history now extant can furnish an instance of an army's suffering such uncommon hardships as ours has done and bearing them with the same patience and fortitude . . . men without clothes to cover their nakedness, without blankets to lie on, without shoes, for want of which their marches might be traced by the blood from their feet. . . ." So wrote General George Washington in describing the winter of 1777–78 at Valley Forge. Then in February 1778 came Baron Frederick von Steuben, a veteran of the campaigns of Frederick the Great of Prussia. As drillmaster, the German whipped the ragged American army into a disciplined fighting force, training men and officers in the manual of arms, tactics, formations, and organization.

Von Steuben's training passed the test in June 1778, when the Continental Army engaged General Clinton's British redcoats at Monmouth, New Jersey. After a day-long fight the British gave up the field, retiring within their fortifications around New York.

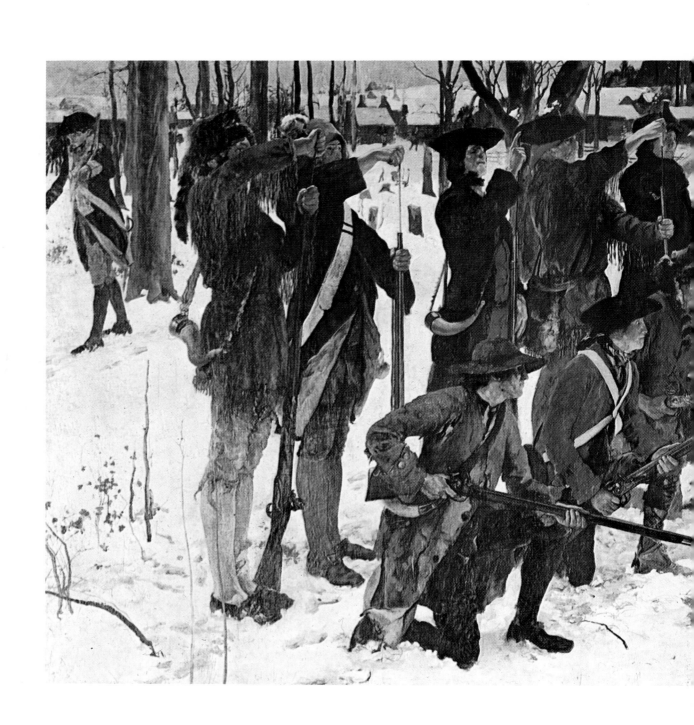

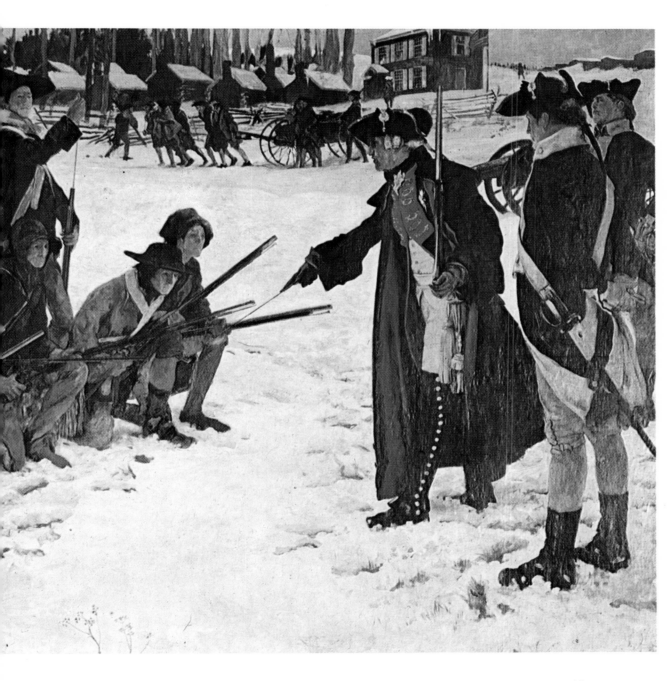

Von Steuben at Valley Forge
by Edwin A. Abbey

The Ship That Sank in Victory

(detail) by J. L. G. FERRIS

Courtesy of William E. Ryder and the Smithsonian Institution

The bloody battle between Captain John Paul Jones's *Bonhomme Richard* and the British frigate *Serapis* is over. In their furious engagement off Flamborough Head, England on September 23, 1779, Jones's famous words, "I have not yet begun to fight," in answer to the British Captain Pearson's challenge, became history. Pearson himself finally capitulated, lowering the British ensign with his own hands, his deck heaped with the dead and the dying. On the morning of September 25, Jones and his prisoner Pearson watch from the quarterdeck of the *Serapis,* now an American prize, as the shattered *Bonhomme Richard* sinks in the distance. Jones, a native of Scotland, became the greatest of all American naval commanders in the Revolution. His record of victories at sea stood unsurpassed, and after the war Congress presented him a gold medal in recognition of his services. Later he served as rear admiral in the navy of Catherine of Russia, and died and was buried in Paris in 1792. In 1905 his body was exhumed and sent to its final resting place in the crypt of the United States Naval Academy at Annapolis, Maryland.

Jones described the moment: "No one was now left aboard the Richard but our dead. To them I gave the good old ship for their coffin. . . . She rolled heavily in the long swell . . . settled slowly by the head, then sank peacefully. . . . The very last vestige mortal eyes ever saw of the Bonhomme Richard was the defiant waving of her unconquered and unstricken flag as she went down."

On the deck of his prize, the Serapis, John Paul Jones gestures toward his ship sinking in the distance as his prisoner, Captain Richard Pearson, doffs his hat in respect to those men who, in death, share the fate of the Richard.

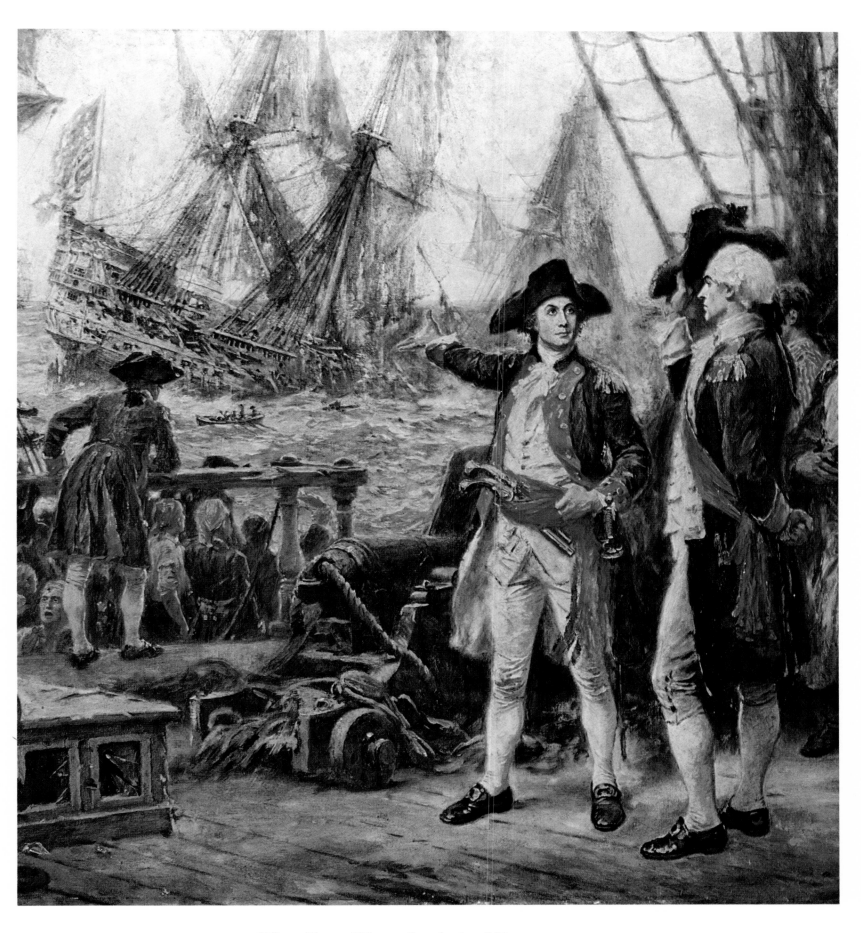

The Ship That Sank in Victory (detail)

by J. L. G. Ferris

Daniel Boone Escorting a Band of Pioneers into the Western Country

Bingham's picture, painted in 1851, represents the emigration of Daniel Boone and his family to Kentucky through Cumberland Gap in 1775. Boone's wife and daughter, shown here, became the first white women in Kentucky. The forbidding aspect of the Cumberland Mountains impressed Boone as "so wild and horrid that it is impossible to behold them without terror." Bingham's own family braved the "terror" when the artist was a child as they emigrated to Missouri over this same Wilderness Road.

by GEORGE CALEB BINGHAM

Courtesy of the Washington University Gallery of Art, Steinberg Hall, St. Louis, Missouri

Carved indelibly upon the records of America's early frontier history, the name of Daniel Boone stands foremost. Pioneer, hunter, Indian fighter, trail blazer, Boone became a legend in his own time. A Pennsylvanian by birth, he moved at an early age to the Yadkin Valley of North Carolina. His hunting forays into the unbroken wilderness of Kentucky gave him a unique knowledge of the country, and as a result, in 1775, Judge Richard Henderson, founder of the Transylvania Company formed to establish a colony in Kentucky, chose Boone to break a trail over the Appalachians. The woodsman, with thirty men, blazed 300 miles of the Wilderness Road through Cumberland Gap to the Kentucky River, where he built a fort and settlement called Boonesborough. Captured by the Shawnees in 1778 while on a salt-making expedition, Boone found himself carried off to the Indian village at Chillicothe where the Shawnee chieftain, Blackfish, adopted him into the tribe. Overhearing plans of an impending attack on Boonesborough, Boone escaped, traveled 160 miles in four days, reached the fort in time to warn the settlers, and joined them in repelling an attack by 400 Indians and 40 Canadians under his adopted "father" Blackfish. After a nine-day siege, the Indians melted into the forest, leaving the Kentucky frontier secured. After the Revolution, Boone, seeking "elbow room," moved on west to Missouri, dying there in 1820 at the age of 86. In the years following the war, thousands of pioneer families journeyed through the mountains over Boone's Wilderness Road.

O! SAY CAN YOU SEE

58

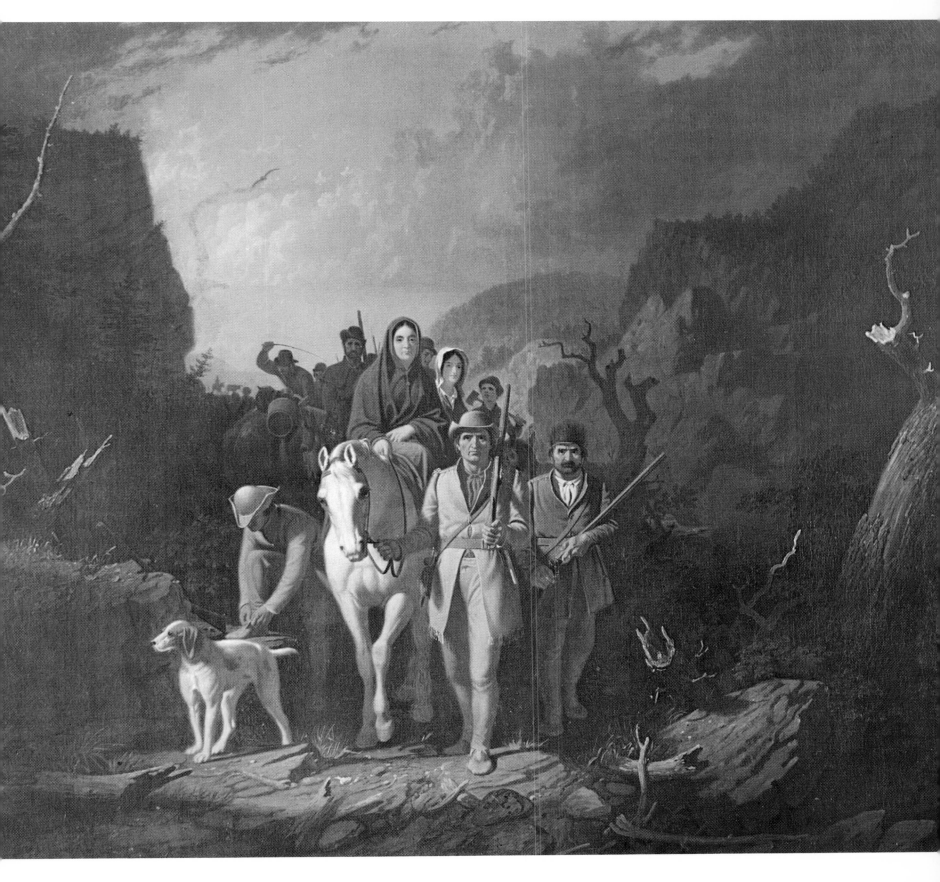

*Daniel Boone Escorting a Band of Pioneers
into the Western Country*
by George Caleb Bingham

The
Surrender
of Cornwallis

In the center of Trumbull's picture General Benjamin Lincoln, on the white horse, waits to receive Cornwallis's sword from O'Hara, who leads the British column from Yorktown. General Rochambeau, commanding the French army, sits his horse at the far end of the French column arrayed to the left; Washington appears at the left of the American flag, his general officers filling the right of the picture. Some thirty-five individual portraits are represented in the canvas.

Bottled up in Yorktown, Virginia, his British army cut off from escape by sea thanks to a French fleet, and under daily bombardment by a besieging Franco-American army under General Washington, Lord Edward Cornwallis surrendered on October 19, 1781. With flags cased, and the redcoat bands playing "The World Turned Upside Down," General O'Hara, acting for Cornwallis, led the British columns out of Yorktown between the ranks of French and American troops drawn up on either side of the road. At Washington's direction, General Benjamin Lincoln received Cornwallis's sword, while seven thousand British troops laid down their arms in an adjoining field. Yorktown marked the virtual end of the Revolutionary War, although a formal peace did not come until 1783.

at Yorktown

by JOHN TRUMBULL

Courtesy of the United States Capitol Historical Society, Washington, D.C. National Geographic photographer, George F. Mobley.

O!
SAY
CAN
YOU
SEE

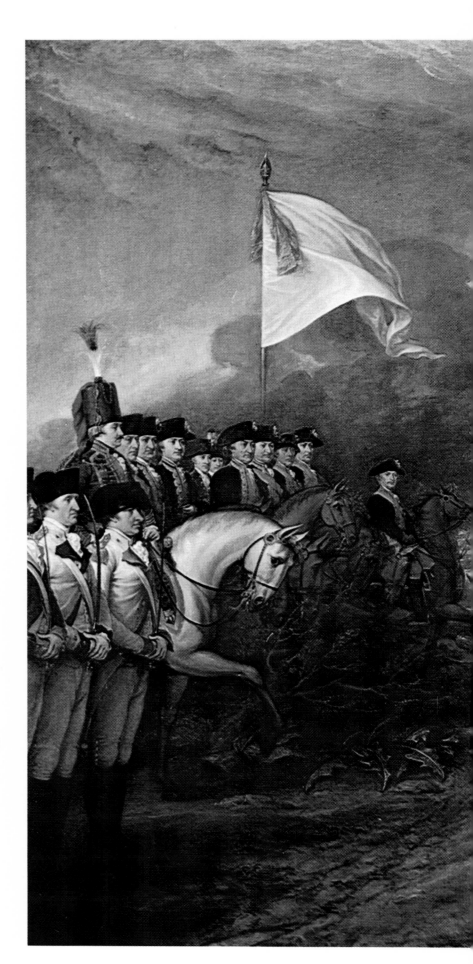

*The Surrender of Cornwallis
at Yorktown*
by John Trumbull

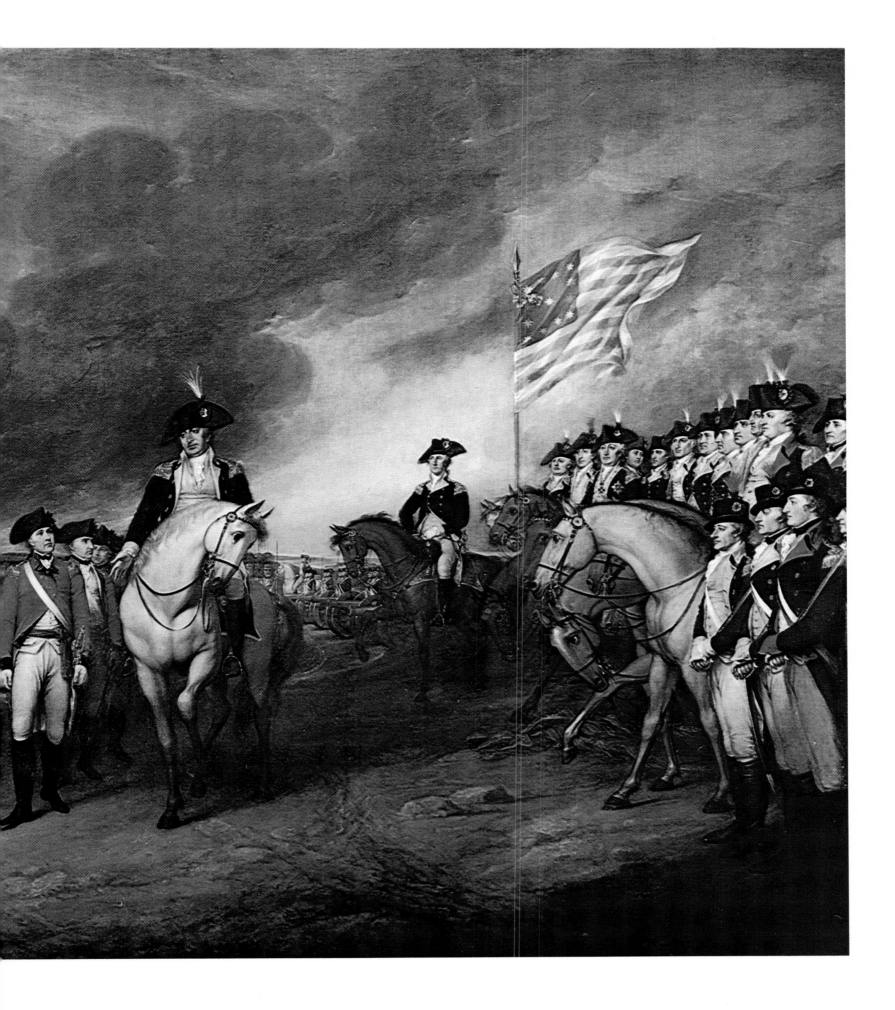

The First Steamboat

by CLYDE O. DeLAND

From the collection of historical paintings
of the Continental Insurance Company, New York, N.Y.

Although Robert Fulton receives credit for the first practical steamboat, the *Clermont,* which steamed from New York to Albany in 1807, a Yankee inventor named John Fitch from East Windsor, Connecticut operated a primitive prototype on the Delaware River some twenty-one years before. He employed a steam engine to activate mechanical paddles which propelled a boat through the water at two miles per hour. The following year, on August 22, 1787, Fitch launched a second and larger boat. Members of the Constitutional Convention, then sitting in Philadelphia, stood on hand to witness the event. This craft, again propelled by paddles, bore the appropriate name *Perseverance.* It persevered through a trip of twenty miles in 1788, going from Philadelphia to Burlington, New Jersey in three hours and twenty minutes. A third ship, moving at eight miles per hour, ran regularly as a packet boat on the Delaware in 1790, covering some 1,000 miles before being discontinued. Fitch later experimented with another craft on Collect Pond, New York City, using paddle wheels and a screw propeller. "I know of nothing so perplexing and vexatious to a man of feeling," he wrote, "as a turbulent wife and steamboat building. I experienced the former and quit in season, and had I been in my right senses, I should undoubtedly have treated the latter in the same manner." Ridiculed, ignored, and impoverished, Fitch committed suicide in Kentucky in 1798.

Fulton built his steamboat working from and improving upon Fitch's plans; it fell to Fulton to prove to a skeptical public the practicability of operating boats by steam, but to John Fitch must go the credit for pioneering the first steam-powered vessel in America.

Clyde O. DeLand's painting represents the trial trip of Fitch's steamboat at Philadelphia on July 27, 1786, before a curious and amused crowd of onlookers. Unaware of the importance of the occasion, they witness the birth of a revolution in water travel. In the background appear the housetops and spires of buildings along the Philadelphia waterfront.

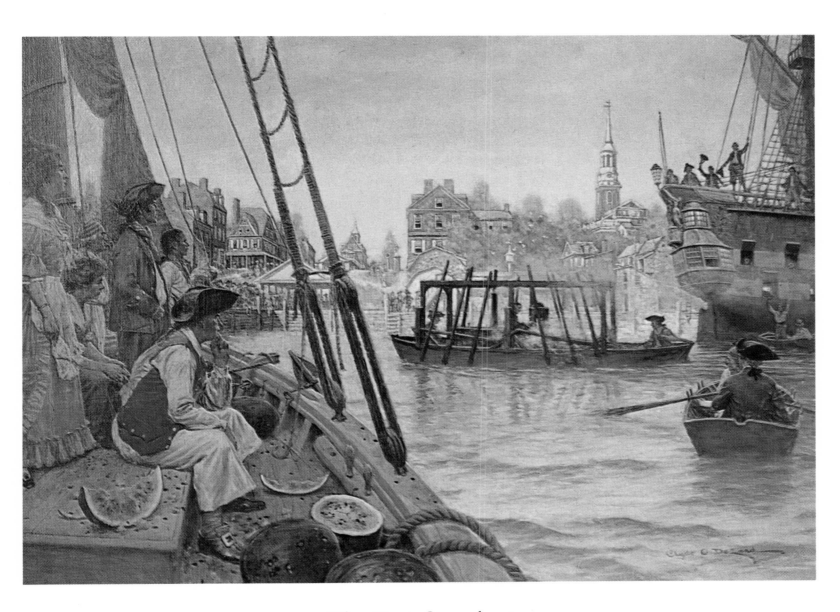

The First Steamboat
by Clyde O. DeLand

Thomas Jefferson

by REMBRANDT PEALE

Courtesy of the New-York Historical Society, New York City

Should the title "man for all seasons" fall upon any single American, Thomas Jefferson of Virginia most readily meets the requirements. Author of the Declaration of Independence, Minister to France, Secretary of State, Governor of Virginia, Vice President and President of the United States, founder and designer of the University of Virginia—his talents, ability, and accomplishments stood without parallel in an age of remarkable minds.

As our third President, he served two terms (1801–1809) and became the driving force behind the infant Republican (now Democratic) party. The most far-reaching single event of Jefferson's Presidency was the Louisiana Purchase in 1803. By a treaty with Napoleon, the United States acquired for $15,000,000 approximately 850,000 square miles of largely unexplored territory, stretching from New Orleans to the Canadian border, and from the Mississippi west to the Rocky Mountains. In 1804 Jefferson dispatched an expedition under Captains Meriwether Lewis and William Clark to explore and map this vast territory.

Jefferson died at his home, "Monticello," on the Fourth of July, 1826, in the eighty-fourth year of a full and productive life. His grave bears the inscription by which he himself wished to be remembered:

HERE WAS BURIED THOMAS JEFFERSON
AUTHOR OF THE DECLARATION OF AMERICAN INDEPENDENCE,
OF THE STATUTE OF VIRGINIA FOR RELIGIOUS FREEDOM,
AND FATHER OF THE UNIVERSITY OF VIRGINIA

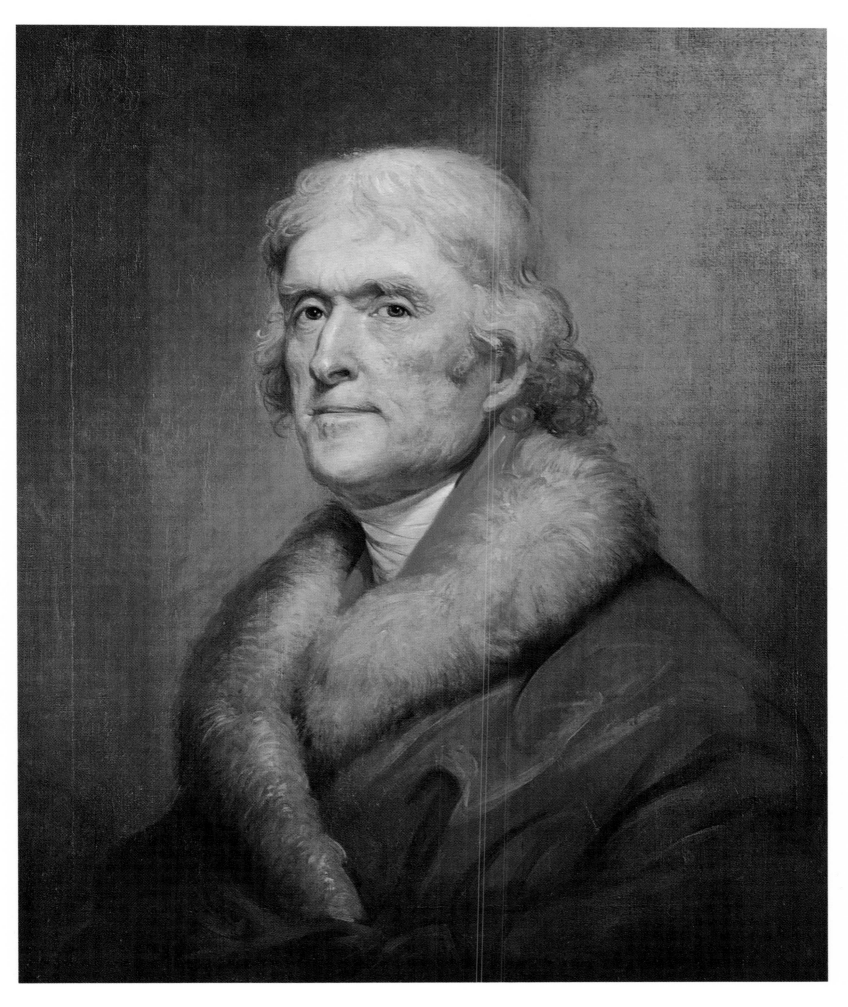

Thomas Jefferson
by Rembrandt Peale

The U.S.S. Constitution moves in close to the shore batteries to bombard the city of Tripoli. Her flag waving in the breeze displays fifteen stars and stripes, a star and stripe for each of the fifteen United States. The Constitution earned the nickname "Old Ironsides" because of the toughness of her live oak hull.

The U.S. frigate *Constitution,* commanded by Commodore Edward Preble, runs in close to the shore fortifications of Tripoli, her blazing broadsides silencing two enemy batteries and creating havoc within the stronghold of the Barbary pirates. It is the year 1804, and the young American republic, with Thomas Jefferson as President, is determined to put an end to piracy in the Mediterranean and terminate the humiliating payment of tribute to the Barbary States of North Africa. "Millions for defense, but not one cent for tribute!" This slogan echoed the mood of the American people. The first Barbary War ended with a shaky and often violated settlement, leaving it to Captain Stephen Decatur, in 1815, to sound the death knell of Barbary piracy when his American squadron appeared off Algiers and threatened to level the city. The Dey of Algiers sued for peace, and Tunis and Tripoli rapidly followed his example. The Barbary Wars tested the mettle of the new American Navy, and it was not found wanting. The Marine Corps hymn still commemorates American action on "the shores of Tripoli."

Bombardment of Tripoli

by N. C. WYETH

Courtesy of the United States Naval Academy Museum, Annapolis, Maryland

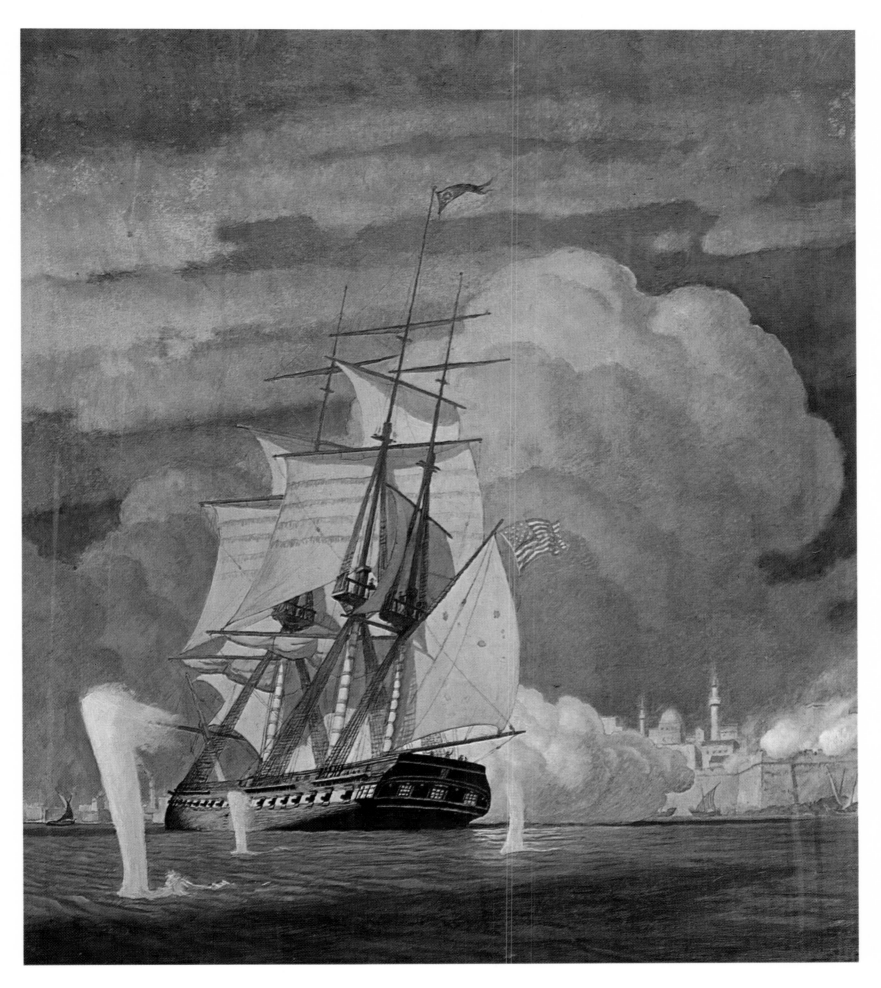

Bombardment of Tripoli
by N. C. Wyeth

Tecumseh and Harrison at Vincennes

by STANLEY M. ARTHURS

Courtesy of the Wilmington Society of the Fine Arts, Delaware Art Center, Wilmington, Delaware

> Brother . . . you have taken our land from us; . . . you are continually driving the red people, and at last you will drive them into the great lake where they cannot stand or work. . . . In the future we are prepared to punish those chiefs who may . . . sell their land. If you continue to purchase of them, I do not know what will be the consequence to the white people.

So spoke one of the most remarkable Indians of his generation, the Shawnee chieftain Tecumseh, addressing at Vincennes in 1810 the Governor of Indiana Territory, General William Henry Harrison. Tecumseh sought to form a united Indian nation to halt the ever-westward expansion of the white man into the Old Northwest, and Harrison stood as his chief antagonist, representing white encroachment on the Indian hunting grounds. The council broke up in bitter denunciations. The next year, while Tecumseh exhorted tribes in the South to join his confederacy, his brother "The Prophet" clashed with Harrison's troops at Tippecanoe. The Indians were routed and Tecumseh's dream of an Indian nation was shattered. Tecumseh himself later died fighting with the British against his old enemy Harrison at the Battle of the Thames, in 1813, while Harrison lived long enough to reach the White House in 1841 on the slogan "Tippecanoe and Tyler too."

O!
SAY
CAN
YOU
SEE

70

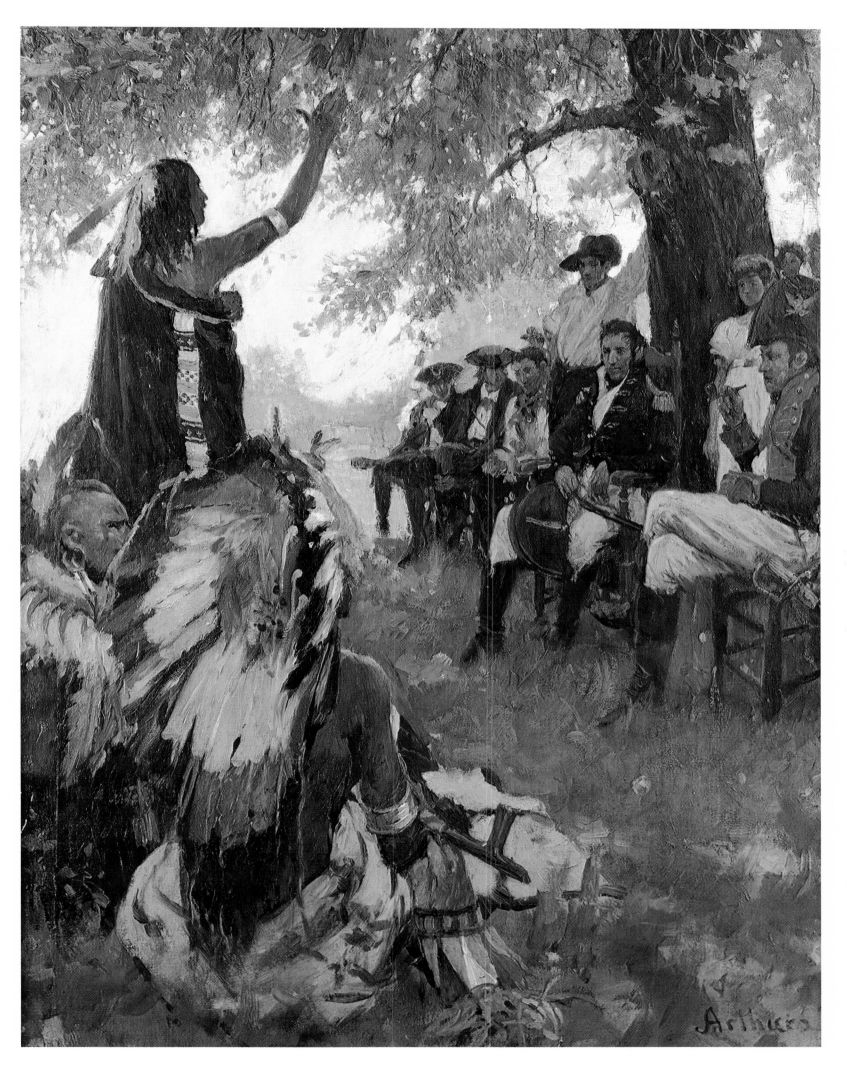

Tecumseh and Harrison at Vincennes
by Stanley M. Arthurs

We Have Met the Enemy and They Are Ours

(detail) by J. L. G. FERRIS

Courtesy of William E. Ryder and the Smithsonian Institution

It is 4:00 p.m., September 10, 1813. On the splintered deck of his flagship, the *Lawrence,* at the head of Lake Erie, Master Commandant Oliver Hazard Perry writes his famous dispatch to General William Henry Harrison:

> We have met the enemy and they are ours.
> Two Ships, two Brigs, one Schooner & one Sloop.
> Yours, with great respect and esteem
>
> O. H. Perry

The battle between the two small British and American fleets joined at Put-in-Bay on Lake Erie. Early in the engagement the fire from Captain Robert Barclay's British flotilla disabled Perry's flagship, the *Lawrence.* Transferring from the battered *Lawrence* to the brig *Niagara* in the heat of battle, Perry then turned defeat into a victory that crushed British naval power west of Niagara. His victory brought glorious news to a nation then engaged in its second war with England, and President James Madison promptly made him a captain. Perry's flag in the Battle of Lake Erie carried the dying words of Captain James Lawrence of the ill-fated *Chesapeake* captured by the British *Shannon* two years before: "Don't Give Up the Ship!"

*O!
SAY
CAN
YOU
SEE*

72

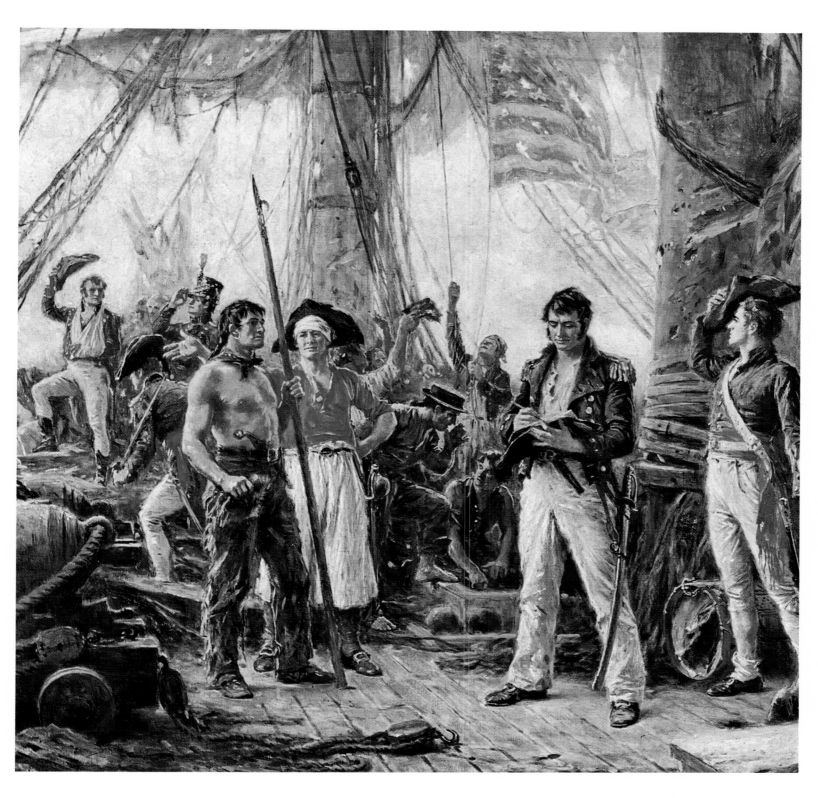

We Have Met the Enemy and They Are Ours (detail)
by J. L. G. Ferris

By the Dawn's Early Light

by N. C. WYETH

Courtesy of Newman Galleries,

Philadelphia, Pennsylvania

As Francis Scott Key peers through the smoke at the flag flying over Fort McHenry, he jots down the verses of his immortal poem. With him on the deck of the American truce ship are Doctor William Beanes, whose release from the British Key effected, and Colonel John Skinner, a United States Government agent.

While conducting negotiations for the release of a friend being held prisoner by Admiral Cochrane's British fleet, then anchored in the Chesapeake off the Patuxent River, 34-year-old Maryland lawyer Francis Scott Key became the unwilling guest of Cochrane when he sailed to attack Baltimore. Lying off Fort McHenry, the British commenced a bomb-and-rocket attack, attempting to reduce the fort and open the way to Baltimore. Throughout the night of September 13–14, 1814, Key watched the bombardment, and was moved to write the verses of "The Star-spangled Banner."

O! say can you see by the dawn's early light,
 What so proudly we hailed at the twilight's last gleaming,
Whose broad stripes and bright stars through the perilous fight,
 O'er the ramparts we watched, were so gallantly streaming?
And the Rockets' red glare, the Bombs bursting in air,
Gave proof through the night that our Flag was still there;
 O! say does that star-spangled Banner yet wave,
 O'er the Land of the free, and the home of the brave?*

The "dawn's early light" revealed the flag still flying from Fort McHenry, which, under the command of Major George Armistead, stood fast. The British, thwarted by the defense of the fort and by the American resistance to a land attack at North Point, withdrew. Key, ashore the next day in Baltimore, published his poem, promptly set to the tune of a popular song of the day, "To Anacreon in Heaven." In 1931 "The Star-spangled Banner" became the national anthem by an act of Congress.

*Original punctuation.

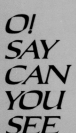

O!
SAY
CAN
YOU
SEE

74

By the Dawn's Early Light
by N. C. Wyeth

The Old House

Morse described his painting: "The time chosen is at candle lighting while the members are assembling for an evening session. . . . The primary design of the present picture is not so much to give a highly finished likeness of the individuals introduced, as to exhibit to the public a faithful representation of the National Hall, with its furniture and business during the session of Congress. . . ." Visitors now see this area as Statuary Hall.

of Representatives

by SAMUEL F. B. MORSE

Courtesy of the Corcoran Art Gallery, Washington, D.C.

After the British burned the Capitol in Washington in 1814, architect Benjamin Latrobe redesigned the House chamber in a semicircular shape. Charles Bullfinch later took over his task and, in December 1819, Congress moved back into the House and Senate chambers. Two years later Samuel F. B. Morse painted this view of the House of Representatives during the administration of President James Monroe. In this monumental painting, 86½ inches x 130¾ inches, eighty-six individual portraits appear for which each person except William Lowndes sat. Morse later sketched Lowndes from the House gallery. The Supreme Court justices appear on the dais at the left rear; note the Indian in the gallery under the scarlet curtains which helped to muffle annoying echoes.

O!
SAY
CAN
YOU
SEE

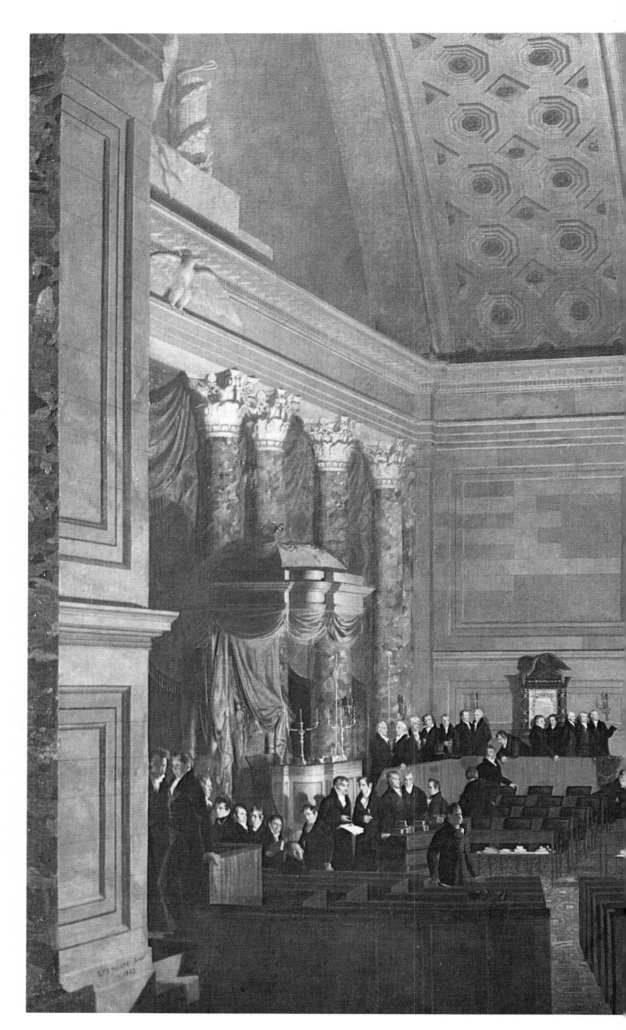

The Old House
of Representatives
by Samuel F. B. Morse

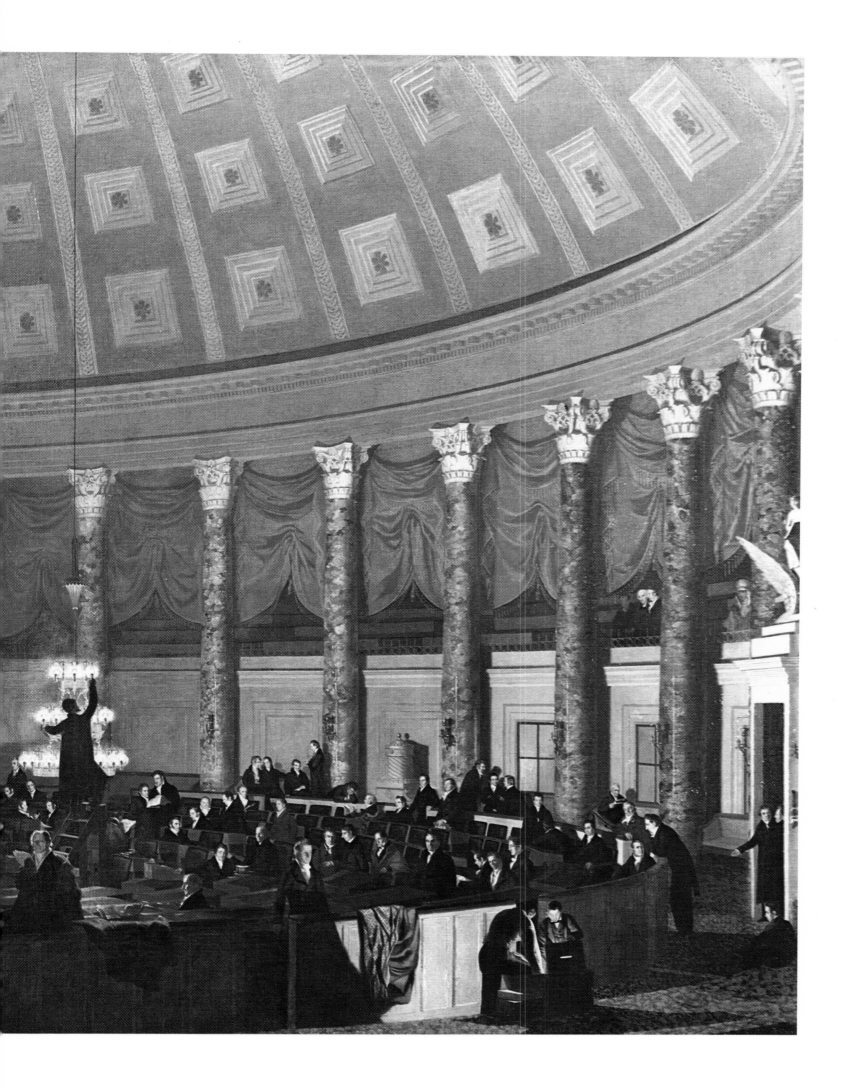

The Trek
of the
Mountain Men

by W. H. D. KOERNER

Courtesy of Ruth Koerner Oliver

The rugged mountain men blazed the trails of the Old West during the first decades of the nineteenth century. Their search for beaver pelts to fill the insatiable demand for beaver fur hats, the fashion of the day for gentlemen in Europe and America, carried them up the Missouri, across the Great Plains, and into the Rocky Mountains. Men like Jedediah Smith, Jim Bridger, and Kit Carson traversed the unbroken wilderness, knew the Indians, and opened the trails followed by those settlers who formed the vanguard of the great Western migration yet to come. Bridger, while in the service of William Ashley's Rocky Mountain Fur Company, discovered Great Salt Lake in 1825; Jedediah Smith and his party crossed the Rockies and became the first to envision the passage of wagon trains across that forbidding barrier; and Smith himself became the first white man to journey from Southern California to the Columbia Valley. Early military expeditions led by explorers like John C. Frémont leaned heavily on the guidance and knowledge of Bridger and Carson.

Spending the long winter months trapping in the wilds, the mountain men met to carouse at the summer "rendezvous" at Green River, Wyoming, selling or trading their pelts to company agents, bartering with the assembled Indian tribes, and often, as in Carson's case, taking Indian brides.

These keen-eyed mountain men, their long rifles at the "ready," appear here from the brush of W. H. D. Koerner as they make their way toward the "rendezvous," their pack horses laden with beaver pelts, the gleanings of long and lonely months in the Rockies. Koerner's love for the West found fruition and wide popular appeal for a generation of readers in his memorable Saturday Evening Post illustrations exemplified by this painting.

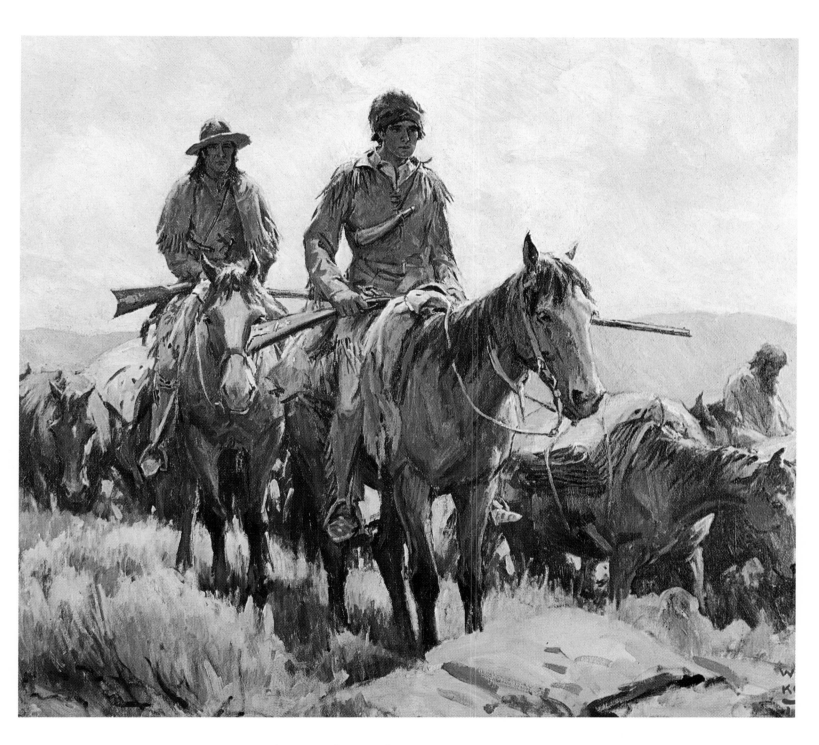

The Trek of the Mountain Men
by W. H. D. Koerner

The Battle of the Alamo

(detail) by F. C. YOHN

From the collection of historical paintings of the
Continental Life Insurance Company, New York, N.Y.

In 1835 the American settlers of eastern Texas, then a Mexican state, took up arms against the military despotism of Mexican President Santa Anna. Determined to crush the rebellion, Santa Anna marched north with an army of over 5,000. In February 1836 he found his way blocked by a small Texan garrison in a fortified chapel, the Alamo, on the outskirts of San Antonio.

On March 6, 1836, after a two-week siege, the Mexicans broke through the defenses of the Alamo. The 182 defenders went down fighting to the last man; but Santa Anna paid a heavy toll for his victory—nearly 1,000 Mexicans fell before the long deer rifles of the Americans in this battle for Texan independence. Among the slain at the Alamo were its commander, Colonel William B. Travis, James Bowie, and the celebrated Davy Crockett, frontiersman and ex-congressman from Tennessee. Santa Anna proceeded north, pursuing a little Texas army gathered by Sam Houston. At San Jacinto, on April 21, Houston turned on his pursuers, routed them, and captured Santa Anna. Independence was won; the defenders of the Alamo bought the necessary time with their blood. Houston became the first President of the Republic of Texas, and nine years later, in 1845, the "Lone Star State" merged into the United States.

Artist F. C. Yohn paints the moment of the last stand of Crockett and his command of Tennesseans as they go down fighting in the area fronting the Alamo chapel. They formed the last pocket of resistance before Santa Anna's troops broke into the chapel itself.

O!
SAY
CAN
YOU
SEE

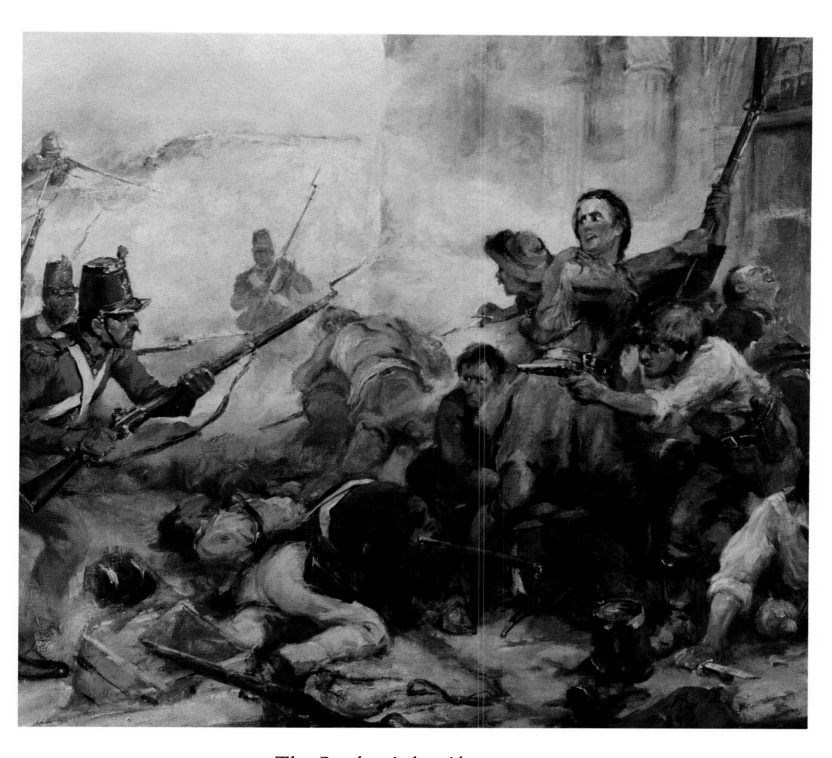

The Battle of the Alamo (detail)
by F. C. Yohn

In 1854 well over 400,000 immigrants, packed in ships like animals, disembarked upon the shores of the New World. It was the peak year of the so-called "old immigration" during the first six decades of the nineteenth century, when England, Scotland, Ireland, Germany, Switzerland, and Scandinavia furnished a great mass of new Americans. In the forty years preceding the Civil War more than two million Irish immigrants, most of them destitute laborers and farmers, poured into the United States; Irish immigration reached its peak in the years following the tragic Irish famine of 1848. With unimaginable shipboard conditions, without the most basic necessities, crowded into vermin-infested quarters, it is little wonder that passengers succumbed to cholera, smallpox, yellow fever, and typhus in terrible numbers. In one year alone, of over 100,000 who left the British Isles for America more than 17,000 died during the crossing. Many of those lucky enough to survive the trip became the victims of unscrupulous gangs in port who forced the confused immigrants into filthy lodgings where they were abused, cheated, and robbed. In later years officials enforced and improved immigration regulations, and with the establishment of reception depots such as Castle Garden, New York, emigration from Europe lost most of its old terrors.

The Bay
and
Harbor of New York

(detail) by SAMUEL B. WAUGH

Courtesy of the Museum of the City of New York, N.Y.

Waugh's painting of immigrants landing in New York seems to belie the stories of hardships encountered by so many thousands of steerage passengers in those days. Those debarking here appear able to afford better accommodations. In the background appears the Keying, the first Chinese ship to visit the United States. Note the trunk of "Pat Murfy for Ameriky."

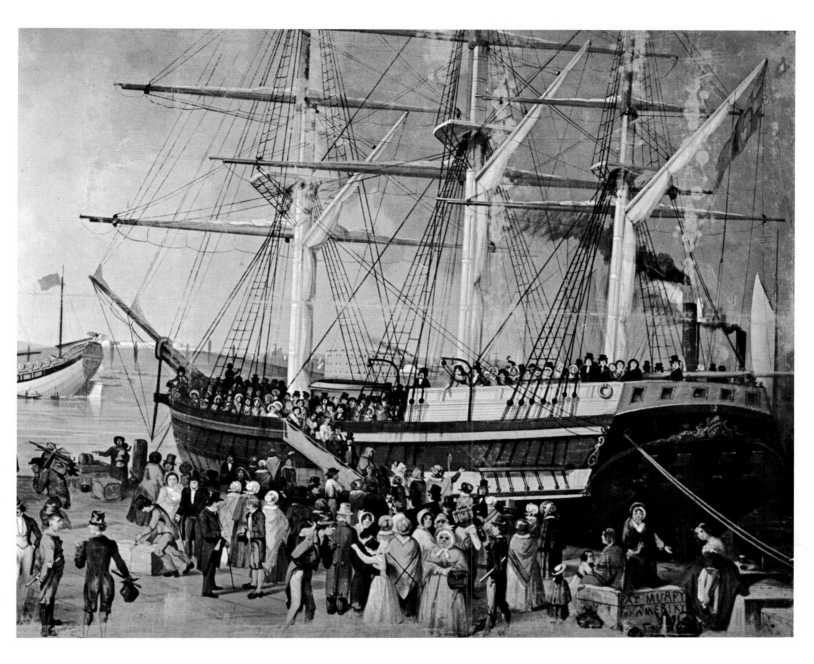

The Bay and Harbor of New York (detail)
by Samuel B. Waugh

News from Mexico

by RICHARD CATON WOODVILLE

Courtesy of the National Academy of Design, New York, N.Y.

The news of victories from the battlefronts in Mexico is old, but no less interesting to this enthusiastic cross section of the American rural public of the 1840s. The young nation, flexing its muscles and impatient to push its western border to the Pacific—to fulfill its "Manifest Destiny"—engaged in its first full-scale invasion of a foreign country. Strange-sounding names found their way into the newspapers—Cerro Gordo, Buena Vista, Matamoros, Churubusco. In the north of Mexico, Zachary Taylor's little army won against superior numbers of Mexican defenders. In the south Winfield Scott fought his way from Vera Cruz to the gates of Mexico City in a succession of battles. But not all Americans believed that "Mr. Polk's war" was either moral or justified. In Congress a young Representative from Illinois named Abraham Lincoln said, "I more than suspect that he [Polk] is deeply conscious of being in the wrong, that he feels the blood of this war, like the blood of Abel, is crying to Heaven against him. . . ."

As the excited reader recounts the news from the war fronts of Mexico, his audience listens with rapt attention. The youthful Woodville's genius in portraying character types is brilliantly displayed in this, one of his most famous genre paintings.

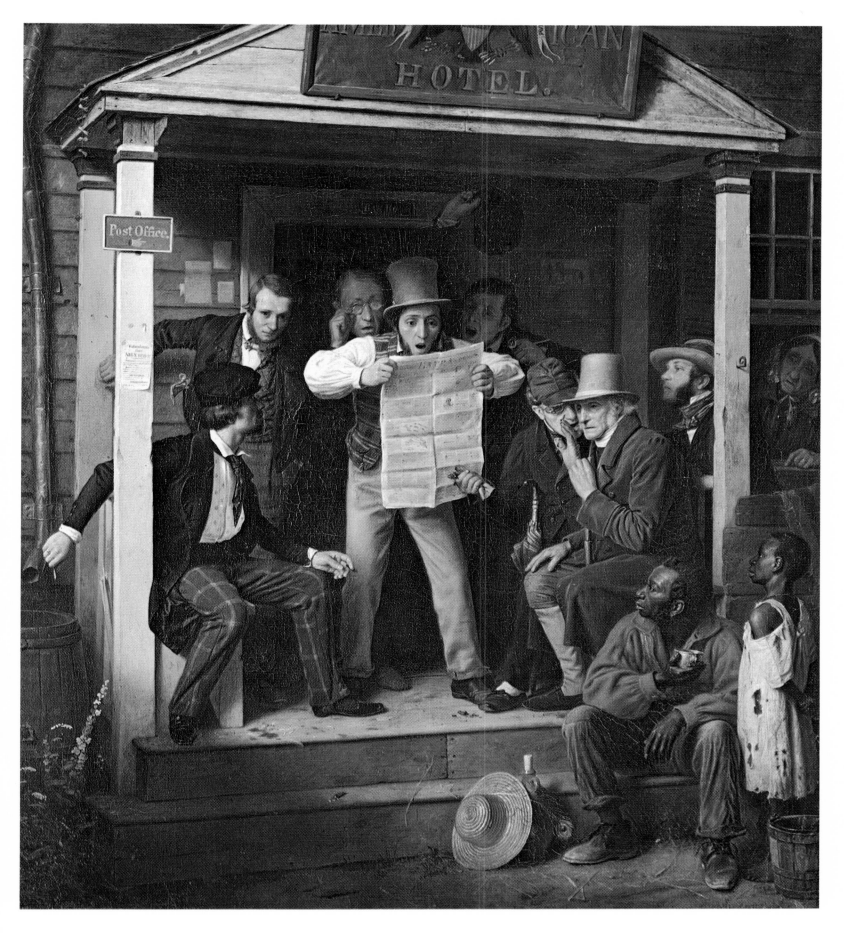

News from Mexico
by Richard Caton Woodville

The Battle of Chapultepec

by JAMES WALKER

Courtesy American Heritage Publishing Company, New York, N.Y., and Mr. Jay Altmayer

On September 13, 1847, General Winfield Scott launched the division of General Gideon Pillow against the rocky prominence of Chapultepec, the last Mexican stronghold guarding the approaches to Mexico City. Moving up the southern slopes, the American troops met determined resistance from the defenders of the height, many of them young Mexican cadets. Using scaling ladders the Americans finally swept over the walls and planted the Stars and Stripes on the ramparts. President Santa Anna fled from the Mexican capital, which fell to Scott's army the following day, virtually ending the Mexican War. Formal peace was signed at Guadalupe Hidalgo on February 2, 1848. The United States agreed to pay Mexico $15,000,000, assuming responsibility for the payment of claims of American citizens against Mexico. In return Mexico accepted the Rio Grande below El Paso as the boundary between the two countries, and ceded to this country almost all of the present southwestern United States.

O!
SAY
CAN
YOU
SEE

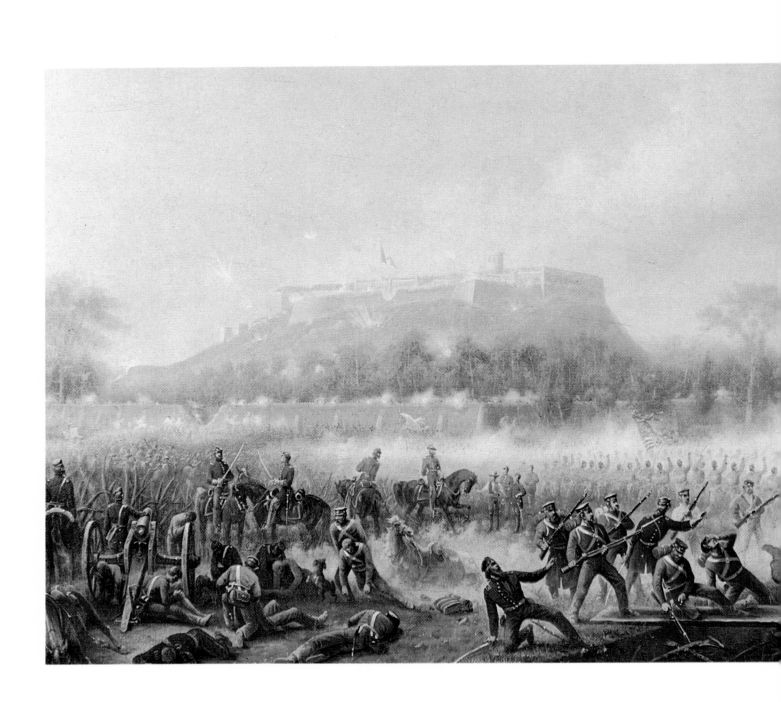

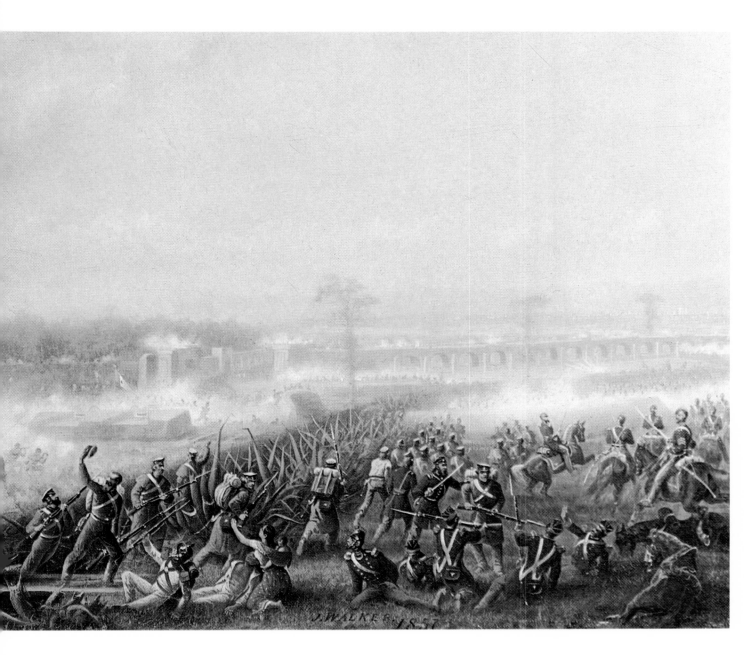

The Battle of Chapultepec
by James Walker

The Jolly Flatboatmen

in Port

by GEORGE CALEB BINGHAM

Courtesy of the City Art Museum of St. Louis, St. Louis, Missouri

The flatboat, a familiar sight on the Mississippi during the first half of the nineteenth century, carried a flimsy house that served as sleeping quarters and protection for the cargo. The open forward deck held livestock. The vessels measured from forty to ninety feet in length; ten to twenty feet in width. Five or six men made up the crew manning sweeps that steered the boats. The crew, a typically rough-and-tumble breed of men, brawled, drank, danced, and gambled their way along the "Father of Waters."

Loaded with the produce of the old frontier, the flatboats passed down the Mississippi on marketing trips to the bustling port of New Orleans, where not only the cargo brought money, but the boats themselves, as firewood. The crews walked home along the old Natchez Trace, paddled upriver in canoes, or worked on keelboats for upstream passage. Twenty-two-year-old Abraham Lincoln rode a flatboat he helped build to New Orleans in 1831, with a cargo of pigs, barreled pork, and corn. He found the number of flatboats converged upon the New Orleans waterfront so concentrated that he walked for a mile across the boats before reaching shore. He enjoyed the comparative luxury of a steamboat trip back upriver to St. Louis, the locale of Bingham's painting made in the 1850s.

By the 1860s the railroad and the steamboat made the clumsy flatboat obsolete, and with its disappearance one of the most picturesque periods of Mississippi River life passed into history.

A favorite subject of Bingham's, the flatboatmen were a hardy, self-reliant group of individuals, the consummate "toughs" of the Mississippi. Here their boat lies tied to the wharf, its cargo disposed of as the "jolly flatboatmen" celebrate their leisure time. Bingham completed this painting in Düsseldorf in 1857. It was the most ambitious of a number of pictures dealing with the flatboatmen painted prior to his trip to Germany.

93

O!
SAY
CAN
YOU
SEE

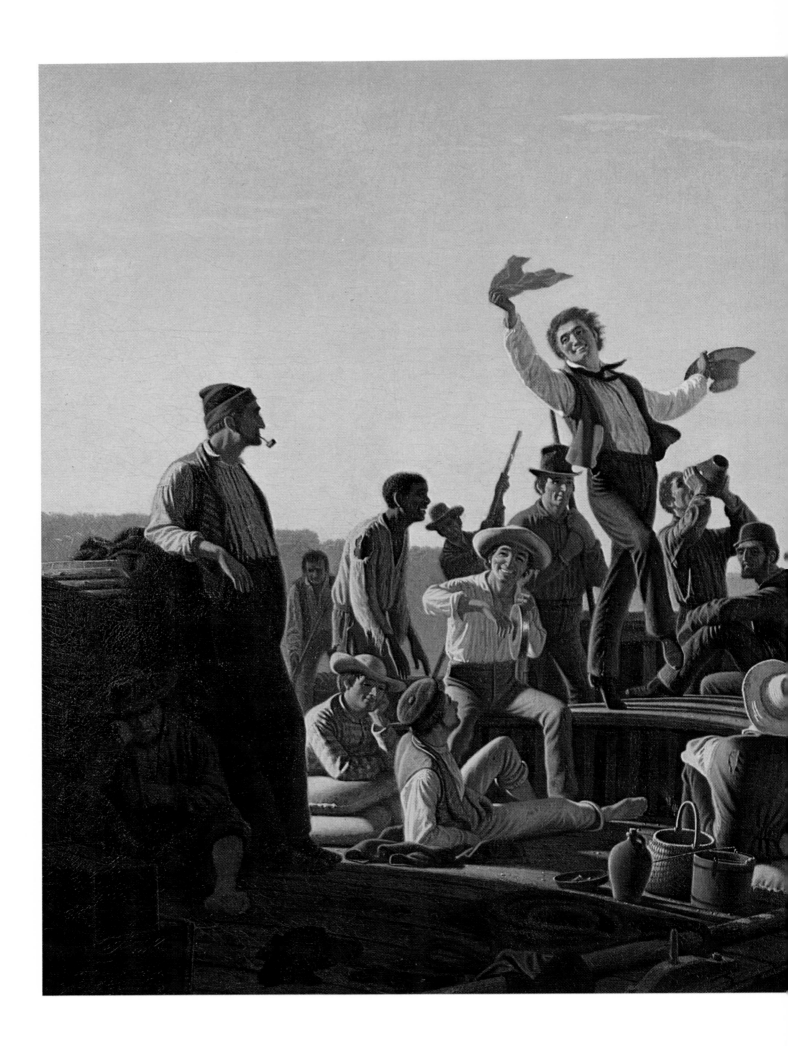

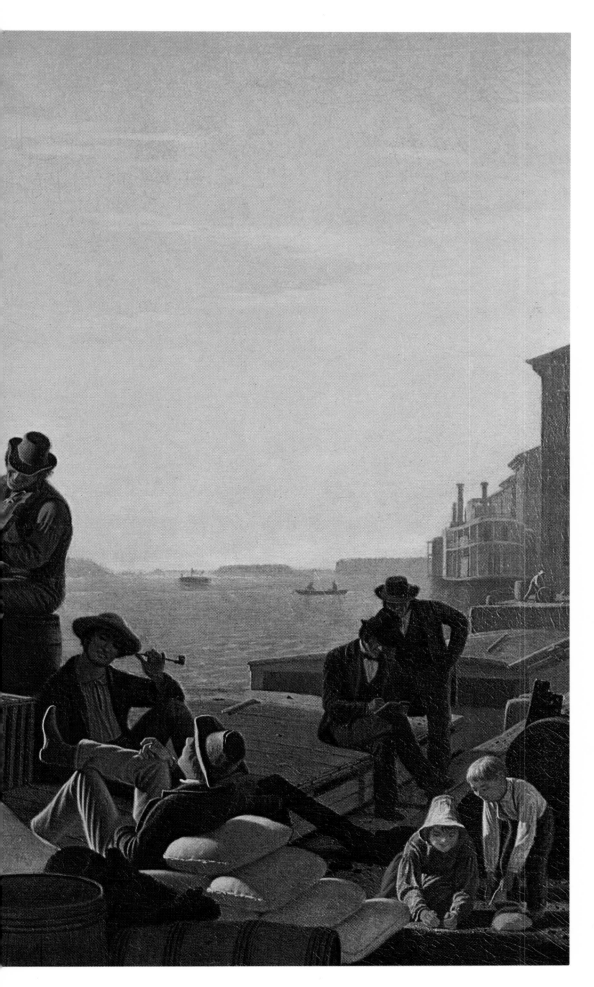

The Jolly Flatboatmen
in Port

by George Caleb Bingham

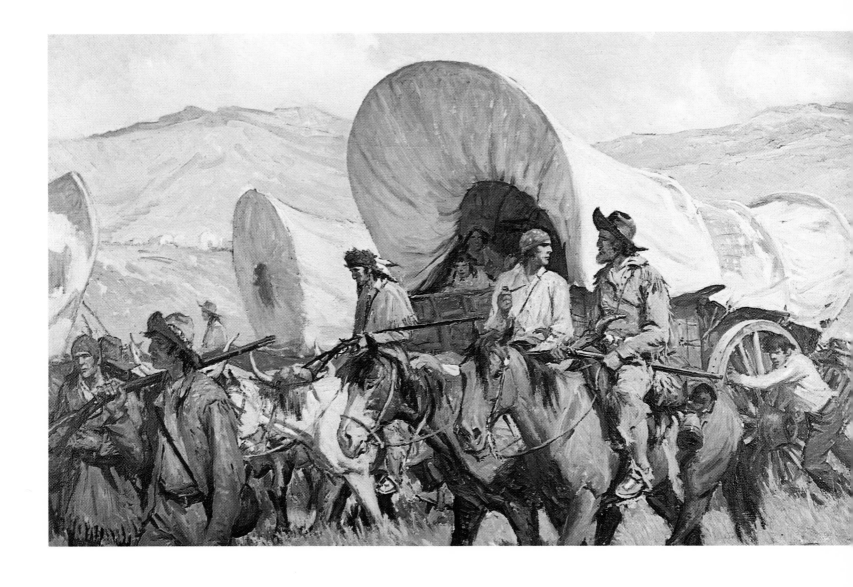

Wagon Train

by W. H. D. KOERNER

Courtesy of Ruth Koerner Oliver

"The first low wash of waves where soon shall roll a human wave." Thus did historian George Bancroft describe the greatest overland movement of people the world had ever seen. In 1843 Americans began moving west by wagon train over 2,000 miles of the Oregon Trail starting from Independence, Missouri, with their goal the Willamette Valley of Oregon. Indian attacks, cholera (which killed thousands of immigrants), thirst famine, floods, precipitous mountain crossings, cold, heat, and the awful dust that enveloped the wagon trains did not deter the land-hungry, the adventurous. They kept coming west. Ezra Meeker came with the migration in 1852.* His little group stopped for four days beside the Trail and counted 1,600 wagons as they passed—wagons that stretched, one close behind the other, for 500 miles! A chain of outposts—Forts Leavenworth, Kearney, Laramie, Bridger, Hall—the lonely oases for the wagon trains stood strung out along the Trail. Here the immigrants bought flour and supplies for the next long leg of their westward trek. A steady stream of wagons, animals, and humanity rolled west undiminished from 1843 to 1869, when completion of the Central Pacific Railroad replaced wagon trails with rails.

* Fifty-four years later Meeker, at seventy-five, retraced the Oregon Trail with ox team and wagon, marking the Trail with stone or concrete monuments.

O!
SAY
CAN
YOU
SEE

96

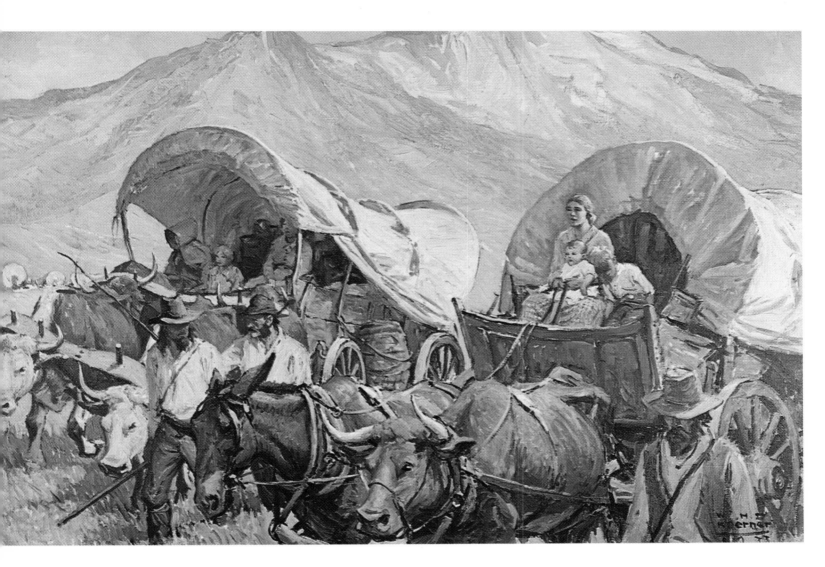

Wagon Train West
by W. H. D. Koerner

West

The variety and magnitude of the great western movement along the Oregon Trail appear vividly in W. H. D. Koerner's painting. He showed in the faces of his subjects the will and determination that led the pioneers in their epic journey across the wilderness.

*Sunday
Morning*

In January 1848, James W. Marshall discovered gold in the millrace of a sawmill being built on the Sacramento River by John Sutter, prosperous California pioneer. Though Sutter and Marshall tried to hide the discovery, news of it inevitably leaked out. Soon headlines screamed across the nation: "Gold in California!" The gold fever became an epidemic. Men abandoned their families, closed homes and businesses, and left their farms idle to join the tidal wave of gold seekers that converged from all points of the compass on California. They came in covered wagons across the Great Plains and the Sierras; around Cape Horn by fast clipper ships; across the Isthmus of Panama to the Pacific Coast. In San Francisco forests of masts studded the bay— ships idled by the desertion of their crews to join in the rush to the gold fields. By 1849 the gold fever reached its peak. The small settlement of San Francisco grew into a bustling metropolis; prices soared outrageously, and the turn of a card often made and broke fortunes overnight. By the end of 1849 the population of California showed an awesome jump from 20,000 to 100,000.

in the Mines

by CHARLES C. NAHL

Courtesy of the E. B. Crocker Art Gallery, Sacramento, California

Charles Nahl's painting of the forty-niners reveals a cross section of types. Sunday was a time for reading the Bible, writing a letter home, indulging in a drunken revelry, washing linen, staging a horse race, or having a brawl. In the foreground are two "cradles," a primitive but functional method for washing gold from the gravel.

O! SAY CAN YOU SEE

*Sunday Morning
in the Mines*
by Charles C. Nahl

Fugitive Slaves

Men like crusading abolitionist William Lloyd Garrison, publisher of the *Liberator,* and Wendell Phillips, whose oratory against the evils of slavery drew crowds in Northern lecture halls, sparked the antislavery movement of the mid-nineteenth century. Harriet Beecher Stowe penned *Uncle Tom's Cabin* in 1852, and the book's antislavery message gained thousands of adherents. The cause of abolition crystallized into action with the "Underground Railroad," a chain of clandestine way stations located across the North, whose operators spirited runaway slaves away from the South to Canada. It is estimated that some 75,000 Negroes found their way to freedom in Canada through the "Railroad." The slavery question would eventually prove the prime factor in plunging Americans into bloody civil war in 1861.

on the Underground Railway

by CHARLES T. WEBBER

Courtesy of the Cincinnati Art Museum, Cincinnati, Ohio

Charles T. Webber's painting shows a winter night on the farm of Levi Coffin on the outskirts of Cincinnati, one of the "stations" on the escape route. Coffin, a prominent abolitionist, is the man with the broad-brimmed hat who appears in the background above the sleigh.

103

O! SAY CAN YOU SEE

Fugitive Slaves
on the
Underground
Railway
by Charles T. Webber

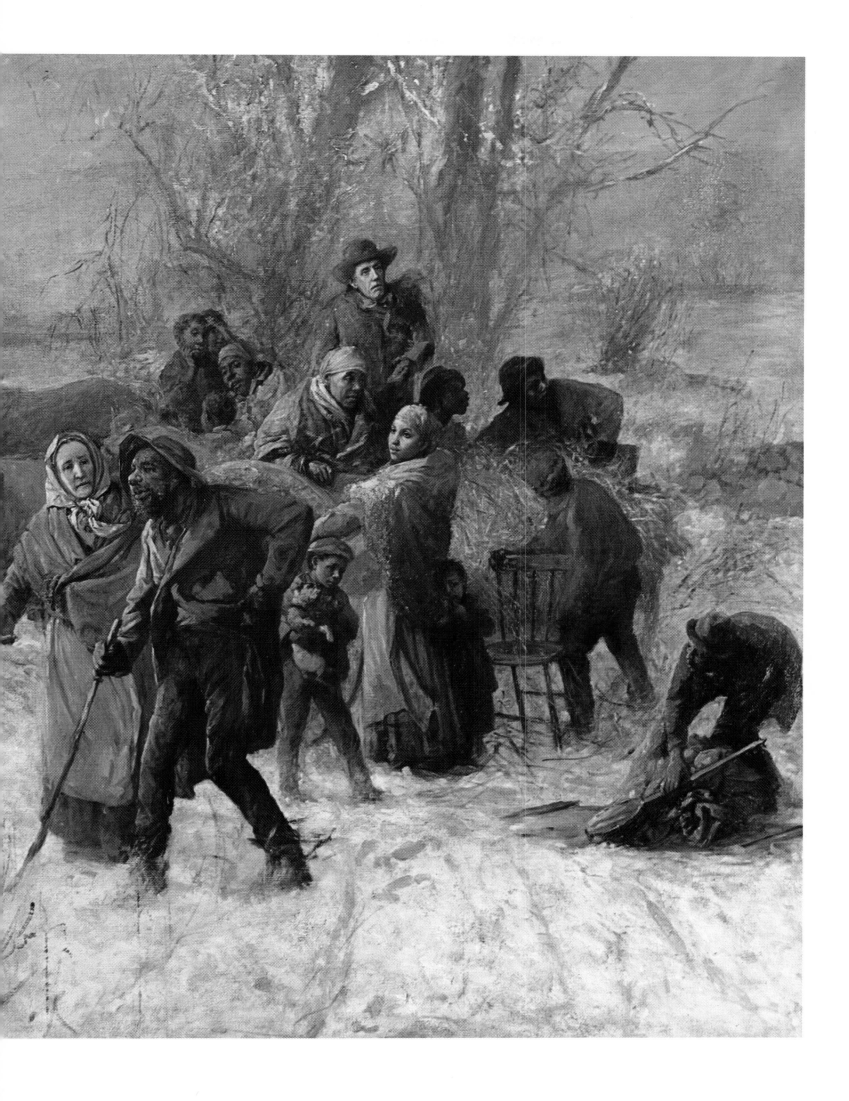

Lincoln Raising the Flag at Independence Hall

Lincoln himself described the flag raising at Independence Hall: "It floated gloriously to the wind without an accident in the bright glowing sunshine of the morning." Harper's Weekly reported the event, and remarked that "the excitement was of a fearful character when the President-elect seized the rope to hoist the flag. . . . The shouts of the people were like the roar of waves which do not cease to break. For full three minutes the cheers continued. The expression of the President-elect was that of silent solemnity."

by J. L. G. FERRIS

Courtesy of William E. Ryder and the Smithsonian Institution

On the morning of February 22, 1861, President-elect Abraham Lincoln, on his way to Washington for his inauguration as sixteenth President of a United States, now divided by the secession of the South, stood before Independence Hall, Philadelphia, and raised the flag above that historic building. Inside the Hall he addressed an overflow audience.

> I have often inquired of myself what great principle or idea it was that kept this confederacy together. . . . It was that which gave promise that in due time the weight would be lifted from the shoulders of all men, and that *all* should have an equal chance. . . . But if this country cannot be saved without giving up that principle—I was about to say I would rather be assassinated on this spot than surrender it. I have said nothing but what I am willing to live by, and, if it be the pleasure of God, to die by.

Lincoln went on to Harrisburg, where he learned of rumors of an assassination plot in Baltimore. His train was secretly rerouted through Baltimore and on to Washington, where, on March 4, 1861, he took the oath of office as President and started on his great mission.

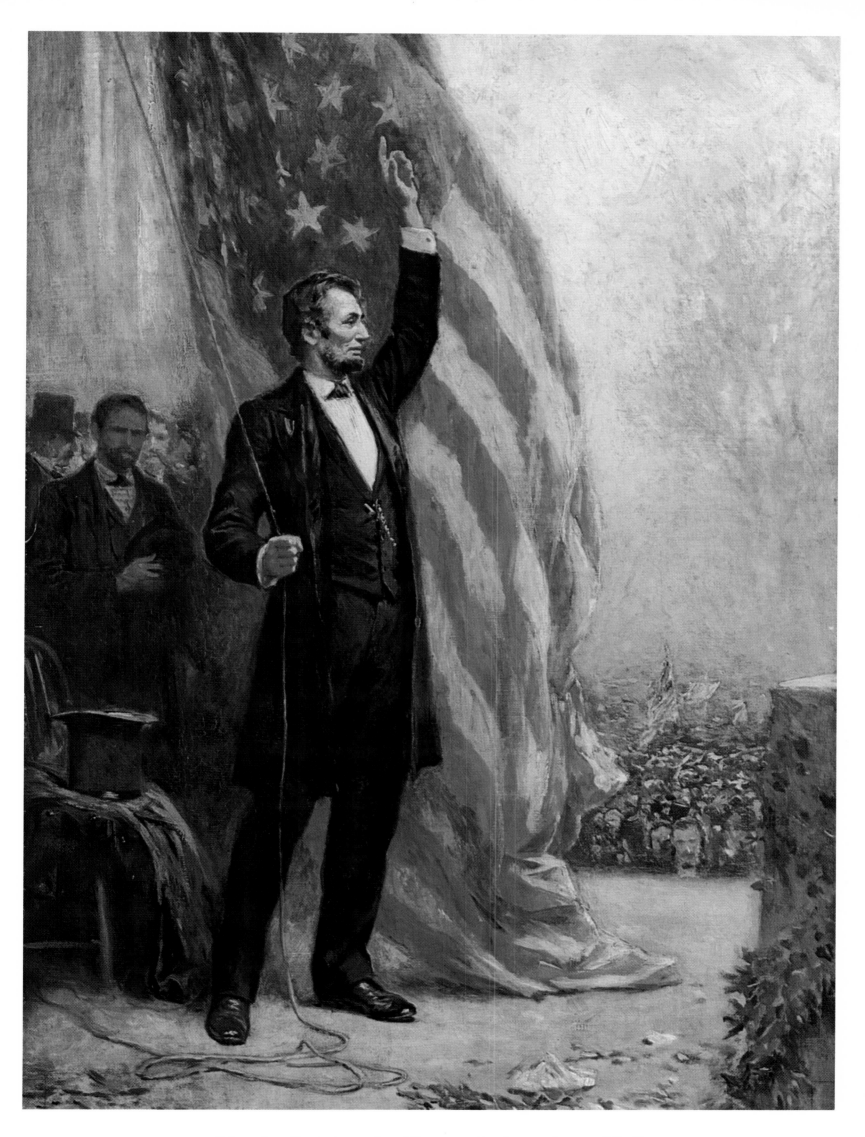

Lincoln Raising the Flag at Independence Hall
by J. L. G. Ferris

In 1850 Daniel Webster spoke before the United States Senate: "No
sir! No, sir! There will be no secession. Gentlemen are not serious
when they talk of secession."

But they were serious, and ten years later secession became a reality.
With the election of Lincoln in 1860, the Southern states withdrew
from the Union, and Lincoln assumed the Presidency of a divided
nation. On April 14, 1861 the Federal garrison at Fort Sumter in
Charleston Harbor capitulated to the armed forces of South Carolina
after a two-day bombardment, and the tragic fratricidal war which
Lincoln hoped to avoid thus began. Before its end more than a half
million died on the battlefield of wounds, in hospitals of disease, or in
prison camps. A Union volunteer army, hastily assembled under the
command of General Irvin McDowell, marched against the Confederate
capital at Richmond, Virginia, only to be defeated and routed at Bull
Run on July 21, 1861. It marked the beginning of a long succession of
Confederate victories.

In 1862 General George B. McClellan's Army of the Potomac, moving
against Richmond, battled along the James River against the Army of
Northern Virginia. The Peninsular Campaign, begun with high hopes,
ended in dismal failure for McClellan despite Union superiority in
arms and men. Robert E. Lee now commanded the Confederate army
in Virginia, and his presence instilled in his men a steadfast loyalty
and fervent confidence in their ability to win.

The
Battle

by N. C. WYETH

Courtesy Mr. and Mrs. George A. Weymouth

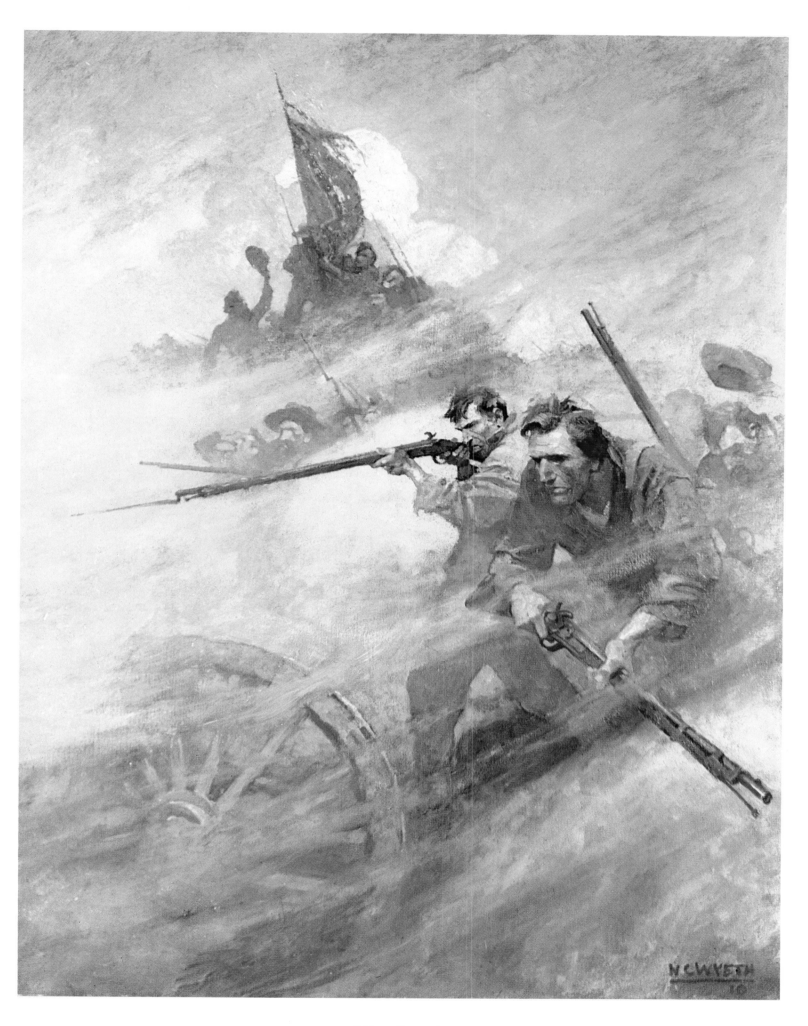

The Battle
by N. C. Wyeth

Eastman Johnson's painting of "The Wounded Drummer Boy," first exhibited at the National Academy in 1872, was based upon an actual incident at the Battle of Antietam, and dramatized the fighting spirit of the "boys in blue" who fought well in spite of often poor leadership. As described in the National Academy catalogue: ". . . a drummer boy was disabled by a shot in the leg. As he lay upon the field he called to his comrades, 'Carry me, and I'll drum her through!' They tied up his wound, a big soldier took him upon his shoulders, and he drummed them through the fight."

The Wounded Drummer Boy

by EASTMAN JOHNSON

Courtesy Union League Club, New York City

Robert E. Lee's strategy in the autumn of 1862 called for crossing the Potomac to outmaneuver and crush McClellan's army. At Antietam, Maryland, on September 17 they fought the bloodiest single day's battle of the war. For the first time Lee lost the field, and retreated into Virginia, his army suffering from heavy losses. The Union success at Antietam provided President Lincoln with the proper timing for the issuance of the Emancipation Proclamation on January 1, 1863, declaring that "all persons held as slaves within any State or designated part of a state, the people thereof shall be in rebellion against the United States, shall be then, thenceforward, and forever free." The object of the war now became twofold— to preserve the Union and free the slaves. It remained for the Thirteenth Amendment, promulgated February 1, 1865, finally to abolish slavery in the United States. The South accepted it at the end of the war.

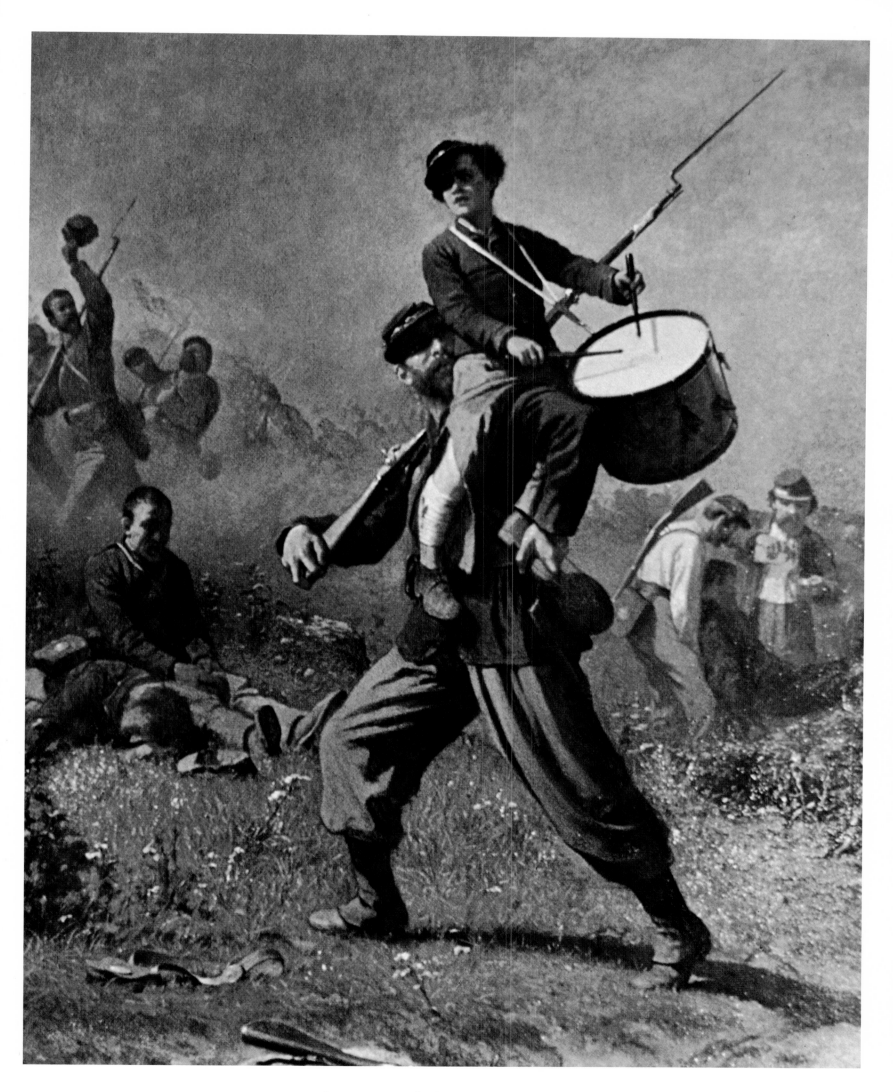

The Wounded Drummer Boy
by Eastman Johnson

(detail) by WINSLOW HOMER

Courtesy of the Metropolitan Museum of Art, New York, N.Y.

Southern victories at Fredericksburg and Chancellorsville encouraged Lee to carry the war again into the North, and in the summer of 1863 the Confederate army marched into Pennsylvania. The three-day carnage at Gettysburg, July 1–3, culminated in victory for General George G. Meade's Union army, but Lee's forces escaped intact to Virginia. Simultaneously with the Federal success at Gettysburg the Confederate fortified city of Vicksburg fell to Federal forces under General Ulysses S. Grant, opening the Mississippi to the passage of Union ships. These two victories marked the turning point of the war; the high tide of the Confederacy began ebbing. In the summer of 1864 Grant, now placed in full command of Union armies by Lincoln, hammered his way from The Wilderness to Petersburg, while General William T. Sherman took Atlanta and proceeded to cut a wide swath across Georgia to Savannah and the sea, bringing the devastation of total war to the heartland of the embattled Confederacy. Lincoln's re-election in 1864 over his Democratic opponent, George B. McClellan, reflected the confidence of the North in "Old Abe's" ability to gain the final victory and restore the Union, now only a matter of time as the South's capacity to wage war crumbled.

As in all wars, the inevitable monotony of camp life became the soldier's lot. Winslow Homer's picture of these Federal cavalrymen, which he painted in 1871, was typical of such intervals between battles. It was based upon the artist's own observations while illustrating for Harper's Weekly during the war.

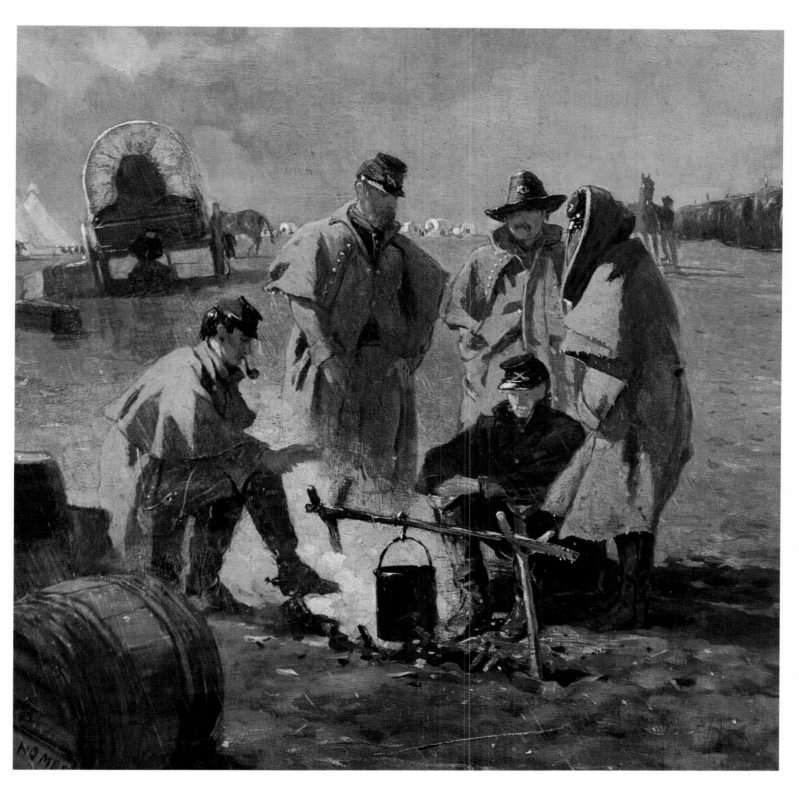

A Rainy Day in Camp (detail)
by Winslow Homer

The Battle

of Nashville

by HOWARD PYLE

From the Minnesota State Capitol, St. Paul, Minnesota

The decisive battle of Nashville raged on December 15–16, 1864, when a Union army commanded by General George H. Thomas, "The Rock of Chickamauga," moved out of Nashville and clashed with General John B. Hood's Confederate Army of the Tennessee. The battle of the first day ended with the Confederate line broken and in retreat. Thomas believed the battle over, but morning found Hood's army in new positions and still spoiling for a fight. The furious fighting of the second day completed the defeat of the Confederate forces, who retreated southward pursued in a continuous running fight until the last of Hood's army crossed the Tennessee River on December 27. Of all the battles of the Civil War, Nashville is considered the most complete in its results; the Union victory freed Tennessee of organized Confederate forces, and put an end to Hood's Tennessee campaign by virtually destroying his army.

O!
SAY
CAN
YOU
SEE

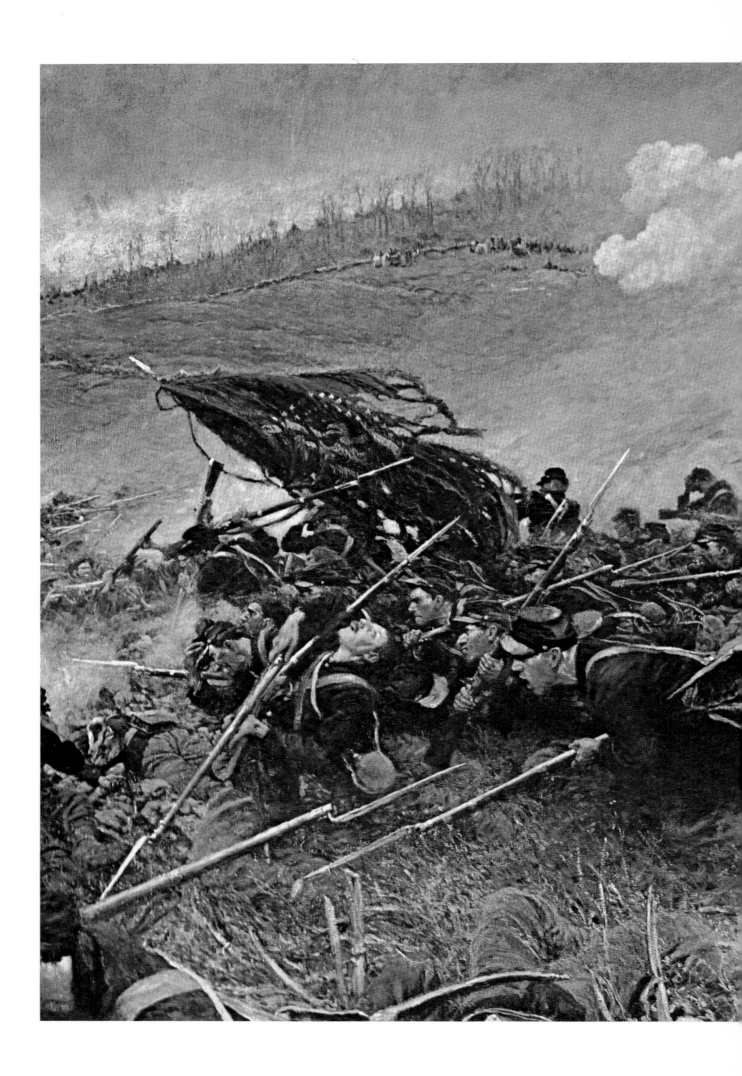

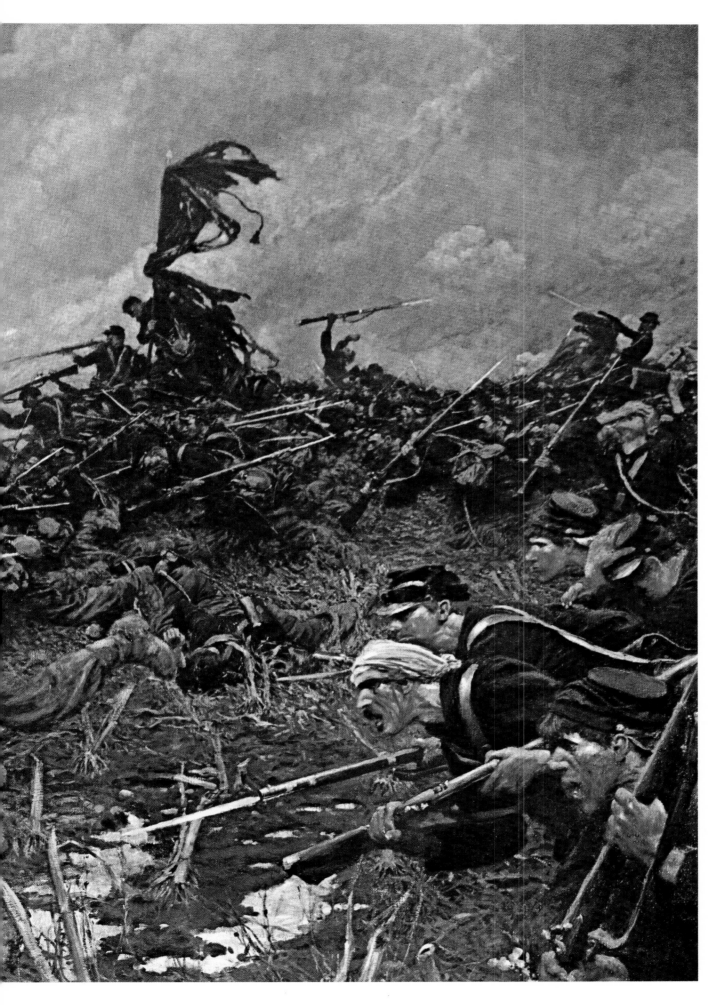

The Battle of Nashville
by Howard Pyle

Let
Us
Have Peace

The contrast between the two commanders was striking: Grant, forty-three years old, wearing a private's blouse with only his shoulder straps to indicate his rank, his boots muddied from the ride to Appomattox; Lee, sixteen years Grant's senior, a tall, imposing figure in a spotless gray uniform with sash and ornate sword. General Philip H. Sheridan stands at the far left; Lee's secretary, Lt. Col. Charles Marshall is the Confederate officer at the extreme right.

by J. L. G. FERRIS

Courtesy of William E. Ryder and the Smithsonian Institution

"I met you once before, General Lee, while we were serving in Mexico. . . ." So General Ulysses S. Grant greeted his formidable antagonist, General Robert E. Lee, in the parlor of the McLean House at Appomattox, Virginia on April 9, 1865. Petersburg had fallen to Union forces on April 1; Grant's army occupied Richmond two days later after President Jefferson Davis and the Confederate cabinet fled south. Lee's Army of Northern Virginia, exhausted and hungry, found no escape from Grant's pursuing army at the little village of Appomattox Court House. An exchange of notes between Lee and Grant agreed upon a meeting to arrange the surrender of the Confederate army "to avoid further effusion of blood." The surrender papers, drawn up in the McLean parlor, allowed Lee's men to retain their horses that they might work their farms once more. The nation's joy over this victory soon turned to mourning for its President, Abraham Lincoln, who died by an assassin's bullet on April 15.

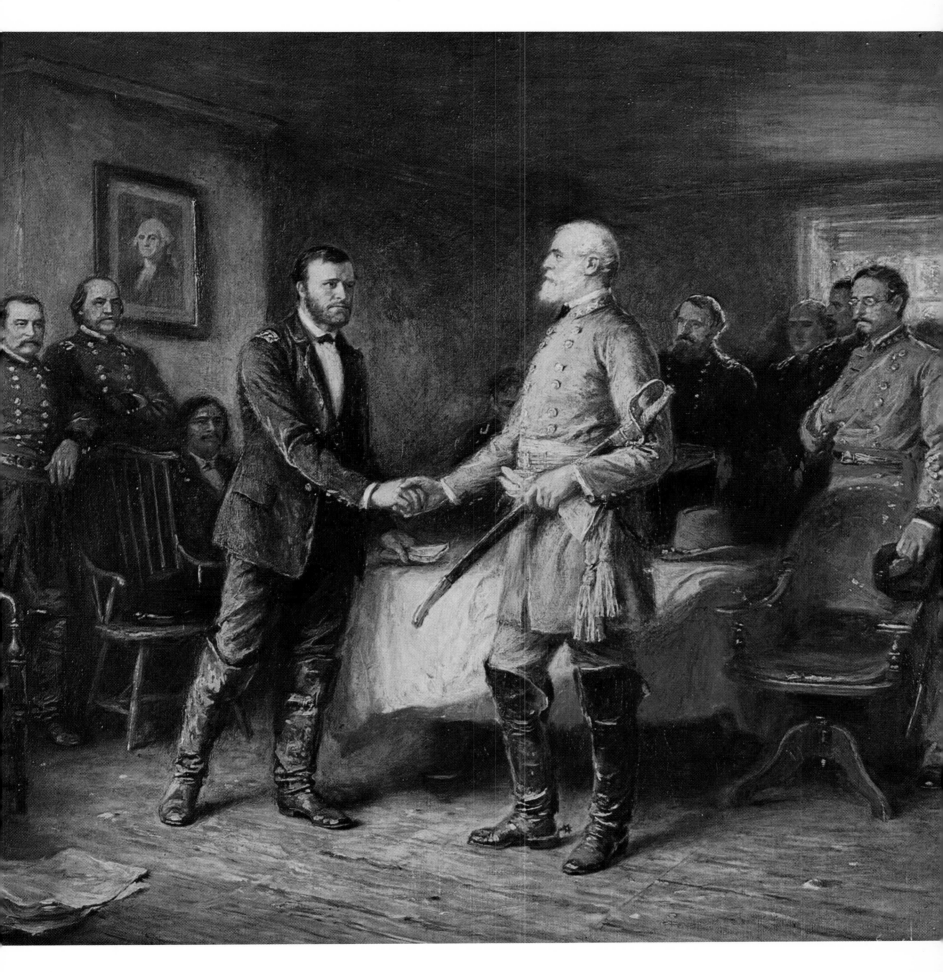

Let Us Have Peace

by J. L. G. Ferris

Forging the Shaft:

A Welding Heat

by JOHN FERGUSON WEIR

Courtesy of the Metropolitan Museum of Art, New York, N.Y.
Gift of Lyman G. Bloomingdale, 1901

The overwhelming manufacturing potential of the North doomed the agricultural South to defeat from the beginning of the Civil War. The demands of the war brought to the North a tremendous commercial and industrial boom as factories poured tons of armaments to the Federal armies in an ever increasing stream; iron foundries turned out cannon, mortars, iron for warships, locomotives, and rails in an industrial acceleration which accomplished in four years what would have taken normally a generation. The Industrial Revolution, born in England, found its fruition in the United States as machines rapidly replaced the handmade products, feeding the appetite of a fast-growing and ever advancing population. The scene illustrated in Weir's graphic painting, executed shortly after the war, served as but a prelude to the vast manufacturing complexes that followed to make this nation the industrial giant and producer for the world that it became.

Weir was one of the first painters of his day to depict the drama of the working man in action. He executed this painting, with its toiling figures reflected in the glow of the iron foundry at Cold Spring, New York, in 1867, and it is a powerful example of this artist's rare talent.

O!
SAY
CAN
YOU
SEE

121

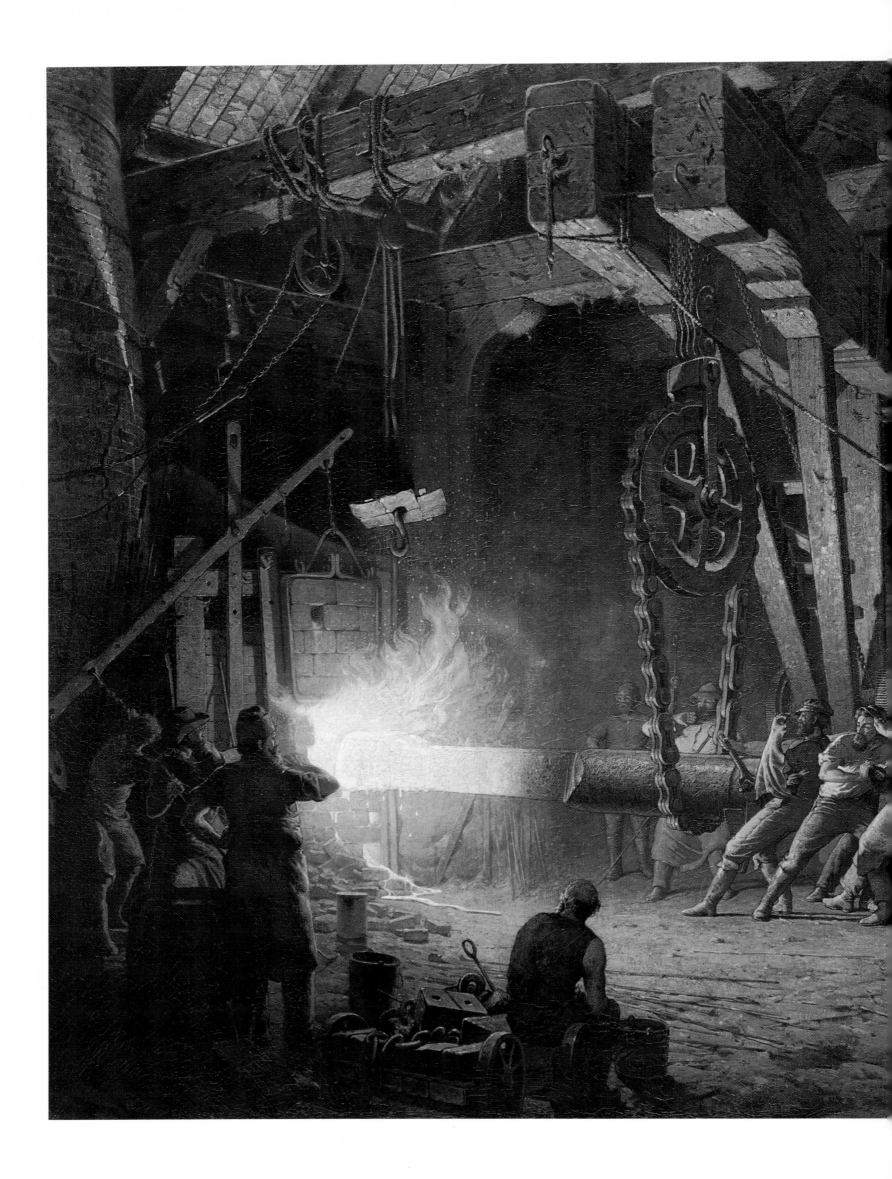

Forging the Shaft:
A Welding Heat

by John Ferguson Weir

The 9:45 a.m. Accommodation,

Stratford, Connecticut

by EDWARD L. HENRY

Courtesy of the Metropolitan Museum of Art, New York, N.Y. Bequest of Moses Tanenbaum, 1937

The first steam railroad in the United States, built by John Stevens, made its appearance in 1827. In 1830 only thirty-two miles of railroad served the nation; by 1860, 30,000 miles. Two years after Edward L. Henry painted this canvas in 1867, the Central Pacific and Union Pacific, joined by a golden spike, brought transcontinental rail travel to reality. The stagecoaches and the slow canal boats gave way to the steam locomotive. Fortunes were made by the railroad barons as building continued at a frantic pace. Quiet communities like this one of Stratford, Connecticut, came within easy reach of metropolitan cities, and the American people, their pace of life increasing in tempo, discovered their own country firsthand from the train window. Distances shrank; the railroads became the arteries that carried the nation's blood from coast to coast. Provincialism, once so jealously guarded, succumbed to the adventurous. Those seeking new horizons and opportunities boarded trains like the "9:45" across the nation to seek their fortunes in another place, another city, another state.

O!
SAY
CAN
YOU
SEE

The 9:45 a.m. Accommodation,
Stratford, Connecticut
by Edward L. Henry

The Stoic of the Plains

by CHARLES M. RUSSELL

Collection of C. R. Smith

The Indian of the western plains differed from his eastern cousin in
his mobility of movement—the result of his acquisition of the horse,
introduced into this hemisphere by the Spanish Conquistadores. As the
waves of white migration poured across the Mississippi and into the
western plains, the vast herds of buffalo, the Indian's chief staple for
sustenance and survival, fell to the settlers and hunters in fearful
numbers. With the settlers and prospectors came the Army, pressing
the red men relentlessly in upon government "reservations." The
Indian wars which flared up through the 1870s came inevitably as a
proud people found their hunting grounds wrested from them. The
Indians struck back in 1876 at the Little Big Horn, where the Sioux
wiped out Custer's command. The surrender of Sitting Bull in 1881
marked the virtual end to the red man's resistance, and the end of a
chapter in this nation's history in which Americans can take little pride.

Charles M. Russell, who knew and admired the Indian, wrote this
compassionate tribute in 1916: "The Redman was the true American.
They have almost gone, but will never be forgotten. The history of
how they fought for their country is written in blood, a stain that time
cannot grind out. Their God was the sun, their church all outdoors;
their only book was nature, and they knew all its pages." *

* Good Medicine: The Illustrated Letters of Charles M. Russell. Doubleday & Co., Inc.,
copyright 1929 by Nancy C. Russell.

The Stoic of the Plains
by Charles M. Russell

Among the perils of riding herd was the dreaded night stampede, sometimes, as in Remington's painting, set off by lightning. While the terrified longhorns lunge blindly through driving rain, a cowboy races along the flank of the herd attempting to turn the cattle and set them into a "mill" where they would race themselves to exhaustion in a circle. During such moments the cowboy's life depended upon the surefootedness of his cow pony.

Stampeded by Lightning

by FREDERIC REMINGTON

Courtesy of Thomas Gilcrease Institute of American History and Art, Tulsa, Oklahoma

The years following the Civil War witnessed the great cattle drives from southwestern Texas into Kansas, where the longhorns boarded trains for shipment to eastern markets. Other drives were made into Colorado and Montana. It was the era of the American cowboy, a rugged individualist who worked in the constant shadow of danger. The exciting days of the big cattle drives of the 1860s and 1870s soon passed into history, though, and the open range fell before the onrush of western migration; towns and cities mushroomed as tens of thousands of new settlers opened the West.

Theodore Roosevelt said of the cowboy, "We knew toil and hardship and hunger and thirst, and we saw men die violent deaths as they worked among the horses and cattle, or fought in evil feuds with one another; but we felt the beat of healthy life in our veins, and ours was the glory of work, and the joy of living." Despite his brief tenure on the stage of history, the cowboy became the most enduring of all American character types, perpetuated in song and story, romanticized by Hollywood and television.

O!
SAY
CAN
YOU
SEE

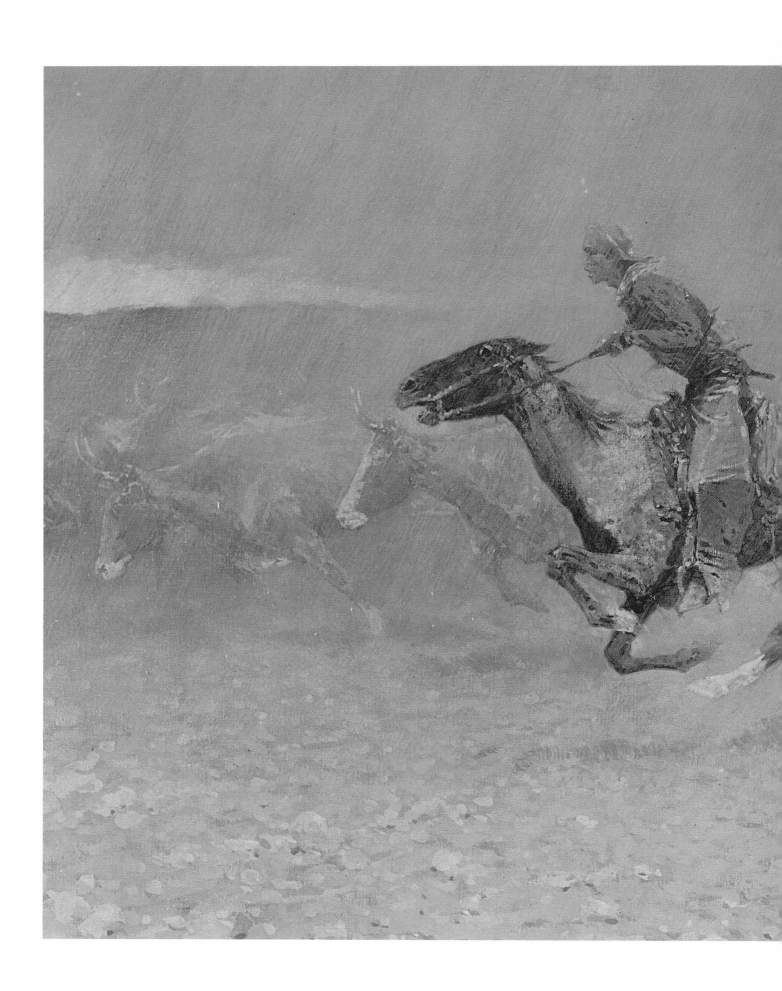

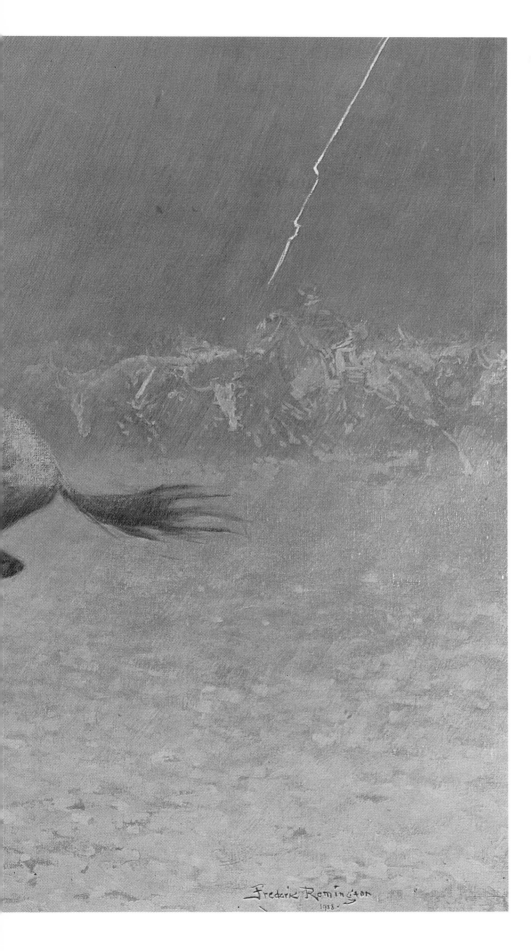

*Stampeded by
Lightning*
by Frederic Remington

The Country

In this picture, painted by Homer in 1871, the young school ma'am, her sunbonnet hanging above the blackboard, surveys her domain with assurance and authority while her small charges probably squirm impatiently waiting for her school bell to announce recess or the end of the school day. The country school house was a favorite theme of Homer's, and he portrayed this passing picture of American life with a sympathetic eye and heart.

The years following the Civil War saw the emergence of the "school ma'am" as contrasted with the dwindling numbers of schoolmasters who previously dominated the American educational scene prior to the war. The one-room schoolhouse, where all classes occupied the single room, must have taxed the most dedicated teacher, but from such simple beginnings came future leaders of industry, statesmen, and Presidents, all well versed in "readin', writin', and 'rithmetic" before going on to higher education. By 1870 over 122,000 such female teachers taught in the "common schools."

School

by WINSLOW HOMER

Courtesy of the City Art Museum of St. Louis, St. Louis, Missouri

O!
SAY
CAN
YOU
SEE

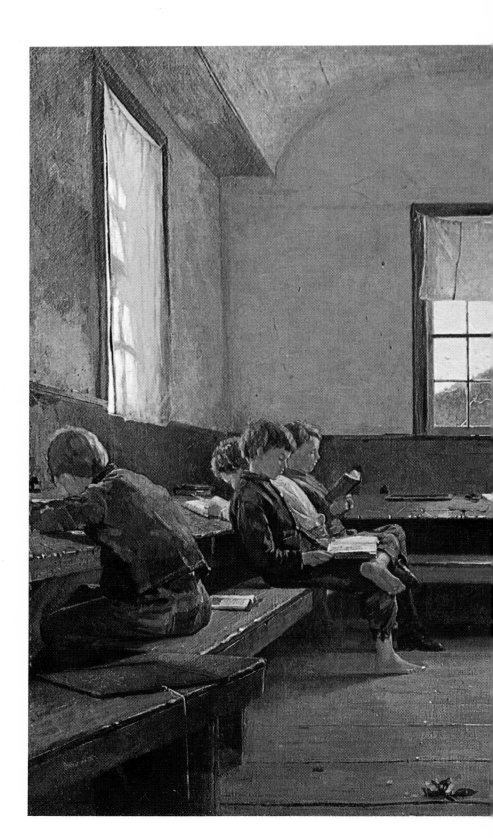

The Country School
by Winslow Homer

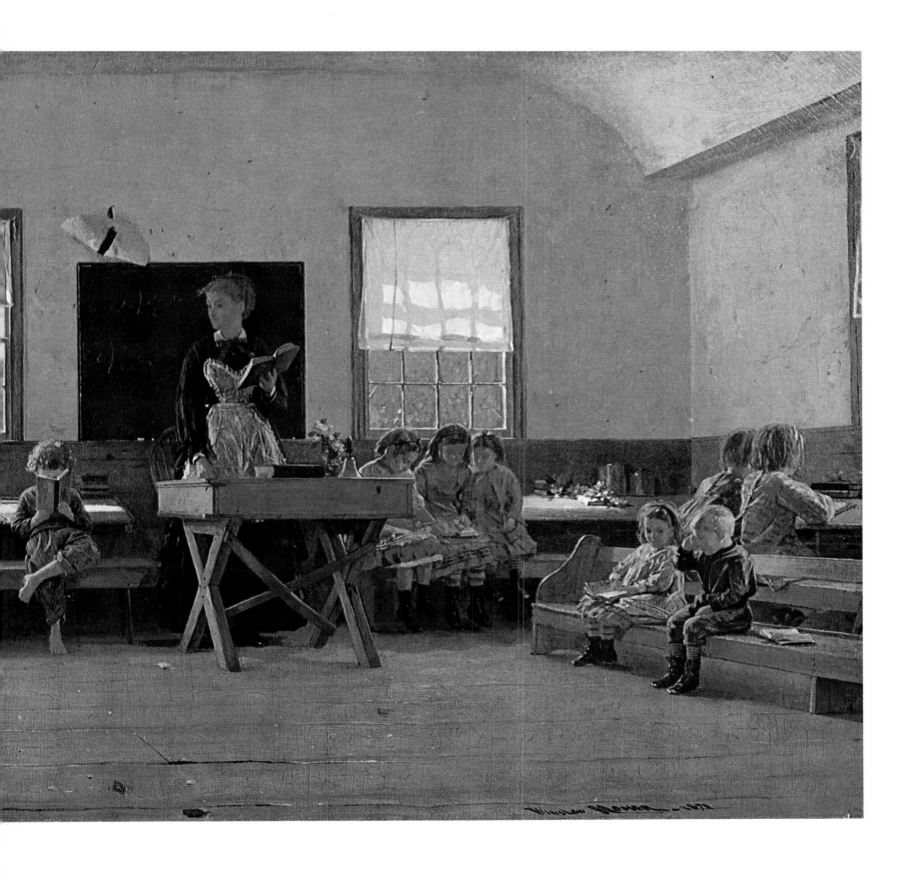

Thomas Edison's Greatest Invention

by DEAN CORNWELL

Courtesy the General Electric Company, Nela Park, Ohio

Dean Cornwell's painting depicts the preparation of the first successful incandescent lamp for its life test on the second floor of Edison's laboratory at Menlo Park, on the evening of October 19, 1879. Edison, with wire, is driving out the last of the gases occluded on the filament surfaces, with current from a battery. Francis Juhl renews the supply of mercury in the reservoir of the Sprengel pump. Others of Edison's aides here shown include Francis R. Upton, Charles Batchelor, John Kruesi, Martin Force, and Ludwig Boehm. This original painting now hangs in the Lighting Institute at Nela Park, headquarters of General Electric's Lamp Division, Cleveland, Ohio.

On October 21, 1879, Thomas Alva Edison, at his laboratory at Menlo Park, New Jersey, activated his first incandescent lamp. The bulb glowed for forty hours, producing the light of a dozen candles. The achievement came as a result of hard and persistent work and thousands of unsuccessful experiments. Edison vacuum-sealed a carbonized thread in a glass bulb and, passing an electric current through the carbon filament, produced the first practical electric light. The following year, after a worldwide search, he found that Japanese bamboo made a better and longer-burning carbon filament. In 1882 Edison opened the first commercial central station on Pearl Street, New York City, the beginning of the electric light system in America, and by 1900 his incandescent lamps enjoyed wide use. Bamboo was replaced some years later by the more efficient ductile tungsten, developed by Dr. W. D. Coolidge of General Electric Laboratories. Edison did not invent the electric light; others, both Britons and Americans, had experimented with workable incandescent lamps before him, but Edison first perfected a lamp that was commercially practical. "The Wizard of Menlo Park" previously invented the phonograph in 1878, and went on to develop the motion picture; but his greatest invention of the 1,093 he patented in his lifetime, was the electric light.

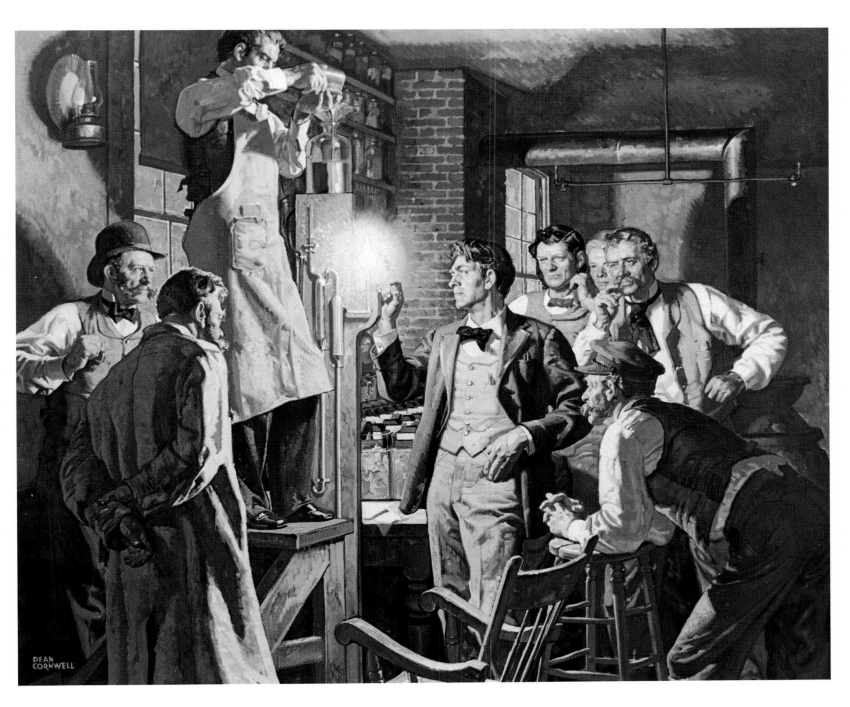

Thomas Edison's Greatest Invention
by Dean Cornwell

The Statue of Liberty Unveiling

by EDWARD MORAN

Courtesy of the Museum of the City of New York, New York, N.Y.

To the accompaniment of the din of a noisy water pageant, the Statue of Liberty ("Liberty Enlightening the World") was unveiled in New York Harbor on October 28, 1886. Sheets of hammered copper formed the gigantic statue, the work of Frédéric Auguste Bartholdi. He completed it in Paris in 1884 as a gift from France to the United States. Including her pedestal, she stood 305 feet over Bedloe's Island. President Grover Cleveland witnessed the unveiling along with John Philip Sousa's Marine Band.

Emma Lazarus of New York penned the famous words engraved at the base of the statue:

> Give me your tired, your poor,
> Your huddled masses,
> Yearning to be free,
> The wretched refuse of your teeming shore.
> Send these, the homeless,
> Tempest-tossed to me;
> I lift my lamp beside the golden door.

In the years to come, that upraised lamp, a beacon of hope and opportunity in America, welcomed and continues to welcome millions of immigrants from Europe.

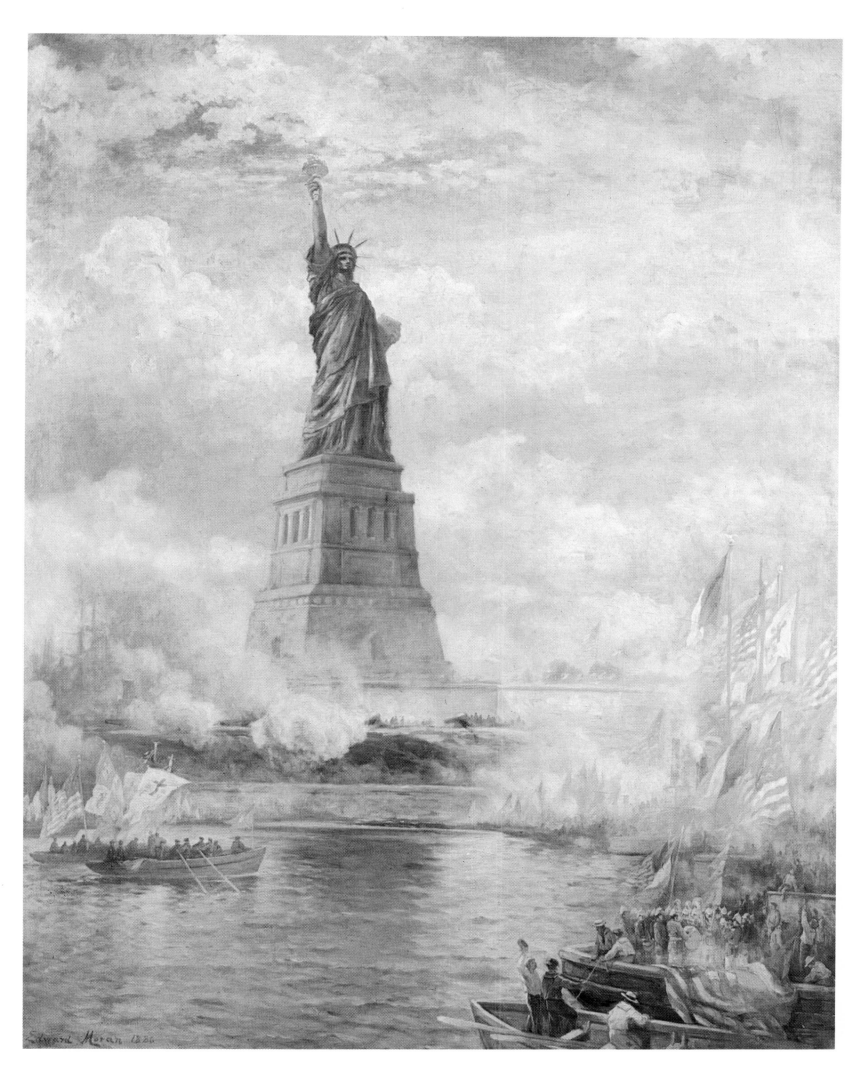

The Statue of Liberty Unveiling

by Edward Moran

Charge of the Rough Riders Up San Juan Hill

(detail) by FREDERIC REMINGTON

Courtesy Remington Art Memorial, Ogdensburg, New York

Secretary of War John Hay called it "the splendid little war." The sinking of the U.S.S. *Maine* in the harbor of Havana, Cuba in 1898 precipitated the Spanish-American War, a crusade to drive Spain from its lonely foothold in Cuba and the Philippines. "Rough Riders" became the nickname of the 1st United States Volunteer Cavalry Regiment, commanded by Colonel Leonard Wood and Lieutenant Colonel Theodore Roosevelt, who resigned as Assistant Secretary of the Navy to assist in recruiting the unit. When Wood won promotion to brigadier general, Roosevelt succeeded him in command of the Rough Riders. In the first important land offensive of the war in Cuba, Roosevelt led the unit in a charge up San Juan Hill on July 1, 1898, seizing the Spanish fortifications and opening the way to the capture of Santiago fifteen days later. The charge at San Juan Hill established Roosevelt as a national hero. In 1901 as Vice President of the United States, he succeeded to the Presidency after the assassination of William McKinley.

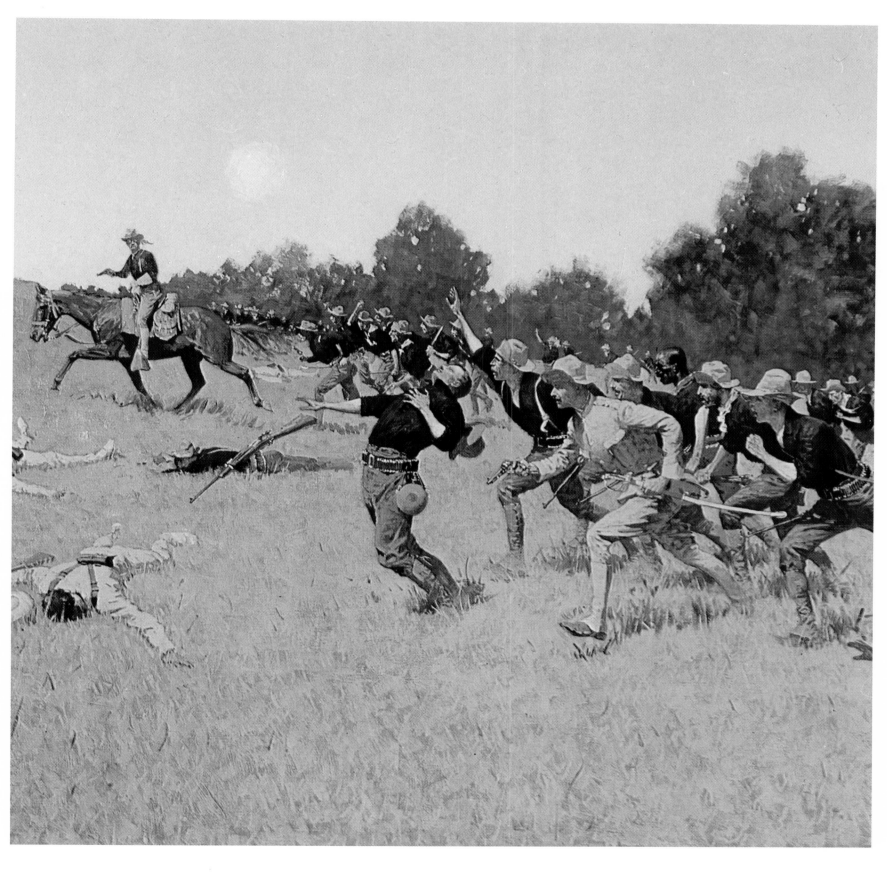

Charge of the Rough Riders up San Juan Hill (detail)
by Frederic Remington

Allies' Day, May 1917

by CHILDE HASSAM

Courtesy of the National Gallery of Art, Washington, D.C.;

Gift of Miss Ethelyn McKinney

in memory of her brother, Glenn Ford McKinney

Childe Hassam's painting, done a month following America's entry into war, illustrates the fervor of Allied unity with the display of French, British, and American flags along Fifth Avenue. The church is the fashionable St. Thomas Episcopal at 53d St. The Gotham Hotel is the tall building in the background.

When the great European war began in August 1914, President Woodrow Wilson issued a proclamation of neutrality urging the American people to be impartial in thoughts and acts. Germany's initial invasion of neutral Belgium and the sinking of the *Lusitania* in 1915 with the loss of 1,153 persons, 114 of them Americans, made neutrality, in thought at least, difficult for the average American. In 1916 Wilson won re-election on the slogan, "He kept us out of war!" but Germany's policy of unrestricted submarine warfare finally thrust the United States into World War I. Wilson's war message to Congress on April 2, 1917 was followed by Congress' declaration of war on the Central Powers four days later. Fifth Avenue in New York City, renamed "Avenue of the Allies" upon U.S. entry into the conflict, presented a colorful display of flags.

Allies' Day, May 1917
by Childe Hassam

The spirit in which the United States entered World War I was eloquently stated by President Wilson: "We fight," he said, "for the rights of nations great and small and the privilege of men everywhere to choose their way of life and obedience. The world must be made safe for democracy. . . ." The nation tooled and mobilized for war, and the American Expeditionary Force, commanded by General John J. Pershing, began pouring into French and English ports. First blooded at Catigny and Château-Thierry in May 1918, the American "doughboy," fighting alongside his French allies, helped stem the German offensive at the Marne. Allied advances in the hard-fought Meuse-Argonne Campaign during September and October rolled back the Kaiser's war machine, and on November 11 forced him to an armistice. The United States began the war with an army of some 55,000; it finished with 4,000,000 troops under arms. Over fifty thousand Americans died in combat in a war that America fought unselfishly—not for territory or power—but for an ideal. She entered the war in time to be the deciding factor in its outcome. "The war to end all wars" had been won, the Treaty of Versailles in 1919 duly signed, and the seeds of a second world war already planted.

The
Prisoner

Harvey Dunn's painting, based upon personal experience while a combat artist, shows a doughboy patrol bringing a German prisoner in for questioning through the rubble of a French village on the Western front.

(detail) by HARVEY DUNN

Courtesy of the Smithsonian Institution, Washington, D.C.

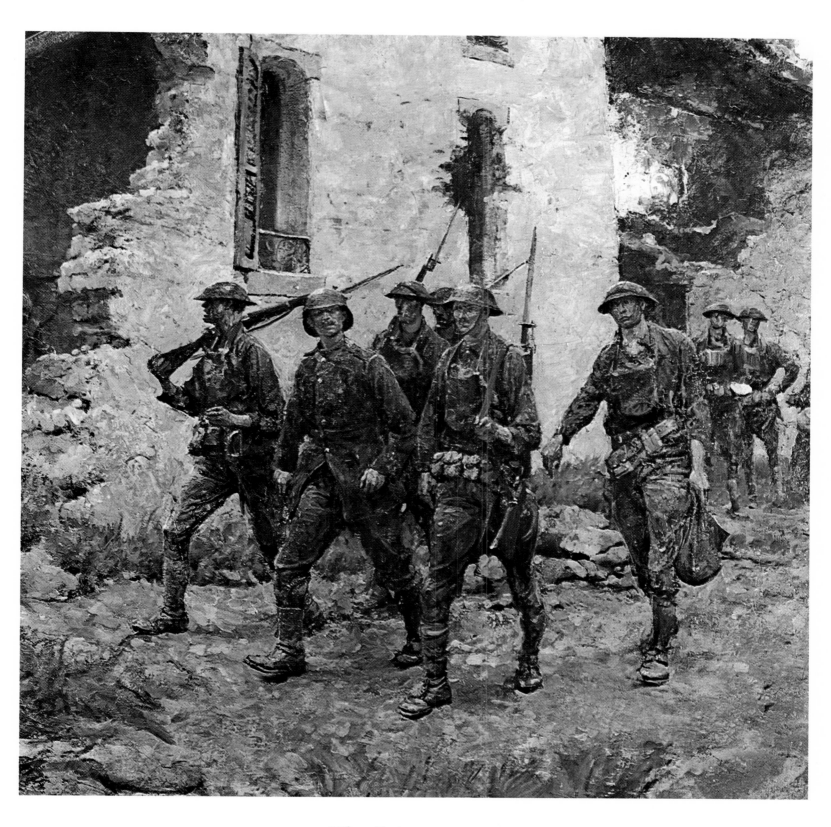

The Prisoner (detail)

by Harvey Dunn

Bellows' painting is a penetrating insight into the torments of the big American city on a summer day in the early 1900s when the streets stood crowded with vendors and the bustling activity of neighborhood life.

The Cliff Dwellers

by GEORGE BELLOWS

Courtesy of the Los Angeles County Museum of Art, Los Angeles, California

When Bellows painted this crowded tenement neighborhood in New York in 1913, the principal "cliff dwellers" came from the newly arrived European immigrants. The Irish, Italian, and Jewish quarters of the big American cities formed well-defined pockets of diverse ethnic cultures. Slowly the mainstream of American life absorbed them, and as they prospered they moved on. Today the white immigrant and his progeny have, in large part, vacated the city slums; the southern Negro and the Puerto Rican have replaced him. The city "ghettoes" have come full circle, and today their problems tax the skill and resources of both local and federal government.

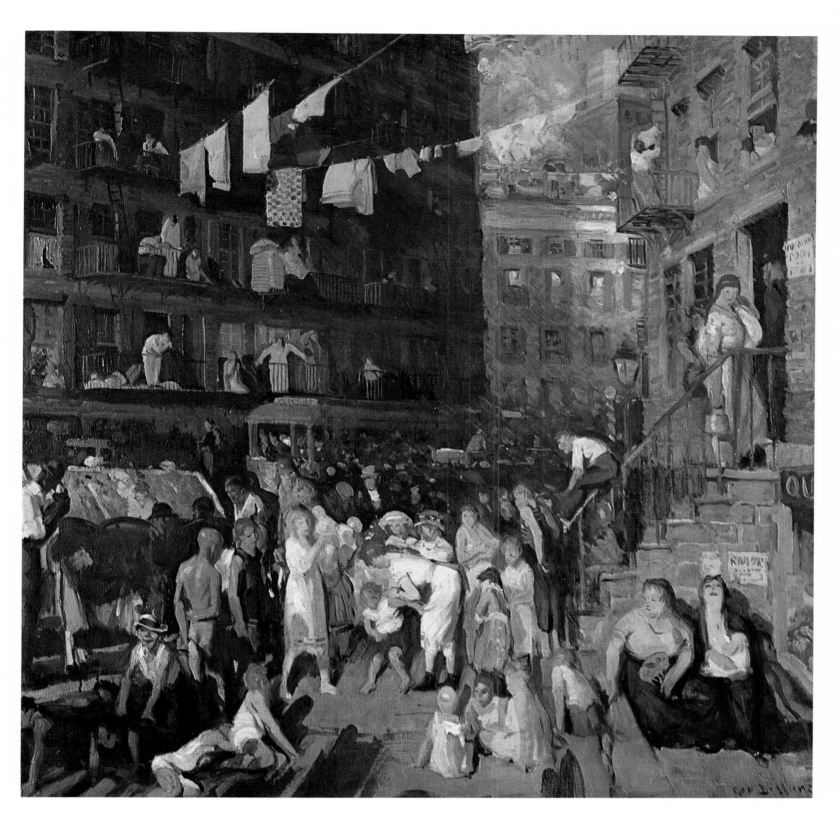

The Cliff Dwellers
by George Bellows

Attack on
Pearl Harbor,

Commander Coale's painting of the attack on Pearl Harbor shows "Battleship Row" in the right background where smoke and flame engulf battleships Oklahoma, Tennessee, West Virginia, and Arizona. In the foreground the minelayer Oglala capsizes, and to the left the battleship Nevada attempts to escape from the harbor as Japanese bombs straddle her midships.

December 7, 1941

(detail) by COMMANDER GRIFFITH BAILY COALE

Courtesy of the United States Navy and Marine Corps Exhibit Center, Navy Yard, Washington, D.C.

On Sunday morning, December 7, 1941, six carriers of a Japanese task force launched 360 planes against the United States Pacific Fleet at Pearl Harbor, Hawaii. The initial surprise attack devastated the airfields, and Japanese dive bombers struck at "Battleship Row," sinking four battleships and three destroyers, damaging four more battleships and three cruisers. American deaths numbered 2,343. In an emergency joint session of Congress on Monday President Franklin D. Roosevelt announced: "Yesterday, December 7, 1941—a date that will live in infamy—the United States of America was suddenly and deliberately attacked."

The United States and Great Britain declared war on the Empire of Japan that same day (December 8) and three days later Congress declared war on Japan's Axis partners, Germany and Italy. A bloody four-year naval and island-hopping war in the Pacific followed as American land, sea, and air forces moved ever closer to the Japanese mainland, and our bombers smashed at the Japanese islands. Names like Corregidor, Guadalcanal, Tarawa, Iwo Jima, and the Battles of Midway, Coral Sea, Leyte Gulf, written in blood, became etched forever in the memories of the men who fought in that great conflict.

O!
SAY
CAN
YOU
SEE

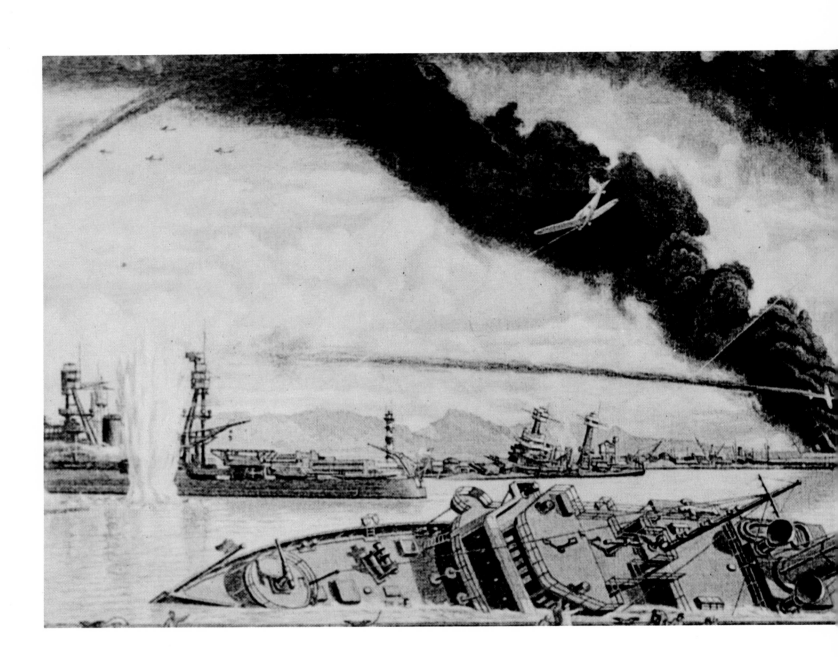

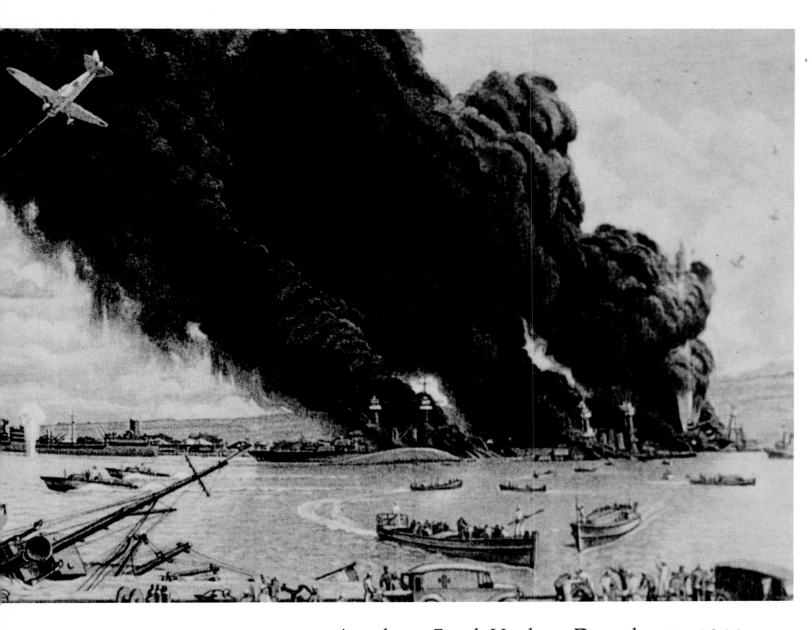

Attack on Pearl Harbor, December 7, 1941 (detail)
by Commander Griffith Baily Coale

Tank Breakthrough at St. Lô

(detail) by OGDEN PLEISSNER

Courtesy Civic Center Commission, Detroit, Michigan

On June 6, 1944 the combined Allied armies commanded by General Dwight D. Eisenhower struck the French beaches of Hitler's "Fortress Europe" in the world's mightiest amphibious assault. The beachheads secured, the Americans fought their way inland through the hedgerows of Normandy against stubborn German resistance. Artist Pleissner writes: "St. Lô, a strategic rail center fiercely defended by German paratroopers, corked up the Normandy bottleneck for almost two months. On July 25, 1944 the combined strength of the Eighth and Ninth Air Forces, numbering 3,000 planes, fell on this town. After one of the most terrific bombing operations of the war, our ground forces pushed through the German lines and swept across France." Paris fell to the Allied forces one month later, and the race to the Rhine began. A winter of heavy fighting on the Western and Eastern fronts ensued. The war finally ended with Hitler's death in his Berlin bunker, and Germany's unconditional surrender at Rheims on May 7, 1945. After VE Day America threw its full power against the Empire of Japan.

The artist wrote of this picture: "I went into St. Lô immediately after it was taken, and this painting depicts the Sherman tanks of the First Army moving through the dust and rubble of the once prosperous Norman city. . . . St. Lô goes down in history as a great battlefield."

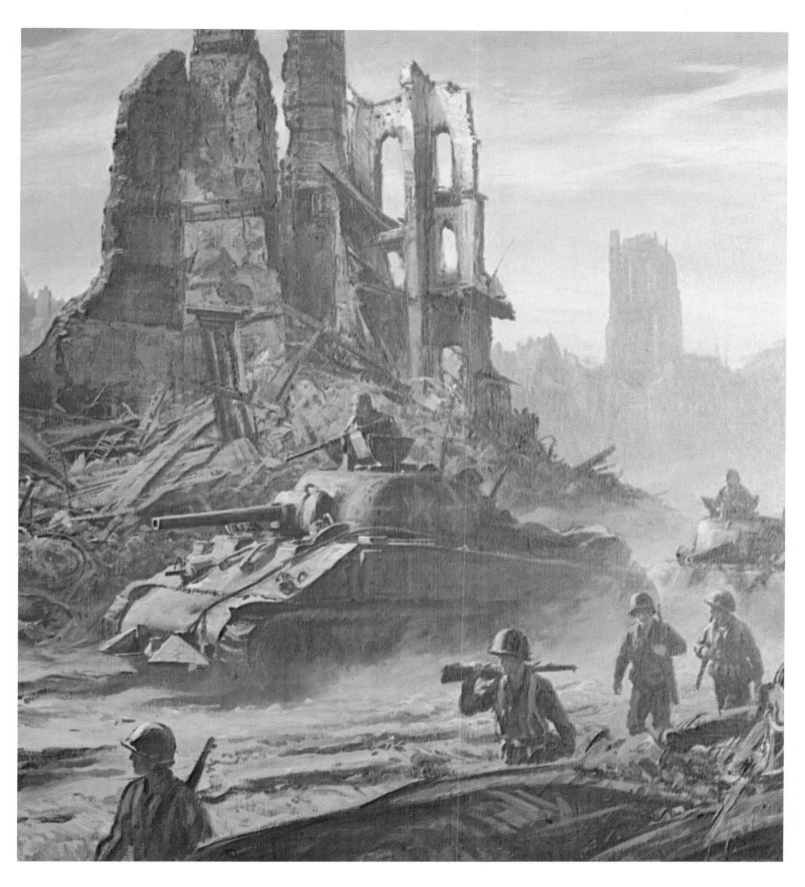

Tank Breakthrough at St. Lô (detail)
by Ogden Pleissner

MacArthur the Receiving Japanese Surrender

(detail) by C. C. BEALL

Courtesy of the artist

World War II comes to an official end with the formal surrender ceremonies aboard the battleship U.S.S. *Missouri* in Tokyo Bay, September 2, 1945. It ended with stunning suddenness: An atomic bomb devastated Hiroshima on August 6; three days later Nagasaki suffered the same fate, and Emperor Hirohito agreed to surrender on August 14. Now, after forty-six long and bloody months of war in the Pacific, General Douglas MacArthur receives the surrender of Japan. The artist, C. C. Beall, who witnessed the surrender, wrote: "It was a gray day. But, the moment MacArthur said, 'These proceedings are at an end,' the sun came out and thousands of Allied planes flew over the *Missouri* dappling the deck with their shadows."

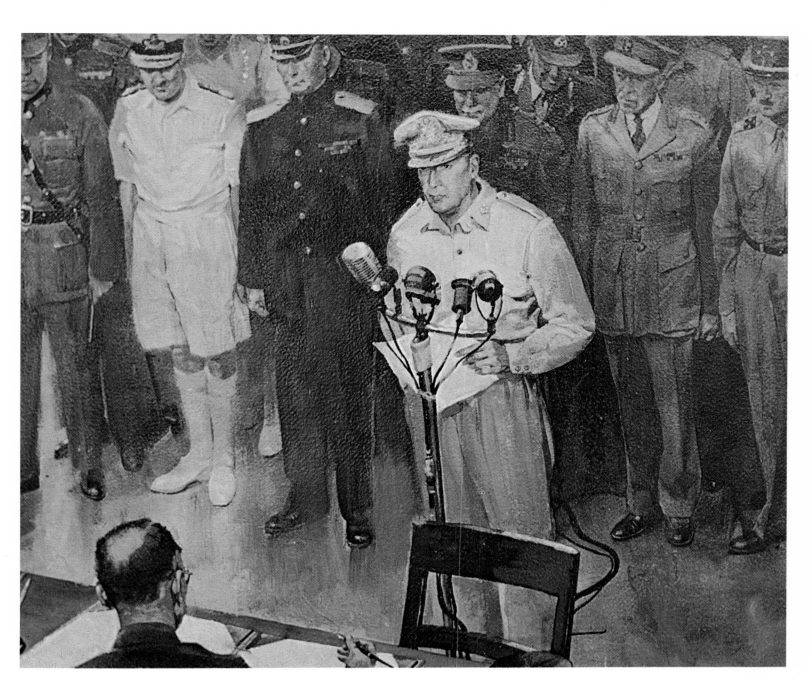

MacArthur Receiving the Japanese Surrender (detail)
by C. C. Beall

The Eagle Has Landed

by CLIFF YOUNG

Painted expressly for the National Historical Society

In 1903 the Wright brothers flew their first airplane at Kitty Hawk, North Carolina. Just fifty-nine years later, in February 1962, John Glenn became the first American to orbit the Earth. A steady succession of successful orbital flights by American astronauts followed his pioneering space flight.

On July 16, 1969, a giant Saturn rocket blasted off from Cape Kennedy Space Center carrying three astronauts—Neil Armstrong, Michael Collins, and Edwin Aldrin—on the historic flight of Apollo 11 to the moon. Four days later Apollo 11 went into orbit around the moon, following the trail blazed by Apollo 10 two months before. Armstrong and Aldrin separated from their spacecraft, *Columbia,* and in the lunar module *Eagle* descended upon the moon. Armstrong's voice was heard at NASA's Manned Spacecraft Center near Houston, Texas: "Houston, Tranquillity Base here. The Eagle has landed." The time was 4:17 p.m. EST, July 20. Armstrong, in his bulky spacesuit, emerged from *Eagle* to become the first man to step upon the moon's surface. "That's one small step for a man, one giant step for mankind," said Armstrong as he stepped from the module's ladder. Hundreds of millions of people on Earth watched on television and heard his words by radio. Aldrin soon followed Armstrong from the module. They planted the American flag on the lunar surface, collected moon rocks, erected a plaque, and received the congratulations of President Richard M. Nixon by radio. A seismometer and a laser reflector were left behind as the astronauts returned to *Eagle* after spending two hours and thirty-one minutes on the lunar surface. *Eagle* then blasted off, returning smoothly to moon orbit and linking up with the orbiting *Columbia,* with Collins at the controls. They accomplished perfectly the sixty-hour return trip to Earth, and the Apollo spacecraft splashed down in the Pacific in the early morning hours of July 24, nine miles from the spot where the U.S.S. *Hornet* with President Nixon aboard waited to recover both spacecraft and astronauts. President John F. Kennedy's commitment in 1961 to put a man on the moon and return him safely to earth before the end of the decade had been fulfilled.

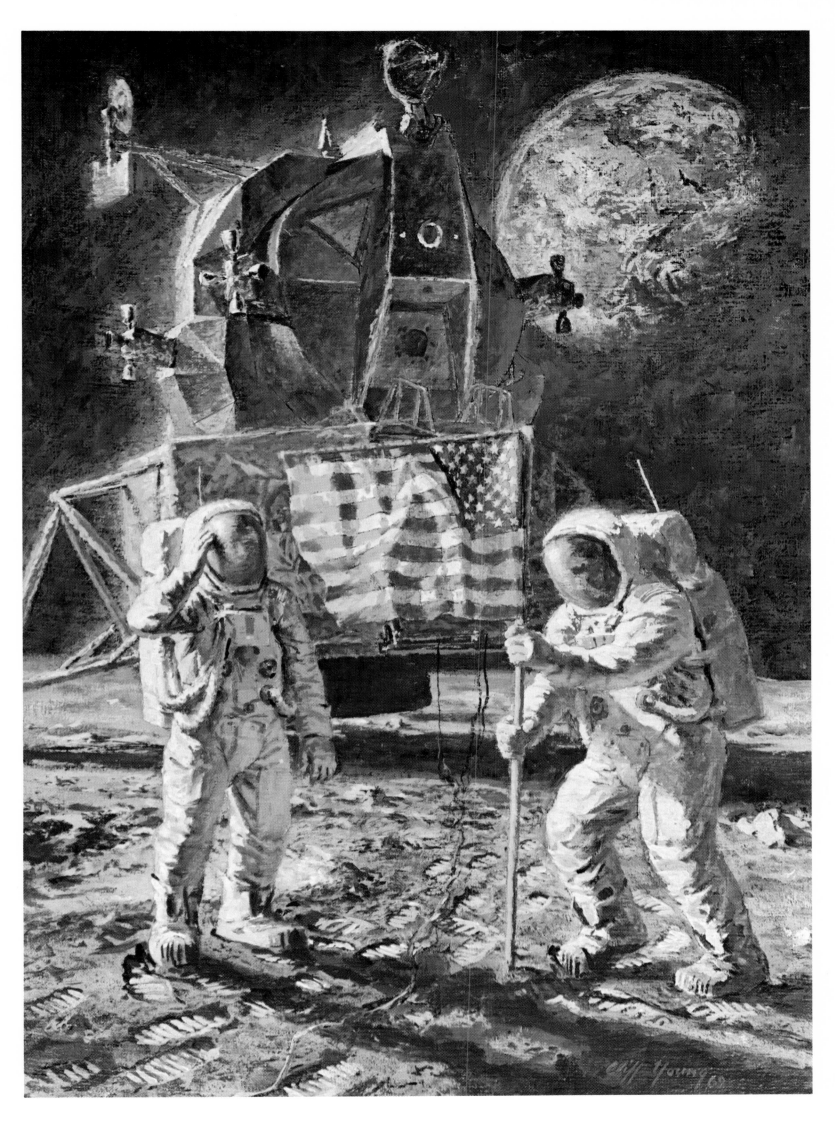

The Eagle Has Landed
by Cliff Young

Biographies of

the Painters

Edwin A. Abbey

Edwin Austin Abbey was born in Philadelphia in 1852. He studied at the Pennsylvania Academy of the Fine Arts. He matured early as a gifted illustrator, and was engaged by Harper and Brothers in 1871 at the age of nineteen. While working for Harpers in New York, Abbey was one of a talented fraternity of illustrators which included A. B. Frost, C. S. Reinhart, and Howard Pyle. In 1878 he established a studio in England. His work, now wholly devoted to English poetry and drama, consistently appeared in *Harper's New Monthly Magazine* in the years prior to the turn of the century. Abbey won international fame as a historical painter and illustrator of the works of Shakespeare. His first picture at the Royal Academy, "A May Day Morning," was exhibited in 1890. Other notable paintings were "Fiammetta's Song," "Richard III and Lady Anne," "The Trial of Queen Katherine," and "The Penance of Eleanor." Among his illustrated editions were *Herrick's Poems, She Stoops to Conquer, Old Songs,* and *Comedies of Shakespeare.*

Among Abbey's finest mural paintings are those he was commissioned to do for the new Pennsylvania State Capitol in Harrisburg; "Von Steuben at Valley Forge" is a fine example. He died in London in 1911 shortly after completing this commission.

Edwin Austin Abbey. *Dictionary of American Portraits,* Dover Publications, Inc., 1967.

Stanley M. Arthurs in his (Pyle's) studio.
Courtesy Wilmington Institute Free Library, Wilmington, Del.

Stanley M. Arthurs

Stanley M. Arthurs was born in Wilmington, Delaware in 1877. He was one of Howard Pyle's most distinguished students, and devoted himself primarily to American historical subjects. In 1900 Harper and Brothers published the first of his illustrations. Of all Pyle's students, Arthurs probably carried on the Pyle tradition most faithfully, combining careful research with rare ability to recreate the essence of America's past. N. C. Wyeth described him as "the truest torch bearer of the splendid Pyle traditions." Many of Arthurs' paintings may be found in such books as James Truslow Adams' *History of the United States,* the fifteen-volume *Pageant of America,* and the Elmwood Edition of the *Bigelow Papers.* The best of his historical canvasses were collected in *The American Historical Scene,* published by University of Pennsylvania Press in 1936. Arthurs also executed murals for Delaware College, the State Capitol in Dover ("Delaware Troops Leaving Dover"), and the Minnesota State Capitol ("The Occupation of Little Rock"). After Pyle's death Arthurs occupied his teacher's studio in Wilmington, where he painted for the remainder of his life amid surroundings both nostalgic and inspirational. He died in Wilmington in 1950.

C. C. Beall

Cecil Calvert Beall was born in Saratoga, Wyoming in 1892. He studied with George Bridgeman at the Art Students' League and Pratt Institute in New York. During World War I he was made Division Artist while serving in France, and accompanied John Singer Sargent on a battlefield painting expedition while Sargent was guest of the division.

After the war Beall's illustrations appeared in many leading periodicals, especially *Collier's.* In 1936 President Franklin D. Roosevelt appointed him art director for the National Democratic Committee after having seen a composite portrait of himself painted by Beall as a *Collier's* cover.

During World War II, Beall as a war correspondent produced portraits of military heroes for *Collier's,* and was aboard the USS *Missouri* in Tokyo Bay to witness the surrender ceremonies. President Harry Truman made his picture of the event the official surrender painting. He produced over fifty portraits for *Reader's Digest* as well as many covers for them and other well-known magazines.

As a member of the Society of Illustrators, New York, Mr. Beall was presented with their Award of Excellence in 1961. He is also a member of the American Water Color Society, Overseas Press Club, and the Salmagundi Club, New York.

Paintings by Mr. Beall are owned by the Air Force Academy Museum, Colorado Springs, Colorado; the Marine Museum, Quantico, Virginia; Kennedy Gallery, New York; Museum of Norfolk, Virginia; Museum of Birmingham; Permanent Collection, Society of Illustrators; and the Museum of San Antonio. He has had many one-man exhibitions in prominent galleries, clubs, and colleges.

C. C. Beall. Courtesy of the artist.

George W. Bellows (self-portrait).
Courtesy Library of Congress.

George Bellows

George Wesley Bellows was born in Columbus, Ohio in 1882, and attended Ohio State University. He left school in his senior year to study art under Robert Henri in New York. He won first prize in 1908 at the National Academy of Design, and was one of the youngest artists ever elected an Associate of the National Academy. He was the junior member of the revolutionary "Ash Can School" of American painters, which included Henri, William Glackens, and John Sloan. The athletic Bellows was famed for his robust pictures of prize fights, barrooms, working men, circuses, and revivalist meetings. By 1910 he was teaching at the Art Students' League in New York. Six years later he had become a prolific maker of lithographs, excelling in that medium. He died in 1925 at the early age of forty-three at the peak of his powers. Bellows' work hangs in many museums throughout the country, including the Metropolitan Museum of Art and the Whitney Museum of American Art in New York, the Buffalo Fine Arts Academy, the Cleveland Museum of Art, and the Los Angeles County Museum of Art.

George Caleb Bingham

George Caleb Bingham (self-portrait).
Courtesy School District, Kansas City, Mo.
Dictionary of American Portraits.

George Caleb Bingham was born in Augusta County, Virginia in 1808. In 1819 his father, a judge, moved his family to Franklin, Missouri. Young Bingham began painting portraits at twenty-one. Largely self-taught, he was strongly influenced by Chester Harding, the New York farm boy turned painter. His studies led him to the Pennsylvania Academy of the Fine Arts in Philadelphia in 1838, and in the 1840s he moved into a studio in the Capitol in Washington, where he painted a number of portraits of famous political leaders. Returning to Missouri in 1845 he turned to painting his now famous genre pictures of life along the Mississippi, such as "Fur Traders Descending the Missouri" (1845) and "Raftsmen Playing Cards" (1847).

Bingham gained national recognition for his work through the sale and distribution of his pictures by the American Art Union in New York. Elected to the Missouri State Legislature in 1846, he continued to make annual trips east to Philadelphia and New York, and in 1856 he went to Düsseldorf, Germany, then a center of a thriving and congenial school of artists. While there he lived near Emanuel Leutze, famous for his historical canvasses such as "Washington Crossing the Delaware." Bingham returned to America in 1859, served as an officer in the Union Army during the Civil War, and later became state treasurer and adjutant general of the state of Missouri. His paintings "The Verdict of the People" and "County Election" reflect his interest in politics. In 1877 the University of Missouri appointed him first professor of the new department of art, a position he held until his death in 1879.

Griffith Baily Coale

Griffith Baily Coale. Navy Department
photo in the National Archives.

Griffith Baily Coale was born in Baltimore in 1890. A graduate of Maryland Institute, he studied art abroad for three years. As a professional painter in Baltimore, he served as Marine Camoufleur E.F.C., U.S. Shipping Board, during World War I. Moving to New York in 1922, he produced many murals, portraits, and decorative paintings for public buildings including the New York Trust Company, New York Athletic Club, City Bank Farmer's Trust Company, Dry Dock Savings Institution, and the Home Office of the Metropolitan Life Insurance Company, to name a few. He was the first artist commissioned in the Navy's Combat Artists Corps; and in 1941, prior to the entry of the United States into World War II, he took part in convoy duty in the North Atlantic. His experiences during that period were recorded in his book, "North Atlantic Patrol." In 1942 Commander Coale went to Hawaii, where he painted the mural of the Japanese attack on Pearl Harbor. He was next assigned to the Southeast Asia Command under Admiral Lord Louis Mountbatten. His final work for the Navy was a mural portraying the Battle of Midway which now hangs in the Naval Academy Mess Hall at Annapolis. He retired from the Navy in 1947, and lived in New York City until his death in 1950.

Prior to his naval service, Commander Coale was president of the National Society of Mural Painters; secretary of the Board of Trustees, Marine Museum of the City of New York; and secretary of the Ship Model Society of New York.

Dean Cornwell

Dean Cornwell was born in Louisville, Kentucky in 1892. In 1911 he went to Chicago, where he studied at the Art Institute of Chicago and worked on the art staff of the *Chicago Tribune.* As one of Harvey Dunn's first students at Leonia, New Jersey in 1915, he was fortified in the Pyle tradition. A superb draftsman and tireless perfectionist, Cornwell was in great demand as a book and magazine illustrator from the First World War to the end of his life.

The Wilmington Society of Fine Arts in 1919 and 1921 awarded him first prize for illustration. He was president of the Society of Illustrators from 1922 to 1926, and also served as president of the National Society of Mural Painters. In 1951 he was awarded a gold medal by the Architectural League of New York. Above all, Cornwell was one of the nation's foremost mural painters; his work may be seen in the Eastern Airlines offices in Rockefeller Center; the Lincoln Memorial in Redlands, California; the Raleigh Room, Hotel Warwick, New York; and the Los Angeles Public Library. The latter mural took five years to paint. Containing nearly 300 figures of heroic size illustrating the history of California, it was begun in London in the studio of John Singer Sargent and finished in a specially built studio in Brooklyn.

Abroad Cornwell executed murals at the International Labor Office in Geneva; the Battle Monument at the American Cemetery in Neuville-en-Condroz, Belgium; and he assisted famed British muralist Frank Brangwyn in a series of murals in the King's Robing Room at the House of Lords, London. His series of paintings, "Pioneers in American Medicine" for John Wyeth & Brothers, were widely distributed throughout the country. A giant in his profession, Dean Cornwell died in 1960 in New York City.

Dean Cornwell. Courtesy Mrs. Dean Cornwell.

Clyde O. DeLand. Courtesy Free Library of Philadelphia.

Clyde O. DeLand

Clyde Osmer DeLand was born in Union City, Pennsylvania in 1872. He attended the University of Rochester and graduated from Drexel Institute, Philadelphia in 1898. He was an early pupil of Howard Pyle and became an avid student of American history. From 1897 he worked as an illustrator, chiefly of American historical subjects. Among his pictures are: "The First Steamboat," "The First Automobile," and "The First Street Railway" (Continental Insurance Company), and "The First American Flag" (City of Somerville, Massachusetts). Among the books he illustrated were: *The Count's Snuffbox* (Rivers), 1898; *Barnaby Lee* (John Bennett), 1902; *A Forest Hearth* (Major), 1903; *Mr. Kris Kringle* (Weir Mitchell), 1904; and *Captain Blood* (1923) and *The Carolinian* (1925), both by Raphael Sabatini. DeLand also lectured on "Drama of American History," using a stereopticon. He maintained his home and studio in Philadelphia, where he died in 1947.

Harvey Dunn

Harvey T. Dunn was born in Manchester, South Dakota in 1884. Reared on a farm, he left the plow to study art at the Art Institute of Chicago. In 1904 he went to Wilmington, Delaware to study under Howard Pyle for two years, and emerged as a successful book and magazine illustrator of rugged outdoor subjects, his illustrations appearing in such periodicals as *The Saturday Evening Post, Collier's,* and *Ladies' Home Journal.* In 1915, with Charles S. Chapman, he opened a school for illustration in Leonia, New Jersey, and became one of the foremost proponents of the Pyle teaching tradition. Among his famous students were Dean Cornwell, and later Harold Von Schmidt and Mario Cooper.

During World War I Dunn was commissioned a captain in the Army Engineer Reserve Corps, producing a powerful pictorial documentary of that conflict. Working in the trenches, he used a specially designed box with rollers to wind his finished sketches and unreel clean sheets of paper as needed. His paintings and drawings of the war are now owned by the Smithsonian Institution. He later carried on his teaching career at the Grand Central School of Art in New York City, his classes being attended by many fledgling illustrators who later became well known. Dunn was a member of the National Academy of Design, and held an honorary degree, Doctor of Fine Arts, conferred by South Dakota State College. During 1948–49 he was president of the Society of Illustrators. Dunn died in Tenafly, New Jersey, in 1952.

A collection of his pioneer subjects, based largely upon his own youth on the Dakota plains, are now displayed at South Dakota State College, Booklings, South Dakota. "I find," wrote Dunn, "that I prefer painting pictures of early South Dakota life to any other kind, which would seem to point to the fact that my search of other horizons has led me around to the first."

Harvey Dunn. Courtesy South Dakota State University.

J. L. G. Ferris

J. L. G. Ferris posing in his studio in front of his canvas,
"Painter and President, 1795," depicting Gilbert Stuart at work
on the famous Atheneum portrait of Washington. Courtesy William S. Ryder.

Jean Léon Gérôme Ferris was born in Philadelphia in 1863. His father, Stephen James Ferris, was a well-known painter and etcher; his mother was the sister of the noted painters, Edward, Thomas, and Peter Moran. Young Ferris began his studies in Philadelphia under his father, and with Christian Schussele, teacher of painting at the Pennsylvania Academy of the Fine Arts. In 1881 his father, a devotee of the French painter Gérôme and the Spanish artist Fortuny, took his son to Spain to study the works of the latter. Young Ferris entered the Academie Julian in Paris in 1884 to study under Bouruereau, who influenced him in the direction of historical painting. Studying in London and Madrid, he traveled through France, Spain, and Morocco, familiarizing himself with the history of the seventeenth century, always with the idea of producing a series of paintings dealing with his own country. Returning to America, he began in 1900 a series of some seventy historical paintings spanning the period from Columbus to World War I. Working from the palette used by Gilbert Stuart, he was especially devoted to pictures dealing with colonial Philadelphia and the life of Washington. In the course of his painstaking research he constructed meticulous models of ships, stagecoaches, and cannon to use as guides in the creation of his pictures.

Ferris' paintings appeared in a number of publications during the early twentieth century. *The Ladies' Home Journal* carried thirty of his paintings from 1917 to 1919; *The Literary Digest* reproduced fifty of his paintings as covers from 1928 to 1932.

"If," wrote Ferris, "through circumstances, one cannot be a great benefactor or leader of humanity, it is your painter's opinion that one's best resource is to become a recorder of great and noble deeds . . . with the thought that some may be led to emulate them."

J. L. G. Ferris died in Philadelphia in 1930. His series of historical paintings, once displayed in Independence Hall, are now owned by the Smithsonian Institution in Washington, D.C.

Childe Hassam

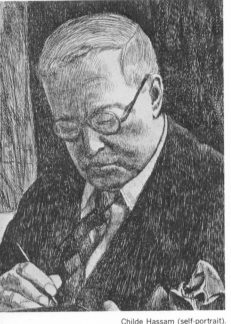

Childe Hassam (self-portrait).
Courtesy Library of Congress.

Frederick Childe Hassam was born in 1859 in Dorchester, Massachusetts. His early interest in painting led him to study at the Boston Art Club, and in 1883 he traveled to Europe. Returning to Boston, he married, and in 1886 he settled with his wife in Paris, where he came under the influence of the French Impressionists and exhibited at the Paris salons. He returned to the United States in 1889, establishing himself in New York, and continued a fruitful career as a painter and etcher in New York, Long Island, and New England. In 1898 he was elected to the National Institute of Arts and Letters, and in 1906 he became a member of the National Academy of Design. With several fellow artists he formed a group called the "Ten American Painters," promoting their works on American themes and exhibiting together in an annual "Salon." Between 1916 and 1919 he produced a series of about eighteen paintings representing New York City, especially Fifth Avenue, then called "Avenue of the Allies," which was profusely decorated with flags.

During his lifetime Hassam won almost every prize and honor available to him, and was elected to the American Academy of Arts and Letters in 1920. When he died in 1935, he bequeathed all the works remaining in his studio to the American Academy to be sold to create the Hassam Fund for the purchase of contemporary American and Canadian paintings. He is regarded as the foremost American impressionist.

Edward L. Henry

Edward Lamson Henry was born in Charleston, South Carolina in 1841. As a child he was taken to New York, and at the age of fourteen began to study art with Walter M. Oddie in that city. In 1858 he went to Philadelphia, studying at the Pennsylvania Academy of the Fine Arts, and pursued his studies in Paris in 1860 under Charles Gleyre and Gustave Corbet. After traveling in Italy he returned to the United States in 1863, sketching scenes of the Civil War along the James River in Virginia ("Westover Mansion"). He was elected to the National Academy in 1869, and settled in New York, where he executed his beautifully detailed historical and genre paintings. His painting, "The 9:45 A.M. Accommodation, Stratford, Connecticut," was done in 1867. Between 1871 and 1881 Henry made three more trips to Europe, sketching in France and England. A popular and successful painter, he received awards both in the United States and abroad. He died in Ellenville, New York in 1919.

Edward L. Henry. Courtesy Library of Congress.

Winslow Homer

Winslow Homer was born in Boston in 1836. At nineteen he was apprenticed to a Boston lithographer, graduating to free-lance illustration two years later. *Harper's Weekly* accepted his first works, and he moved to New York where he became *Harper's* best-known contributor. When the Civil War broke out he went to the front as a staff artist for *Harper's;* and his drawings, reproduced as woodcuts, appeared in profusion in that periodical throughout the war.

Homer's first important war painting, "Prisoners from the Front," appeared in 1866, and made his reputation as a painter, though he continued to work as an illustrator until he was forty. He painted for a short time in France in 1866, but his art retained a purely American look, the European school of painting having little apparent influence on him. His paintings of the country were the natural outgrowth of his love for the outdoors, and his pictures of life at summer resorts on the East Coast present an engaging record of fashionable American life in the 1860s and 1870s. "A Rainy Day in Camp" and "Country School" were both painted in 1871. In 1881 he went abroad a second time, painting water-colors in England and developing a love for the sea that was the turning point of his life. Upon his return to the United States he settled at Prout's Neck on the Maine coast, where he produced his famous pictures of the sea and the wilderness. Wintering in Nassau, Bermuda, and Florida in the late 1890s, he painted some of his finest watercolors. Homer died at Prout's Neck in 1910, the most vital and varied of our nineteenth-century American painters.

Winslow Homer. Courtesy Peter A. Juley & Son. *Dictionary of American Portraits.*

Eastman Johnson

Eastman Johnson was born in Lowell, Massachusetts in 1824 and grew up in Augusta, Maine, where his father was secretary of state. Apprenticed to a Boston lithographer at fifteen, he began to draw crayon portraits, and worked through the 1840s in New England and Washington, D.C. In 1849 he went to Düsseldorf to study with German-born American painter Emanuel Leutze, famous for his historical canvasses. He later painted in France, Italy, and at The Hague, where he was strongly influenced by studying the Dutch masters. Johnson painted for a short period in Paris with French genre painter Thomas Couture, and returned to the United States in 1855. At this time he painted his genre scenes of Southern Negro life and Indian life in the Great Lakes area. Elected to the National Academy in 1860, he worked during the summers at Nantucket, where he produced his best-known genre pictures. He died in New York in 1906.

Among Johnson's notable genre pictures are "The Kentucky Home," "Husking Bee," "The Stage Coach," and "The Pension Agent." He painted portraits of many notables of his day, including Presidents John Quincy Adams, Arthur, Cleveland, and Harrison; and Daniel Webster. He exhibited and received medals at Paris and London and at the Philadelphia Centennial, World's Columbian, and the Buffalo and Charleston Expositions. His works are owned by the Metropolitan Museum of Art and the Lennox Galleries, New York; the Corcoran Gallery, the White House, and the Treasury Building, Washington; the Capitol at Albany; the Knickerbocker, Century, and Union League Clubs, the Chamber of Commerce and the Board of Trade, New York.

Eastman Johnson. *Dictionary of American Portraits.*

W. H. D. Koerner

William Henry David Koerner was born in Germany in 1878, and emigrated with his family to Clinton, Iowa at the age of two. In 1896, young Koerner went to Chicago, where he studied at the Art Institute and worked for seven years as a newspaper staff artist with the *Chicago Tribune,* and went on to become art editor of *the Pilgrim,* a literary magazine in Battle Creek, Michigan.

In 1905 he entered into free-lance work in New York while studying under George Bridgeman at the Art Students' League, and was accepted in Howard Pyle's classes in Wilmington, where his fellow students included N. C. Wyeth, Harvey Dunn, Frank E. Schoonover, and Anton Otto Fischer. A prolific illustrator, he produced work for many major periodicals and books, but he is probably best known for his Western illustrations in the *Saturday Evening Post* during the 1920s and 1930s. Between the end of World War I and the Depression, the *Post* attained a weekly circulation of 3,100,000 copies, and was the country's most prestigious showcase for the illustrator. Spending many working summers in Montana, Koerner knew the West firsthand, and until his death at Interlaken, New Jersey in 1938, he was the foremost proponent of the best Western art traditions of Remington and Russell.

W. H. D. Koerner. Courtesy Ruth Koerner Oliver.

Edward Moran. *Dictionary of American Portraits.*

Edward Moran

Edward Moran was born in Lancashire, England in 1829. He emigrated to America at fifteen and settled in Philadelphia, where he plied his trade as a weaver before his artistic talents were discovered by landscape painter Paul Weber, under whom he studied—later developing his talents toward marine painting. His brothers, Peter and Thomas Moran, were artists of note, the latter famous for his Western scenes. From a modest beginning, living above a cigar store in Philadelphia, Moran in 1862 went to London to study at the renowned Royal Academy. His harvest years began upon his return to America, as commissions for his marine painting poured in. At the peak of his career he began, in 1885, his series of thirteen canvasses, the "Marine History of the United States." The series spanned the history of the United States from the landing of Leif Ericson to the Spanish-American War. He devoted the last years of his life to this project, and three years after his death in 1901 the series was exhibited in the Metropolitan Museum of Art, New York City. They are now on permanent display at the United States Naval Academy.

Samuel F. B. Morse

Samuel Finley Breese Morse was born in Charlestown, Massachusetts in 1791. Upon his graduation from Yale in 1810 he went to London, where for four years he studied painting with the American artists Washington Allston and Benjamin West. His work was favorably received and was exhibited at the Royal Academy. Returning to the United States in 1815, he traveled through New England as an itinerant portrait painter, spending the winters in Charleston, South Carolina (1818–21). His painting "The Old House of Representatives" was executed in 1822. Morse took the picture on tour, hoping to stabilize his shaky financial position with the proceeds from paid admissions. Lack of public interest, however, only contributed to Morse's gradual abandonment of painting to devote himself to scientific work. Finally settling in New York City in 1823, he received two years later the important commission to paint a full-length portrait of Lafayette for the City of New York. A founder of the National Academy of Design in 1826, he served as president of that organization until 1845 and again in 1861–62. Despondent over the deaths of his wife, father, and mother, Morse returned to Europe, painting and traveling in Italy and France from 1828 to 1831. Back in New York, he began to devote more and more time to electrical experiments which led to his invention of the telegraph, first demonstrated to Congress in May 1844, when he sent his famous "What hath God wrought" message from Washington to his associate, Alfred Vail, in Baltimore. He had ceased painting altogether by 1837, devoting all of his time to perfecting the invention which eventually brought him world-wide fame and honors. He continued his interest in the arts, however, participating in the formation of the Metropolitan Museum of Art and serving as its vice president during the last year of his life. Morse died in New York in 1872.

Samuel F. B. Morse. *Dictionary of American Portraits.*

Charles C. Nahl

Charles Christian Nahl was born in Cassel, Germany, in 1818. Migrating to America in 1849, he went to California a year later, worked in the gold fields, and then resumed his career as an artitst in San Francisco. While working with his brother, Hugo, as a photographer and commercial artist painting historical subjects, he obtained the patronage of Judge E. B. Crocker in 1867, and was commissioned to paint several large canvasses of California pioneer life, fine examples of which are "Sunday Morning in the Mines," painted in 1872, and "Fandango"—both of which hang today in the E. B. Crocker Art Gallery in San Francisco. Nahl died in 1878.

Charles C. Nahl. Courtesy E. B. Crocker Art Gallery, Sacramento, Calif.

Charles Willson Peale

Charles Willson Peale was born in Queen Anne's County, Maryland in 1741. He was strongly influenced on a trip to Boston by the works of portrait painter John Singleton Copley; and after studying under Benjamin West in London (1767), he matured into a fine portrait painter. His sitters were a veritable "Who's Who" of Revolutionary America and the early Republican period. Peale served as a captain in Washington's army, and saw action at Trenton and Princeton. He painted seven portraits of Washington from life, his first being painted at Mount Vernon in 1772, before the war, and during his life produced in all sixty portraits of Washington. One of the most versatile Americans of his day, Peale was a painter, inventor, scientist, and writer, and founded a museum of natural history in Philadelphia, the first of its kind in America (1784). He was also one of the founders of the Pennsylvania Academy of the Fine Arts in 1805. He fathered an illustrious family of painters, his son, Rembrandt Peale, being the most able. Peale died in Philadelphia in 1827 after a long and active life.

Charles Willson Peale (self-portrait).
Courtesy Pennsylvania Academy of the Fine Arts.
Dictionary of American Portraits.

Rembrandt Peale (1778–1860)

Rembrandt Peale was born in Bucks County, Pennsylvania, in 1778, the son of noted painter Charles Willson Peale. At an early age he began to study art under his father, and copied paintings in the latter's Philadelphia museum gallery. In 1795, at the age of eighteen, he painted a life portrait of Washington. In 1801 when the elder Peale unearthed the skeletons of two mastodons in Ulster County, New York, Rembrandt Peale assisted in mounting them and went to Europe to exhibit one of the skeletons. While in England he studied under Benjamin West, and two of his portraits were exhibited at the Royal Academy in 1803. Back in America, he produced for his father's gallery additional portraits, the most noteworthy being that of Thomas Jefferson in 1805. In the same year he was one of the founders of the Pennsylvania Academy of the Fine Arts in Philadelphia. Three years later he went to France to paint portraits for his father's museum, and upon his return to America made an unsuccessful attempt to establish his own museum in Baltimore (1814). In 1820 he painted a large historical canvas, "The Court of Death," which was widely exhibited on tour, earning him $9,000. Establishing a studio in New York, he worked there until 1823, moving again to Philadelphia, where he worked on his "ideal" portrait of Washington. Returning to New York in 1825, he was elected president of the American Academy of Fine Arts, and made yet another painting trip to Europe in 1828. In his later years his portraits of Washington became a preoccupation with him; he traveled throughout the country, lecturing and exhibiting these portraits, and exploiting his claim that "I am now the only painter living who ever *saw* Washington." Peale died in Philadelphia in 1860.

Rembrandt Peale (self-portrait).
Dictionary of American Portraits.

Ogden Pleissner

Ogden Pleissner was born in Brooklyn, New York in 1905 and studied at the Art Students' League in New York City. He became a National Academician in 1939, executing paintings of war industries in 1942. He served as a captain in the Army Air Forces in 1943 and as War Artist Correspondent for *Life* magazine the following year. In the European Theater and the Aleutians during the war he produced many paintings of the conflict. Numerous museums throughout the country own his works, including the Metropolitan Museum of Art, The Minneapolis Museum, Brooklyn Museum, National Collection of Fine Arts, the Philadelphia Museum of Art, and the Library of Congress. His military paintings appear in the *Life* war art collection, the West Point Museum, Army Air Force Collection, and the U.S. Navy Collection. Mr. Pleissner is a member of the Art Students' League, and has received awards from the National Arts Club, the National Academy of Design, the American Water Color Society, and many others.

Ogden M. Pleissner. Courtesy of the artist.

167

Howard Pyle

Howard Pyle was born to Quaker parents in Wilmington, Delaware in 1853. He studied art briefly in Philadelphia, and in 1876 went to work for *Harper's* in New York, an association which was to last the rest of his life, as did his friendships with fellow illustrators like Edwin Abbey and A. B. Frost. Feeling his apprenticeship in New York fulfilled, Pyle returned to Wilmington, where for thirty odd years he produced a remarkable outpouring of children's books (*The Merry Adventures of Robin Hood, Pepper and Salt, Otto of the Silver Hand, The King Arthur* series, and others), and thousands of illustrations for *Harper's* and other leading publications of his day. Noted for his authoritative representation of the American historical scene, Pyle was equally gifted in his depiction of medieval subjects. At the height of his success he launched himself into a teaching career, first at Drexel in Philadelphia, then in Wilmington, and at a summer school at Chadds Ford. "Throw your heart into your picture, and leap in after it," he advised his students, who numbered among them such illustrious names as N. C. Wyeth, Frank E. Schoonover, Stanley M. Arthurs, W. J. Aylward, Thornton and Violet Oakley, and Harvey Dunn, to name but a few. Pyle's mural paintings included a series for the Hudson County Courthouse, Jersey City, New Jersey, and "The Battle of Nashville," painted in 1907 for the Wisconsin State Capitol. Probably no other man left such an indelible imprint on the quality of American illustration, his students perpetuating his teaching methods and enriching American illustration for the next generation and beyond. When Howard Pyle died in Italy in 1913 on his first trip abroad, *Harper's* eulogized, "We shall not see his like again."

Pyle's famous pirate pictures and his American historical illustrations were brought together in *Howard Pyle's Book of Pirates* and *The Book of the American Spirit*, published in 1921 and 1923 by Harper and Brothers.

Howard Pyle at work on his painting "Battle of Nashville." Courtesy Wilmington Society of the Fine Arts, Delaware Art Center, Wilmington, Del.

Frederic Remington in his studio.
Courtesy Remington Art Memorial Museum. Ogdensburg, N.Y.

Frederic Remington 1861–1909

Frederic Remington was born in Canton, New York, October 1, 1861. His only formal art education was received at Yale University Art School, which he attended for two years. With a small inheritance he headed west to Montana in 1881 at the age of nineteen, and promptly fell in love with the American West, a romance that lasted throughout his life. The first of his many Western illustrations appeared in *Harper's Weekly* in 1882. During the next few years he took up ranching in Kansas, married, hunted Apaches with General Nelson Miles in Arizona, and by the mid-eighties had established himself as the foremost Western illustrator in the country. Alternating between his studio in New Rochelle, New York, trips to the West, assignments in Europe and later in Cuba during the Spanish-American War, his outpouring of pictures was prodigious—some 2,700 paintings and drawings; 142 books carried his illustrations, 13 of them written by the artist himself; and 41 different magazines used his illustrations—all this in a working span of only twenty-five years! In 1895 Remington turned his talents to sculpture. His first and most famous piece, "The Bronco Buster," was followed by twenty-three more bronzes. He died at the peak of his career as America's most illustrious Western painter at the early age of forty-eight in 1909. His epitaph was as he wanted; it read: "He knew the horse."

Remington's pictures of the American cowboy, the Mexican *vaquero*, the Indian, and the cavalryman remain today a superb documentation of an era which has long since passed into history. A permanent exhibition of Remington's work is on display at the Remington Art Memorial Museum at Ogdensburg, New York; The Amon Carter Museum, Fort Worth, Texas; and the Thomas Gilcrease Museum of American History and Art, Tulsa, Oklahoma.

Charles M. Russell

Charles Marion Russell was born in St. Louis, Missouri in 1864. As a young boy, he was enrolled in a New Jersey military academy, but his father finally acceded to his wanderlust and dreams of going West, and in 1880, at sixteen, young Russell arrived in Helena, Montana. Like Remington, he was largely a self-taught artist, and his own early life as a wrangler working with the cowboys and participating in the cattle drives gave his pictures undisputed authenticity. In 1888 he lived for a time among the Blood Indians of Canada, enriching his love and knowledge of Indian lore. After a few more lean years of wandering the range, Russell settled in Great Falls, Montana in 1892. With his marriage in 1896, his wife, Nancy Cooper Russell, became his business manager, and he soon began to prosper and gain fame as a painter of the Western historical scene and for his sympathetic depiction of the American Indian. He produced many magazine and book illustrations, and his canvasses were exhibited in New York and London galleries bringing substantial "dead man's prices," as Russell put it. In 1911, at the height of his fame, he was commissioned to paint a mural for the Montana House of Representatives in Helena. The result was the canvas, "Lewis and Clark Meeting the Flathead Indians at Ross's Hole," which he finished the following year. Russell was equally adept at sculpture, and produced many fine bronzes. He died in Great Falls in 1926. Among the museums housing his much sought-after works today are the Historical Society of Montana in Helena, the Trigg-Russell Gallery at Great Falls, and the Amon Carter Museum of Tulsa, Oklahoma. Of himself, Russell characteristically wrote, "I am an illustrator. There are lots better ones, but some worse. Any man that can make a living doing what he likes is lucky, and I'm that. Any time I cash in now, I win."

Charles M. Russell at work in his Great Falls studio.
Courtesy Charles M. Russell Gallery, Great Falls, Montana.

Alfred Wordsworth Thompson.
New England Magazine, 1896.

Alfred Wordsworth Thompson

Alfred Wordsworth Thompson was born in Baltimore in 1840. In 1861 he went to Paris and began the study of art under Charles Gleyre, and for a time he was a pupil of Emile Lambinet. In 1864 he entered the studio of Albert Pasini, working there for one year. His first publicly exhibited picture, "Moorlands of Au-Fargi," was shown at the Paris Salon in 1865. Thompson returned to the United States in 1868, settling in New York. In 1873 he sent to the National Academy of Design the painting "Desolation," on the strength of which he was made an Associate of that institution. He was elected Academician in 1875, and regularly sent his pictures to the exhibitions of the Academy. He became one of the first members of the Society of American Artists in 1878. His painting "On the Sands, East Hampton" was exhibited at the Centennial Exhibition in Philadelphia in 1876. As a historical painter, he is noted for his paintings of Southern life in the eighteenth century and scenes of the American Revolution, the best known being "Departure of Smallwood's Command from Annapolis" in the Fine Arts Academy, Buffalo, New York, and "Old Bruton Church, Virginia, in the Time of Lord Dunmore" at the Metropolitan Museum of Art. Thompson died at Summit, New Jersey in 1896.

John Trumbull

John Trumbull was born in Lebanon, Connecticut in 1756 and was graduated from Harvard College in 1773. He served as an aide to General Washington during the early part of the Revolution, resigning from the Army in 1777 over a minor grievance. Three years later he went to London via Paris, with the intention of studying under Benjamin West, but was arrested "on suspicion of treason." His release was conditional upon his departure from England. The war over, he was back in London in 1784, painting portraits under the tutorage of West. It was at this time that he conceived the idea of producing a series of paintings commemorating the principal events of the Revolution, "in which should be preserved," he wrote, "as far as possible, faithful portraits of those who have been conspicuous actors in the various scenes . . . as well as accurate details of the dress, manners, and arms of the times; with all of which he [Trumbull] had been familiarly acquainted." Among these paintings were: "The Battle of Bunker's Hill," "Death of Montgomery in the Attack on Quebec," "The Declaration of Independence," and "The Surrender of Cornwallis at Yorktown." The last two hang in the rotunda of the Capitol in Washington.

John Trumbull. Engraving by Asher B. Durand
after a painting by Wlado and Jewett.
Dictionary of American Portraits.

Trumbull returned to the United States in 1789. He was appointed secretary to John Jay, returning to London with Jay in 1794 as one of the commissioners for putting into operation the terms of the Jay Treaty. In 1804 he opened a studio in New York, returning four years later to London to paint portraits, then finally going back to New York in 1816 where he was appointed director of the American Academy of Art. He retired to New Haven in 1837, giving his gallery of paintings to Yale University in exchange for a pension. He died in New York in 1843.

James Walker

James Walker was born in England in 1818. His family moved to America in 1824, and at the age of nineteen he left New York and traveled to Mexico, where he painted and taught art, and was residing there at the outbreak of the Mexican War. Banished from Mexico City by President Santa Anna, Walker escaped to the American lines and served as an interpreter with Winfield Scott's American army. This experience contributed to the accuracy of his subsequent series of pictures of Mexican War scenes, which he began painting in a New York City studio in 1850 following a painting tour of South America. His painting "The Battle of Chapultepec" was executed in 1857–62. During the Civil War Walker again took the field as a combat artist with the Union Army, and executed a number of paintings including "The Battle of Chickamauga," "The Battle of Gettysburg," and "The Battle of Lookout Mountain." In 1884 he went to California to paint a battle picture for a private gallery in San Francisco. He died in Watsonville, California in 1889.

James Walker. Courtesy New York Public Library.

Samuel B. Waugh

Samuel Bell Waugh was born in Mercer, Pennsylvania in 1814. A portrait and landscape painter, he is best known for his panorama painting of Italy, a country in which he studied art for eight years prior to 1841. The panorama was exhibited in Philadelphia in 1849, and was still on display as late as 1855. A second series entitled "Italia" was shown from 1854 to 1858. Waugh spent most of his time in Philadelphia, though he was in New York City in 1844–45 and lived at Bordentown, New Jersey in 1853.

Waugh was made an Associate of the National Academy in 1845 and an Honorary Member, Professional, in 1847. His panorama painting of immigrants landing at the Battery, New York was painted in 1855. His portrait paintings include those of Dorothea Dix (1868) and polar scientist John Wilkes (1870). Waugh died in Janesville, Wisconsin in 1885. Other artists in his family included his wife, Mary Eliza (Young) Waugh; daughter, Ida Waugh; and son, Frederick Judd Waugh, who won renown as a seascape painter.

Charles T. Webber

Charles T. Webber was born in 1825 in western New York State, and moved in 1858 to Cincinnati, where he became well known for his portraits and genre scenes. His painting "Fugitive Slaves on the Underground Railway" was first exhibited at the World's Columbian Exhibition in Chicago in 1893, and later survived the fire that destroyed the Cincinnati Chamber of Commerce Building. The painting was subsequently purchased from the Webber estate for the Cincinnati Art Museum through a fund raised by famed painter Frank Duveneck and others. Webber died in 1911.

Charles T. Webber. Portrait by Frank Duveneck.
Courtesy Cincinnati Art Museum.

John Ferguson Weir

John Ferguson Weir was born at West Point, New York in 1841. His artistic training came from his father, Robert Walter Weir, who painted "The Embarkation of the Pilgrims" for the rotunda of the National Capitol. After further training at the National Academy he developed into a portrait and genre painter of rare ability, his unique pictures of the industrial scene setting him apart from his contemporaries. "Forging the Shaft: a Welding Heat: a Welding Heat" (1867) and the "Gun Foundry" are among the best examples of his pictures. For thirty years he was director of the Yale School of Fine Arts, and in 1902 wrote *John Trumbull and His Works*. His work as a sculptor included statues of President Woolsey and Professor Silliman of Yale University. He died in 1926.

John Ferguson Weir.
Portrait by John W. Alexander.
Courtesy Yale University Art Gallery,
gift of Professor Weir's colleagues,
friends, and pupils, 1913.

Benjamin West

Benjamin West was born of Quaker parents near Springfield, Pennsylvania in 1738. He received his first portrait commission at the age of fifteen, and by 1756 he was working in Philadelphia as a professional sign and portrait painter. From 1760 to 1763 he studied in Italy, winning fame for producing remarkable historical canvasses. Settling in London, he was in great demand for paintings of mythological and historical subjects, and portraits. His famous canvas, "Death of Wolfe," painted in London in 1770, was an innovation for its day in that it portrayed a historic event in the costume of the period rather than in Roman togas like most heroic paintings of this sort.

West justified his departure from tradition: "The same truth which gives law to the historian should rule the painter. If, instead of facts of action, I introduce fiction then shall I be understood by posterity?" When first exhibited in England, the painting drew the largest crowds ever recorded for such an event.

In 1772 West became historical painter to King George III, and from 1792 until his death in 1820 he was president of the illustrious Royal Academy. West was a generous and hospitable mentor to young American painters in London such as Charles Willson Peale, John Trumbull, and Gilbert Stuart, and his influence can be seen in their work. West was buried with great ceremony in St. Paul's Cathedral in London.

Benjamin West. From the portrait by Gilbert Stuart.
Dictionary of American Portraits.

Richard Caton Woodville

Richard Caton Woodville (self-portrait).
Courtesy Maryland Historical Society, Baltimore, Md.
and Frick Art Reference Library.

Richard Caton Woodville was born in Baltimore, Maryland in 1825 of socially prominent parents. He attended the University of Maryland Medical School, but in 1845 gave up his medical studies to pursue an art career in Düsseldorf, where he studied under genre painter Carl Ferdinand Sohn. Though he worked during most of his brief life in Europe, Woodville's genre paintings portraying the American scene were immediately successful in the United States. Engravings made from his pictures were popularly received. After working for five years in Düsseldorf, Woodville deserted his wife and moved to Paris, where he continued to paint.

He died in London in 1855 at the age of thirty, apparently from an overdose of drugs. A meticulously detailed painter, Woodville's works include the popular "News From Mexico" and "Waiting for the Stage" (1851), owned, respectively, by the National Academy of Design, New York and the Corcoran Gallery, Washington. As a professional artist Woodville must be considered an unqualified success. He sold all but three of the pictures he painted.

N. C. Wyeth

Newell Convers Wyeth was born in Needham, Massachusetts in 1882. His early art training in Boston preceded his entry into Howard Pyle's classes in Wilmington, where he became one of Pyle's most gifted pupils. An early trip west in 1904 inspired his first important works in the Western illustration field. Wyeth's attraction to Chadds Ford on the Brandywine, where Pyle conducted his summer classes, prompted him to build his home there. In his hilltop studio he painted a long succession of illustrations and murals. The publication in 1911 of his illustrated edition of *Treasure Island* launched him upon what are perhaps his best-known works for the many illustrated classics published by Charles Scribner's Sons that would follow over the years—*Kidnapped, David Balfour, King Arthur, The Scottish Chiefs, The Deerslayer, The last of the Mohicans,* and others. Besides his book and magazine illustrations, Wyeth won wide recognition for his "easel paintings," many executed during his summer residence at Port Clyde on the Maine coast. His murals decorate the Missouri State Capitol in Jefferson City; Metropolitan Life Insurance Building, New York; Federal Reserve Bank and First National Bank of Boston; and National Geographic Society in Washington, to name a few.

In 1945 N. C. Wyeth was killed in a tragic railway crossing accident at Chadds Ford. A prolific and energetic worker, Wyeth nurtured his own family in his artistic tradition. His son Andrew is today the country's foremost painter, and James, son of Andrew, is well on his way to fame as a painter.

N. C. Wyeth at work on his painting "Landing of Columbus" in his Chadds Ford studio. Courtesy *Life* magazine.

F. C. Yohn. Courtesy Library of Congress.

F. C. Yohn

Frederick C. Yohn was born in Indianapolis in 1875. He attended Indianapolis Art School for one year, then studied at the Art Students' League in New York under noted mural painter Henry S. Mowbray. At nineteen his first published illustration was sold to *Harper's*. He was an artist-reporter during the Spanish-American War, and his illustrations of historical subjects appeared frequently in books and periodicals during the turn of the century. He illustrated a series of frontier sketches written by Theodore Roosevelt, and was a constant contributor to *Scribner's Magazine*. Yohn's virile technique was ideally suited to the military themes for which he is best known, the most notable of his illustrations appearing in Henry Cabot Lodge's *The Story of the Revolution*, published by Scribner's. Yohn made his home in Norfolk, Connecticut. He died in 1933. A permanent collection of Yohn's work is preserved in the Cabinet of American Illustration, Library of Congress.

Cliff Young. Drawing by Dora. Courtesy of the artist.

Cliff Young

Cliff Young, an Ohioan by birth, attended the Art Institute of Pittsburgh, the Chicago Art Institute, the National Academy of Design, and the Art Students' League in New York City. He studied with Harvey Dunn, taught life drawing at the Grand Central School of Art in 1941, and now teaches Figure Construction and Illustration at the New York Phoenix School of Design. He has created murals in mosaic, oils, and other media for churches, institutions, and government buildings, including the Zenger Memorial Room, Federal Hall National Memorial, New York City. He also assisted both Dean Cornwell and Barry Faulkner on mural commissions. His portraits, paintings, and drawings are in museums and private collections, his historical and location sketches being a permanent part of the U.S. Navy and Marine Corps Combat Art Collections. Mr. Young was present on the U.S.S. *Guam* when the astronauts of Gemini II were brought aboard in 1966, and witnessed the return of the Apollo 11 astronauts aboard the U.S.S. *Hornet* in July 1969. The artist is a member of the National Society of Mural Painters, the Architectural League of New York, the Salmagundi Club, and the Society of Illustrators, New York City.

Two Hundred Years of Pictorial History

by Dr. Charles Coleman Sellers

The "High Art" of History Painting

One of the greatest and most attractive American success stories is that of an artist, Benjamin West. From a remote Quaker village in colonial Pennsylvania, poor and unknown, he became painter to the King of England, commanding wealth and admiration, the towering genius of his time in the eyes of nobility and populace alike. He was still young, in his twenties, when this came about. There is a fairy-tale quality in it all. People saw an inborn talent, bright and pure, guided by a mysterious providence into that position of world renown. A child of seven who had never seen a picture of any sort (his father's inn did not even have a picture sign), he had made a drawing of his baby sister in her cradle. The family and neighbors marveled. Wonder and encouragement followed each new effort, and the boy went on, himself believing in the light of genius which they saw.

He sailed for Italy in 1760, the first of the hundreds of young American artists to study abroad. He became a sensation in Rome, and three years later traveled north through France to England. England and France had just made peace after seven years of war—the peace by which the vast French dominions in Canada were ceded to Britain. London was in a mood of victory and conquest, and in London West was a sensation once more—a native genius from a remote outpost of the expanding empire, a young man not content with portrait painting (the bread-and-butter work of all English artists), but dedicated to "high art," to those large scenes from ancient history or mythology which were

O!
SAY
CAN
YOU
SEE

173

regarded as the culminating tests of imagination, knowledge, and taste. Britain had had no outstanding painter of these themes, and here found a champion to rival the artists of the Continent, particularly of France. Sober British eyes had never approved what was being done across the Channel. Dr. Samuel Johnson in 1759 had deplored an art "by which palaces were covered with pictures that neither imply the owner's virtue, nor excite it." The young American's pictures were virtuous. He was a new, an American, Raphael, master of an art marked by both purity and grandeur. It fitted their sense of a new era dawning.

It appealed also to Britain's young king, himself setting a new standard of royal respectability and taste. So West gained the personal friendship of George III, and was able to hold it through the years while remaining, always, stoutly American. The Royal Academy was founded soon after this friendship began, West shining as its star of first magnitude through all his long life. There, early in his career, West challenged the art conventions of his time in a wholly American picture, his "Death of Wolfe" (see pp. 34–35) of 1771. Noble patrons and connoisseurs pleaded with him to maintain the classical tradition of high art by showing his figures in the dress of Roman warriors rather than the transient costume of their own times. West would have none of that. He shows the battle on the Heights of Abraham as the news of victory was brought to the dying general. In detail, the scene is as realistic as he could make it. In composition, it is poetically and richly symbolic. One's eye moves from the messenger, at left, bringing the news, to the body of the fallen commander, upward to the flag behind him and the dark clouds of impending death. Over the messenger's head, lighting the battlefield and touching the hero's brow, the sunlight of victory has broken through the clouds.

The picture was a victory for the artist too. There was no more talk of togas and armor as essential to enduring art on a great theme. Seen by thousands, published in engravings, it proved before all that history painting must stand with historical truth. Poetic symbolism there could be, and West's use of it here would be echoed again and again in art. But without the force of realism it would have lost all impact. More than half of West's greatness was in the man himself—dedicated to art with a depth of feeling not unlike the religious approach to painting which one sees in the first English Pre-Raphaelites of a later generation. The public came to think of him as art personified, superior to events, to parties and rivalries of any sort, always a friend and never a competitor of other artists, a priestly figure in the world of ideals and imagination.

For years, young Americans could cross the ocean to study art, sure of a place in West's studio—Peale, Stuart, Trumbull, and many more. John Singleton Copley, settling in London in 1775, had West's friendly aid, but Copley was different—a mature painter of West's own age, and ambitious of financial success. Copley turned to history painting, too, choosing contemporary events. Filling them with likenesses of living persons introduced him to a wealthy, influential patronage—most of all through his "Death of Lord Chatham" of 1781. The scene is in the crowded House of Lords, the Earl stricken in the midst of his speech, prostrate before them in a composition owing much to the "Death of

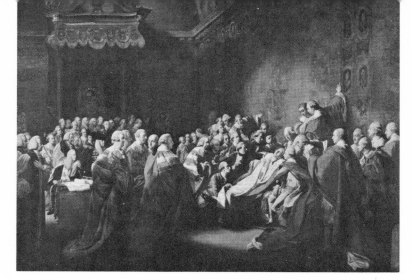

"The Death of Lord Chatham," by John Singleton Copley.
From the Tate Gallery Collection, London.

Wolfe." However, it is for all that a brilliant and sensational piece, and
the Royal Academy expected it to be a major attraction at its annual exhibition.
Academicians and noble lords were alike enraged when Copley, instead, rented
a room of his own and showed the "Chatham" at a price, dramatically hung
behind a proscenium. The Bostonian earned much ill will, but at the same
time demonstrated a fact of which other Americans would take note. He had
shown that a history painter need not be dependent alone upon the sale of his
picture to the owner of some great mansion. He could have that, but he could
also reap a noble profit by its exhibition, follow this by the publication of
engravings, and the value of the picture itself would be enhanced by all this
accumulated fame. Copley had also further demonstrated the enormous
popular interest in the dramatic presentation of a great moment, especially a
great moment in contemporary life.

West, at the close of the Revolution, thought of celebrating the new nation's birth in a
series of large history paintings, and wrote to Charles Willson Peale for
uniforms and background information. Soon after, he turned the whole project
over to another of his young protégés, John Trumbull. Trumbull, who had seen
action as a colonel in the American Army, took up the project with ardor, and
made it a life work. His first piece was "The Battle of Bunker's Hill." This, and

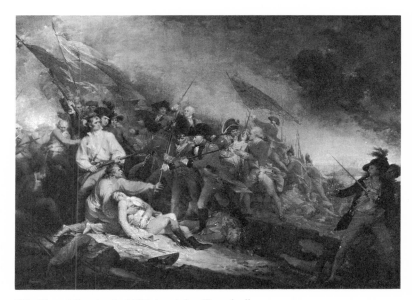

"Battle of Bunker's Hill" by John Trumbull.
Courtesy of Yale University Art Gallery.

O!
SAY
CAN
YOU
SEE

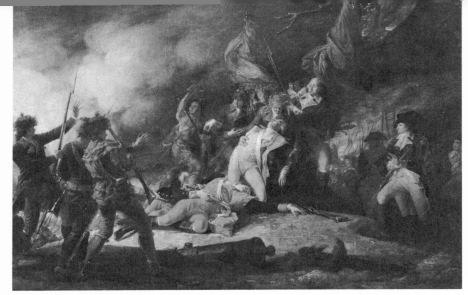

"Death of General Montgomery in the Attack on Quebec, December 31, 1775,"
by John Trumbull. Courtesy of Yale University Art Gallery.

his "Death of General Montgomery," both painted in West's studio, are spirited pieces much influenced by the master. Trumbull's later works, crowded with authentic portraits, too often bring us rows of faces, with little of the excitement of the event. Yet to patriotic young America they were nonetheless exciting, and his long "national work," as he called it, came to a climax in 1817, when Congress commissioned him to paint the four great pictures in the rotunda of the Capitol, "The Surrender of Burgoyne," "The Surrender of Cornwallis at Yorktown" (see pp. 62–63), "The Declaration of Independence," and "The Resignation of Washington." There you can see them today, a monument to the steady ardor of the one-eyed old colonel—a man who looked as if he might have stepped out himself from among the figures in his heroic paintings—handsome, dignified and courtly, always high-strung, overready to take offense, a proud, aloof man, yet achieving a popularity through his paintings and their reproduction in countless histories and school books perhaps unequalled by any other American artist.

With Trumbull turning out those last great works at $8,000 each, and exhibiting them privately at a price before delivery, other artists were stirred to emulation and a hope for further public commissions. Among them, Thomas Sully, a lovable, warm-hearted painter who had come under West's influence in a smaller way, . painted a large "Washington at the Delaware." It is heroic, stately, but without the dramatic intensity of the famous piece by Emanuel Leutze, painted in Düsseldorf fifty years later. For authenticity of detail, few historical paintings have been so thoroughly discredited as this by Leutze. "Washington Crossing the Rhine," the critics called it, and quipped about the folly of standing up in a small boat in midstream. But the drama is all there—that sense of driving forward through danger into greater dangers, and of fateful issues waiting on that cold and barren farther shore.

"Washington Crossing the Delaware," by Emmanuel Leutze.
The Metropolitan Museum of Art, Gift of John S. Kennedy, 1897.

In Leutze's day, young American painters were flocking to Germany for study, sometimes
to France. In England, the Pre-Raphaelites were bringing a new vitality into the
old traditions of high art. Everywhere, small paintings of casual scenes from
contemporary life, sometimes the life of the past, were popular in America, as
produced by such talented painters as George Caleb Bingham (see p. 59),
William Sidney Mount, Richard Caton Woodville (see p. 87), or, later, Winslow
Homer (see pp. 113, 136–137) and Edward Lamson Henry (see pp. 126–127).
These, today, are often of more genuine historical interest than the large
formal works. But it was again an American, working through most of his life
in England, who refined and modernized the tradition established by West.
Edwin Austin Abbey, a Philadelphian, had been living in England since 1878
when, in 1896, he was commissioned to paint his great works for the State
Capitol at Harrisburg (see pp. 54–55). In 1909 he was invited to paint the
official picture of the coronation of Edward VII. He declined the honor, but it
was nonetheless a royal accolade echoing those which had come to Benjamin
West, so long before.

"Pilgrims Going to Church," by George Henry Boughton.
New York Historical Society.

Abbey's friend, George Henry Boughton, was another American-trained artist who settled
in England, where he also continued to paint American scenes for the
American public. Large reproductions of his "Pilgrims Going to Church," at the
New York Historical Society, once hung in countless American homes. They show
men and women in a snowy landscape, dramatically evoking a sense of
danger as did Leutze's piece, but within a mood of piety rather than
patriotism. While works such as these flourished in the fine arts on both sides
of the Atlantic, another sort of historical art had, for a hundred years, been
developing in directions of its own.

O!
SAY
CAN
YOU
SEE

The Low Road

From colonial days, American culture had one outstanding, unique characteristic: a low level and a wide spread. In the eyes of a European sophisticate our cultural achievement was deplorably meager, but in his own country he would never find so many with a hunger for the arts, for knowledge. Our eyes were constantly on Europe, eager to absorb at least something of the new styles and wonders of the Old World and eager to create wonders of our own.

In the 1780s, the decade that saw the end of the American and the beginning of the French Revolution, exhibitions such as Copley's were bringing pictures into the realm of the popular attraction. For the first time, any man with a shilling or a two-bit piece could enjoy high art, or some amazing imitation of it. Ingenious men began to cast about for astonishing new effects. In London, Philip James De Loutherbourg, David Garrick's scene painter, who at Drury Lane had matched the new realism of Garrick's acting with a new realism in stage setting, opened a miniature theater of his own in which, by transparent and moving panels, clever lighting and sound effects, he brought the painted scene to life as never before. It became the rage for a while. Across the ocean, Charles Willson Peale took up the idea in 1785 with landscapes and imaginative scenes in which water flowed, winds blew, birds sang, and light changed from dawn to dark. He had one scene of dramatic action, the battle between the *Bonhomme Richard* and the *Serapis,* complete with smoke and thunder, the maneuvering of the ships, the *Richard* going down as her flag was raised on the *Serapis.* De Loutherbourg's name for his show, "Eidophusikon," was too cumbersome for Peale's public, and he tagged his with a new one, "Moving Pictures."

In Edinburgh, meanwhile, a landscape painter named Robert Barker was working on a new sort of realism and popular appeal which again had a tie to the theater. Barker's sensational idea was to surpass in size even the greatest history paintings of the day and to eliminate that feature of a painting which most clearly marks it as a counterfeit of reality—the frame. The painting would stand in a huge circle, with the spectators at its center. The entrance would be from below. A circular ceiling would screen the top of the canvas from view, but allow the light to fall upon it. Some parts of the picture would be carried into the foreground with actual objects—for a battlefield, for instance, cannon, scattered weapons, a body or two. The name "cyclorama" more closely defines this art form, and was applied to it later, after "panorama" had become more widely and loosely used. Barker's first piece, a view of Edinburgh, made an immense sensation in 1788. By 1792 he had completed a view of London on a grander scale, and had erected the first cyclorama building, ninety feet in diameter, to hold the canvas. Such structures were to become familiar objects in city architecture for a century to follow: round in form, with the whole sky-lighted second story for the picture, below which were the entrance, ticket booth, and generally a smaller exhibition of some sort.

One of the admirers of Barker's London show was the American artist, Robert Fulton. Crossing to Paris in 1796 to offer his inventions in submarine warfare to the

French government, Fulton carried with him a ten-year patent right for exploitation of this new type of picture show in France. With the help of fellow Americans in Paris, *"Le Panorama, ou Tableau sans Bornes"* appeared on the Boulevard Montmartre. It had twin rotunda towers, for one of which their corps of painters produced a view of Paris, and then for the other a piece of history in what was to become the most popular cyclorama subject, a battle scene, *"L'Evacuation de Toulon par les Anglais en 1793."*

Bonaparte, the hero of Toulon, became himself an enthusiast for the new art form, and by 1810 was planning a group of eight such towers in which his greatest battles would be shown. The tides of war engulfed this plan, but French artists did go on, not only perfecting Barker's idea, but taking over De Loutherbourg's invention. One led all the others, and this was Louis Jacques Mandé Daguerre, the Parisian scene painter who in 1822 produced the "diorama" and in 1839, the photograph. No other man has wrought more profound changes in art history. The De Loutherbourg and Peale "moving pictures" could be viewed only by small audiences, and the complexity of each scene made the labor unprofitable. The diorama was similar, but in large scale, its essential principle being the use of transparent materials lighted from behind to give changes of light and the illusion of living nature.

As for America, Barker's astonishing invention had leapt over into the western world at a bound. In January 1790, a view of Jerusalem was showing in New York at "Lawrence Hyer's Tavern, No. 62, between the Gaol and the Tea Water Pump. The sight is most brilliant by candlelight." It was still drawing a public twelve years later. Edward Savage brought the first to Philadelphia in 1795, and William Winstanley set up a view of Charleston in New York in 1797. Specially built cyclorama buildings came more slowly, since such an investment could only pay in a large population center. Yet there was one in New York in 1804, and in Philadelphia in 1806, both showing Sir Robert Ker Porter's "Battle of Alexandria." Its New York announcements accord this piece 3,000 square feet of canvas. Philadelphia papers just doubled this figure (the same painting, undoubtedly) and stressed also the correct portraits of ninety British officers. The publicity buildup was under way. "The Battle of Paris," by Henry Aston Barker, son of Robert, was in both cities in 1818 and 1819. It was 150 by 18 feet, with a cast of 150,000 fighting soldiers, and it was double-featured with the same painter's "Battle of Waterloo" on 2,440 square feet of canvas. Panoramic shows that had run their course in Europe lived again on the American circuit. Soon, however, American painters with American subjects were on the billboards too, and within a few years they would be following up American successes by European tours.

America's first full-scale and permanent cyclorama building followed John Vanderlyn's return from France to his native New York in 1815, bringing with him his huge "Gardens of Versailles," parts of which are now at the Metropolitan Museum. Most of our painter-producers turned to shows involving less investment, more novelty, and better adaptation to touring the smaller towns. "Phantasmagoria,"

179

featuring magic lantern and colored light projections, had appeared in 1803; such shows, specializing in the supernatural, were popular for a century after. Daguerre's diorama played for years on Broadway and, when history was in the making, echoed it with "Taylor's Victories in Mexico." There was ever a searching for ways in which to bring pictures into motion. Working models and automatons were popular. After the War of 1812, for instance, "The Treaty of Ghent" was enacted with mechanized historical and allegorical figures. A panoramic "Battle of Bunker Hill" ran for years, with mechanical figures in action before the painted scene, and in 1834, just to cite a typical offering, New York was being treated to a "Grand Picturesque and Mechanical Exhibition of the Polish Revolution in Warsaw." But the greatest of all the exploiters of semimechanized history was surely the German, John Nepomuk Maelzel who, after European triumphs, brought his shows to America in 1825 and held American audiences spellbound for the next ten years. Maelzel had witnessed the burning of Moscow in 1812, the turning point in Napoleon's career of conquest. He made the scene his masterpiece. Highbrow and lowbrow alike were swept off their feet by the grandeur of this amazing spectacle, "The Conflagration of Moscow." As a cultured Philadelphia lady saw it,

> The city was before us, closely built up and the houses all aflame. We quivered at the sight; saw men, women, and children making their escape from the burning buildings with packs of clothing on their backs. The scene was terrible, and so realistic that when we went to bed after returning from the spectacle we hugged each other and rejoiced that our house was not on fire.

And then this, from Major Jack Downing's "Cousin Nabby," down east in Portland, Maine,

> Then they said they would show us the Congregation of Moskow. And presently I begun to hear a racket and drums and fifes agoing, and bells a dinging, and by and by they pulled away some great curtains that hung clear across the hall, and there was a sight that beat all I ever see before. I jumped and was going to run for the door at first, for I thought Portland was all afire; but ant Sally held on to me till I got pacified a little, and then I sot down.
>
> And, there, I must say it was the grandest sight that ever I did see. A thousand buildings and meeting houses was all in a light flame, and the fire and smoke rolling up in the clouds, and thousands and thousands of soldiers marching and riding through the streets, and the drums and the fifes and the bugles and the bells and the guns; O Sally, you must come and see it, if you have to come afoot and alone as the gal went to be married.

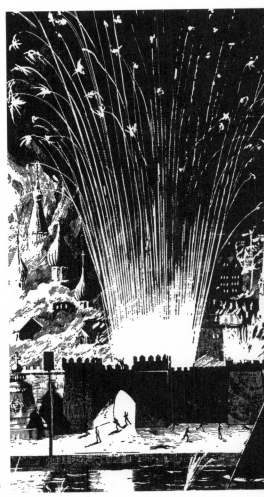

"The Burning of Moscow."
From Albert Hopkins, "Magic: Stage
Illusions and Scientific Diversions."

O!
SAY
CAN
YOU
SEE

180

Curiously, with the picture shows of the early nineteenth century struggling to produce some illusion of life and motion, the legitimate theater was at the same time reflecting the overwhelming popular interest in pictures by assuming some of their static quality. The result was one of the least glorious epochs of our dramatic history. Conventions of pose became more fixed, and scenic effects were overemphasized. The actors grouped themselves in pictorial compositions, the one with an important speech moving front center to make it and then holding a brief tableau through his round of applause. The final climactic moment would bring a full-scale tableau—all actors rigid as if painted there. Thus ends, for instance, the famous Act Two of *Ten Nights in a Bar Room*. Slade hurls the bottle that misses Joe Morgan but strikes down his little daughter. Morgan snatches up a stool and rushes upon Slade, crying, "Here, by the side of my murdered child you shall die the death of a dog!" The barroom loungers seize him as the weapon is still upraised above the cowering villain, and the whole group is instantly frozen into immobility while (as the script directs) "soft music" plays. Many pieces, such as *Uncle Tom's Cabin*, were acted out largely in a series of tableaux. On patriotic occasions, Trumbull's *Declaration of Independence* might be added to the bill of the evening, with living actors posed exactly as in the painting, and perhaps the added fillip of Mars and the Goddess of Liberty cavorting overhead. Americans had discovered that a picture, fixed and motionless, has a power of emphasis and an emotional impact lacking in a transient art.

Size had always been a prime attraction in the painted shows. People liked to see art, as well as other things, done in a big way. Out of this developed the rolling panorama, a series of large pictures rolled from one tall reel to another. A scene is shown, accompanied by the voice of a lecturer, extolling and explaining. Then music plays, to cover the creaking of the rollers while the next scene moves into view. Length would be bounded only by the staying power of the audience. This form was ideally adapted to the travelogue. Its most successful and most often repeated subject was the rich and scenic wonder of the Mississippi Valley. This brought the picture show business into the West and, more, it brought knowledge of the West to the East. The rolling panoramas have their place in the history of migrations and land speculation. Greatest of them all was John Banvard's "Panorama of the Mississippi River" of 1847, which dramatized 12,000 miles of river scenery on a reputed three miles of canvas. It had its lecture, interspersed with musical accompaniments especially composed for it. It thrilled alike the backcountry folk and the literary lights of New England, and it went on to play in triumph before Victoria and Albert of Britain, and the crowned heads of the Continent.

A few of the old rolling panoramas survive. One, owned by the University of Pennsylvania's University Museum, was recently shown at the City Art Museum of Saint Louis—appropriately, for Saint Louis is not only in the show's locale, but was once a center of the panorama industry. This one, "The Panorama of the Monumental Grandeur of the Mississippi Valley," had been painted in

181

"Fort Rosalie. Extermination of the French in 1729."
From the Egan Mississippi Panorama. Collection of the
University Museum. University of Pennsylvania, Philadelphia.

Philadelphia in 1850 by John J. Egan, and had a long and successful tour with
Dr. Montroville W. Dickeson as lecturer. It is painted in tempera on muslin
sheeting, 348 by 7½ feet (15,000 feet of canvas," according to the publicity),
and the travelogue is interspersed with historical scenes and comic relief. The
Minnesota Historical Society owns another, luridly reporting "The Sioux
Massacre" of August 1862. It was painted, 1870–78, by John Stevens, a sign
painter of Utica, New York. His thirty-six scenes are on a roll of canvas 225 by
6 feet. The show opens with an idyllic picture of life in Minnesota, followed by
Indian atrocity in every detail of murder and mayhem, and winding up with
the mass execution of the braves.

Detail from "The Sioux Massacre" showing the mass execution
of the Sioux chiefs. Minnesota Historical Society.

Detail from "The Sioux Massacre" by John Stevens
showing the killing of two captives, Julia Smith
and her mother. Minnesota Historical Society.

Detail from the cyclorama painting
"The Battle of Gettysburg"
by Paul Philippoteaux.

After the Civil War, with the growth of urban populations, and with battles galore as subject matter, the more expensive and sophisticated cyclorama flowered anew. Milwaukee became the Hollywood of this industry in 1885 when William Wehner, a promoter, imported twenty German-trained artists who produced for him two "Crucifixions," a "Christ's Entry into Jerusalem," two "Battles of Chattanooga," two "Battles of Atlanta," and a "Battle of Gettysburg." Another "Gettysburg," a vast and vivid view from the "Bloody Angle," painted by the French artist, Paul Dominique Philippoteaux, was long a Philadelphia attraction and is now permanently installed in the National Park Headquarters at Gettysburg. "The Battle of Atlanta," still a popular attraction at Atlanta, has remained intact, preserving all the original finesse and realism of its first showing.

Meanwhile, the rolling shows still rolled through the little towns and villages and, in the tradition of Copley, large paintings of fine art quality still made the tours, many on the great religious themes which were always sure of success. Yet none of these could ever equal the popularity of one native piece, "Breaking Home Ties," by Thomas Hovenden. Hovenden will be best remembered today for his "John Brown Being Led to Execution," a poignant moment in history which has been reproduced many times. Yet "Breaking Home Ties," a simple family group, with its tender farewells as the eldest son leaves his home in the country to face the world, touched every heart more closely. It became one of the major attractions of the World's Columbian Fair of 1893, and afterward toured the country on its own.

"Breaking Home Ties" by Thomas Hovenden,
Philadelphia Museum of Art.

O!
SAY
CAN
YOU
SEE

That year brings us to the advent of the cinema. By then, easel painting had long been attempting to outdo the realism of the photograph, or else to escape from it into some world of artistic virtuosity where the photograph could not follow. But as far as these dramatic reflections of history or contemporary life were concerned, the new moving picture simply took over from the painted shows. Producers and promoters of panoramas became producers and promoters of the silver screen. Their experience in the one could be applied at once to the other. They were ready with the startling and effective publicity, and they were adept at fitting the theme to the audience. The old silent movies owe more in their origin to the painted shows than to the legitimate theater.

History in Your Hands

The traveling picture shows helped to give America a sense of identity, satisfied religious and emotional longings, and taught people something of their own history, of their place in the history of the world. All this came at the price of a small admission charge, sometimes a little more for the souvenir booklet. Even as this business was flourishing, others in another way catered to the yearnings of this sprawling, growing public, this new culture in the mass. Almost from the first, the big pictures had their echoing counterpart in popular literature— on one side the big paintings and, with many, a spoken lecture; on the other, little pictures and a printed text. One enthralled you wholly but briefly, while the other could be taken home for continuing enjoyment. Both were advertised as moral and educational. Both put entertainment value to the fore, with a tendency toward sensationalism. Both appealed to the American longing for culture, for glimpses of wonderful, distant lands, for release from the humdrum and for a sense of national unity and glory—for that excitement which pictures can always give when they make the oft-told story "come real."

Pictures in the small, like pictures in the large, have their own history of technical advance. The know-how, spurred on by that vast American popular demand, moved from the simple woodcuts of early days into the great era of color printing, served by great artists and writers, and with history as a prevailing theme. The popular woodcut has been with us since the New England Primer, and through thousands of schoolbooks, tracts, and the rest, in the generations that followed. The woodblock could be set and printed with the type. It was much cheaper than the more elegant and vastly more expensive copperplate engravings, and better adapted to large printings. From about 1835 onward, the use of wood engraving in American publishing expanded with increasing rapidity, with improvements in technique, and with adaptation to higher levels of subject matter. Thomas Bewick, the English master who in the late eighteenth century had given the art a new finesse, both technical refinement and personal touch, had had his prompt and competent disciple in Alexander Anderson of New York. Bewick and Anderson gave to others the realization that this was not just a profitable industry, but an art with individual qualities of its own.

Yet wood engraving flourished in our country not so much in response to the engravers' skill as from the steady increase of the book-buying public, particularly those who, having acquired some degree of wealth and social status, wanted a sprinkling of culture with which to season it. It can be seen in the economic index. Waves of prosperity have been accompanied by waves of books purveying useful knowledge, explaining the conventions of good manners, and supporting causes. Above all, the flowering of popular book illustration in America is linked to the public school systems, to the great educational advances of the 1830s, 1840s, and 1850s—to these, and to the desire of the less well-taught older generation to keep pace by having on the shelf with the Holy Bible one or more books of general information. Production was concentrated where the educational urge was strongest, in New York and New England. Philadelphia became a great publishing center, preeminent particularly in copperplate engraving, but with fine craftsmen on wood. The larger volume and more "downright" product, however, were coming from New York and Boston, later, too, from Cincinnati, all flowing out to a receptive public throughout the nation.

The most profitable of these illustrated books were sold by subscription agents, turning up everywhere and always artful in approach. Those sent out by Robert Sears, printer and publisher of New York, were carefully instructed not to seek out the persons with a known literary propensity in any neighborhood, but to knock at those doors where they would find simpler people, but with money in the teapot. It worked, and amazingly well. Sears had brought out his *Pictorial Illustrations of the Bible* in 1840–41, followed this with *The Wonders of the World in Nature, Art and Mind,* and then his *New Pictorial Library, or Digest of General Knowledge; Comprising a Complete Circle of Useful and Entertaining Information Designed for Family Reading,* and thus continued to tense his bow and let fly his arrows until the outbreak of the Civil War put a stop to it all. Another highly prolific and successful entrepreneur-author was the Maine Yankee, John Frost, whose popular histories and biographies—weighted heavily on the side of battles, heroes and heroines, Indians, Western adventure, and the whole range of derring-do—ran in competition with Sears. His *Pictorial History of the United States* and *Pictorial History of the World* had tremendous sales. His *Grand Illustrated Encyclopedia of Animated Nature,* New York, 1855, was "Embellished with thirteen hundred and fifty spirited illustrations." Let the panorama men vaunt the prodigious footage of their painted spectacles, and the book men would boast no less of numerical abundance.

Simultaneously, the field was exploited on a higher level in particular by three men who were at once artists, writers, and promoters, who were moved by a genuine feeling for history and by the sense of a mission to preserve and transmit it. The eldest of the triad was John Warner Barber, born in Connecticut in 1798. In 1836 he published his *Connecticut Historical Collections,* setting a pattern which was to be repeated again and again with notable success. In its preparation he visited every township in his concise little state, giving each historical and statistical summary, and an illustration. Barber as a boy had been apprenticed to a bank note engraver, and his works have some tinted full-page copperplates, but the illustrations are primarily small woodcuts of his

own design and execution, each a factual and charming portrait of a village green or other once-familiar view. To historians, the book has had a genuine value from the very first, and as a business venture it had a built-in success. To local people who had been interviewed or had seen the author-artist at work, the event of his visit was a subject of conversation leading straight on to the purchase of the volume. The idea was picked up by a younger man, Henry Howe of New Haven, who tried it out in a venture of his own, and later worked in partnership with Barber. Howe went on to an active career in Cincinnati, where the "Queen City of the West" became a center for the publication of the general-information woodcut-illustrated book. The third figure is Benson John Lossing of New York, wood engraver, artist, and author. His great monument in a long and productive life is his *Pictorial Field Book of the Revolution*. The Barber-Howe formula was so well established by 1848 that in that year Harper and Brothers began the advances which enabled Lossing to visit all the battlefields of the War for Independence, recording scenes and events in a work which is still an important source book for historians. It appeared in two large volumes, 1850–51. Later, he moved on to the War of 1812, and then to the Civil War. He illustrated also the works of other authors, contributed to magazine illustrations, and turns up in the vast output of the indefatigable "Peter Parley."

No review of this field of endeavor would be complete without a respectful mention of Connecticut's Samuel Griswold Goodrich, author and promoter of countless juveniles conceived in the literary image of Britain's Hannah More. They include his "Peter Parley" books, and a formidable array of historical and descriptive tomes published under his own name. All of these kept the wood engravers of Boston and New York busy. His *History of All Nations* of 1849 had 700 engravings. His *Natural History* of 1868 had 1,500. Goodrich was a gentleman of culture, traveled, and with a creditable record in the diplomatic service.

Inevitably the popular illustrated book was accompanied by the popular illustrated magazine. England's *Penny Magazine* met the call for popular edification in that country. It was a restrained and earnest thing, the upper classes speaking to the lower. The *Illustrated London News*, founded in 1842, set a pattern more acceptable in America. Our engravers, however, were not yet able to handle such large blocks, and to meet news deadlines with them. Only in 1851 was *Gleason's Pictorial Drawing Room Companion* (after 1854 *Ballou's Pictorial Drawing Room Companion*), launched in Boston. It lasted a decade. *Leslie's Illustrated Weekly Newspaper* began its run in New York in 1855, where, two years later, it had the formidable competition of *Harper's Weekly*.

The big picture magazine, *Harper's Weekly*, with its sedate elder sister, *Harper's Monthly Magazine*, had together a central and profound effect upon the development of book illustration, upon the art and techniques of wood engraving, and a good measure of influence as well on the history of American painting. They employed many artists, mostly young, and they paid well. The work was all under pressure, with strong emphasis on realism—dramatic, if possible, but within the framework of accurate

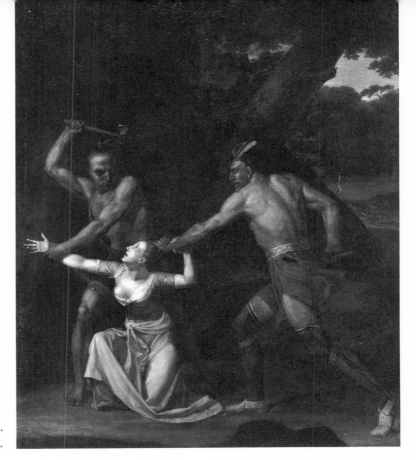

"Death of Jane McCrea" by John Vanderlyn.
Courtesy Wadsworth Atheneum, Hartford.

reporting. Pyle and Abbey were products of this school. Winslow Homer's plates from the old *Weekly* are collectors' pieces now. It was a stringent, effective apprenticeship in art, though the artists had often the frustration of seeing their work lose character as it was rushed through to the press, sometimes several engravers working on parts of the same design. Photography would change all this, as it has changed so much. Toward the end of the century, by coincidence, shortly before the time the movies began to take over from the panorama shows, photo-engraving and process gave the illustrators new freedom. It was possible then to reproduce an original work, first in line and then in color, and the artist was no longer obliged to make his original exactly in the page size.

This opened the door to our great age of illustration. Photo-engraving appeared primarily in books and literary magazines, and it flourished through the 1890s to the first World War. In history and fiction, artists of talent worked in concert with talented writers. Some, like Howard Pyle, fused the two arts by giving visual expression to writings of their own. It was not simply a result of technical advances. It had a tradition of its own which had grown with the growth of American publishing, meeting the need and demand of that still young, exuberant, eager, still expanding, American culture. We have a fine early example of vigorous illustrative art in John Vanderlyn's "Murder of Jane McCrea." The story was well-known, the scene often pictured: a beautiful American girl seeking a tryst with her lover in Burgoyne's army, cruelly slain by the Indians who followed the British standard. This picture was painted in France in 1803, as an illustration for Joel Barlow's epic poem, *The Columbiad*. Poet and painter disagreed as to price and *The Columbiad*, which had been conceived as a masterwork of literature and art, appeared with vapid engravings after an English artist. The poem itself is a stilted affair, but illustrations such as Vanderlyn's could have given it new force and value.

Vanderlyn, historical and portrait painter and panoramist, was, like West, Trumbull, and their school, only incidentally concerned with book illustration. Of those who made a career of it, our first great figure is beyond question the vigorous, indomitable Felix Octavius Carr Darley, born in 1822. His character sketches of American life first attracted attention when he had just turned twenty. Barber's work was new then, book illustration a coming thing, and publishers were looking for an artist with a ready pen, wit, and an eye for both the people and the scene. It is worth noting that the young man was the son of an actor and an actress. Everywhere one finds these links between subject painting and the theater, and Darley's feeling for the comic situation, his sense of high drama also, surely owed much to this background. He illustrated Washington Irving's *Legend of Sleepy Hollow*, *Rip Van Winkle*, and the wonderful Diedrich Knickerbocker caper, all in the true spirit of the tales. He illustrated Cooper's romances of forest and sea, catching their mood of grandeur. He was the first American illustrator of British works, notably Dickens, and they fared better at his hands than any other. English novels of the early Victorian period had been illustrated by George Cruikshank and others, largely in a vein of caricature, suitable for *Pickwick* but out of tune with the later stories. Today, we must admire Darley most of all for his pictures of the life around him, a primary source on American character and manners before the Civil War.

Darley moved at last from New York to a less pressured life at Clayton, Delaware. His studio in the Brandywine Valley was not far from where Howard Pyle would live and teach a generation later. It is with the coming of Pyle, his enormous success and his many students and followers, that we see for the first time the rise of a school of American painting, a school in the full sense of the continuing transmission of a style. It is a style with the *Harper's Weekly* emphasis on accurate reporting, but there is much more in it than that. Designs were skillfully composed, not to command the viewers' immediate attention, but to give force and poignancy to the subject. That tie to theater art is ever present. In a remote way it is in the tradition of West, yet with the change from a poetic to a prose style. Compare, for instance, the flamboyance of Trumbull's "Battle of Bunker Hill" with the steady rhythm of Pyle's (see pp. 46–47). The new school is more deft, more true, with character delineation. In West's day, certain facial expressions, gestures, and body poses were tied to certain emotions in both painting and drama. Pyle, as would an actor of our own day, felt the emotions of the scene within himself, and expressed them so.

The eventual decline of illustrative art was due in some measure to a loss of this facility, a return to conventionalized faces and poses—largely at the insistence of the publishers of popular magazines, who were developing formulas as to what was pleasant and safe with their public. Pyle refused to do this, and one can see his blunt honesty echoed here in his work and in that of some of his followers, N. C. Wyeth, Clyde DeLand, Stanley M. Arthurs, Harvey Dunn, and Dean Cornwell. It is a vigorous quality which held true also in the work of the Western artists, Frederic Remington and Charles M. Russell, men who pictured, directly and vividly, only the world around them—cowboy, Indian, soldier, and settler.

The delight in this art of the people has been national, but in following its history one finds himself brought back again and again to the Philadelphia area, from which Benjamin West had come at the beginning. The intellectual freedom of Pennsylvania life in colonial days had much to do with this. Early America tended to regard pictures as vain and idolatrous; artists and actors alike aroused suspicion. Another factor was the primacy of the old Pennsylvania Academy of the Fine Arts, founded in 1805; and then there followed the city's long period as a publishing center, particularly of illustrated periodicals all the way from the *Columbian Magazine* of the eighteenth century to *Sartain's* or *Graham's* in midcourse of the century following, and then, in our own, the *Saturday Evening Post* and *Ladies' Home Journal*.

Philadelphia and the *Ladies' Home Journal* were home ground to the last American artist to be described professionally as "historical painter." J. L. G. Ferris died in 1930, leaving behind him some seventy paintings of American history, a vivid and delightful gallery in itself, though all were painted to be reproduced in color on the printed page. They are a sincere reflection of the past, full of light and drama, and a reflection also of the genial, gentle nature of their creator. Ferris was the son of an artist, and nephew of another, Edward Moran (see pages 22–23, 141). He bore the name of the towering figure in French academic painting of the time, Jean Léon Gérôme, whose "Eminence Grise" is one of the most subtly dramatic of all historical character studies. Young Ferris studied at the Pennsylvania Academy under Christian Schussele, then the outstanding American history painter. Schussele, firm in the old tradition, was still producing large paintings for exhibition on tour at a price, but within the dignified realm of high art—such themes as his "Andrew Jackson before Judge Hall at New Orleans, 1815," a dramatic grouping with thirty-six original portraits of warriors and lawyers. Ferris finished his education in Paris, where the great Gérôme met and gave friendly criticism to his namesake.

Movies and television have taken the dramatic picture shows from the road and swept away the literary magazines through which so many artists once met their public. Yet the need and the demand for these informed and skillful evocations of the past are with us still, even though it is the photograph that best records our own and recent times. The continuing popularity of the masters of the art makes this clear. We must still be able to sense, as we can so well in this way, the dignity and unity of our national life, our place in time and the world.

O!
SAY
CAN
YOU
SEE